DIGITAL FAMILY ALBUM

SPECIAL OCCASIONS

DIGITAL FAMILY ALBUM

SPECIAL OCCASIONS

Tools for Creating Digital Memories

Janine Warner

Watson-Guptill Publications/New York

I dedicate this book to all who celebrate the holidays and to the many ways we collect and share our memories and traditions. I hope the lessons and designs in the *Digital Family Album* series inspire you to share your photos, stories, and celebrations. And may you always be surrounded by those you love.

Copyright © 2007 by Janine Warner

First published in 2007 by Watson-Guptill Publications, Nielsen Business Media, a division of The Nielsen Company 770 Broadway, New York, NY 10003 www.watsonguptill.com

Library of Congress Cataloging-in-Publication Data

Warner, Janine, 1967-
 Digital family album special occasions : tools for making digital memories /Janine Warner.
 p. cm.
 Includes index.
 ISBN 978-0-8174-3802-9 (alk. paper)
 1. Photographs—Conservation and restoration—Data processing. 2. Photograph albums—Data processing.
3. Scrapbooks—Data processing. 4. Photography—Digital techniques. I. Title.
 TR465.W372 2007
 775—dc22
 2007006021

Editorial Director: Victoria Craven
Senior Development Editor: Michelle Bredeson
Designer: Pooja Bakri
Production Director: Alyn Evans

Manufactured in Malaysia

First printing, 2007

2 3 4 5 6 7 8 9 / 15 14 13 12 11 10 09 08 07

Acknowledgments

It has been delightful to include so many friends and family in this book, but my sister-in-law Stephanie continues to deserve the most credit for inspiring me to create this series. I can't thank her enough for all of her photos, cards, and scrapbook designs. She is a talented photographer, a gifted storyteller, and an amazing mom. Thanks also to my brother Kevin, who has been a solid source of support in my life and an inspiration as a parent. And special thanks to their three beautiful daughters and their new son, who bring me such joy and are the subjects of some of my favorite photos.

Thanks to the love of my life, my husband David LaFontaine. Your intelligence and creativity inspire me, and your love brings me such happiness. I can't imagine where I'd be without your sense of humor, your strength, or your culinary skills.

Thanks to all four of my parents, Malinda, Janice, Helen, and Robin, and to all of my extended family, including my brother Brian, Aunt Margaret, Uncle Tom, and Aunt Mindy.

A special thanks to David's large and wonderful collection of relatives who have made me feel such a part of the family and brought me many new traditions and reasons to celebrate. Thanks to Gail, Dave, Linda, Beth, Sarah, and everyone in the LaFontaine, Roos, and other clans.

Throughout these pages you'll find pictures of my family and friends, as well as the work of some outstanding photographers, including Mary Bortemas in Michigan whom I discovered after my nieces visited her toy-filled studio (www.unforgettablephotos.org), Anissa Thompson (www.anissat.com) who is a talented Web designer and photographer in Los Angeles, and the many other photographers whose family photos grace these pages, including Stephen Perrotta, Nick Quach, Barbara Driscoll, Ed Philbrick, and Adela Morales.

Special thanks to all of the beautiful people in these pages. Your smiles, your antics, and your colorful images bring this book to life. I hope all of you who appear in these designs—from my adorable nieces to my friends in Spain, Miami, Michigan, and beyond—appreciate how much you mean to me. Thanks also to Manuela Torgler for letting me feature her lovely collection of family websites.

Thanks to the entire team at Watson-Guptill, from Victoria Craven, who helped turn this book into a series, to Michelle Bredeson, who reviewed every word and helped organize the book, to Pooja Bakri, who created the design.

And, finally, thanks to everyone who has purchased books in this series. I wish you all the best with your scrapbooks, online photo albums, and other digital memories. The many beautiful projects I have seen created from these lessons inspire me more than anything.

—Janine Warner

Happy Birthday
Anne

With love from,
Everyone in the pack

Happy Thanksgiving

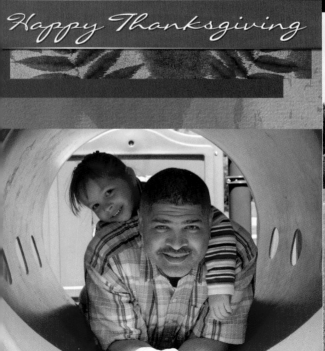

CONTENTS

Introduction

So Many Occasions, So Many Ways to Celebrate

This book is dedicated to the many ways families celebrate special occasions: from personal Christmas cards that feature family photos to cookbooks filled with your best Passover or Thanksgiving recipes, and from digital scrapbook pages to unique gift ideas that will be treasured by even the pickiest people on your list.

Throughout these pages, you'll find designs for specific holidays, including Halloween, Easter, Hanukkah, Rosh Hashanah, Three Kings Day, and Chinese New Year. You won't find designs for every holiday in this book (I'd have to write hundreds of pages to cover them all), but I've included a wide variety of special occasions because I believe we can all learn from each other's traditions and ideas as we create our own digital memories. No matter which holidays your family celebrates, I hope you'll be inspired by the techniques and projects in this book and use them to create digital memories of the special moments you share with your loved ones.

In writing this book, I drew on the diverse experiences of my friends and family, gathering ideas from their many holiday traditions, gift ideas, and celebrations. I also worked with a team of professional designers and photographers, combining their best tips, design ideas, and photographs to create a wide range of projects that are easy and fun to create. Here's a sampling of what you'll find in these pages:

- My parents inspired me to seek out the best websites where you can personalize coffee cups, puzzles, ornaments, and other gifts with your own photos.

- My friend Shari Witkoff's tales of the many wonderful meals she's enjoyed at her mother's table at Hanukkah, Rosh Hashanah, Purim, and Passover prompted me to create a variety of family cookbook designs.

- My nieces gave me the idea to create thank-you cards with room for personal messages in a child's own words because, well, children do say the darndest things.

- My friends Paul and Tait Viskovich inspired a Father's Day brag book and an award you can customize for any worthy recipient.

A CARD SHOP IN YOUR OWN HOME
Why spend hours hunting for just the right card at the store when you can quickly and easily make personalized cards for any occasion? In this book you'll find lots of ideas for making customized cards that feature your favorite photos. (Photo by Stephanie Kjos-Warner.)

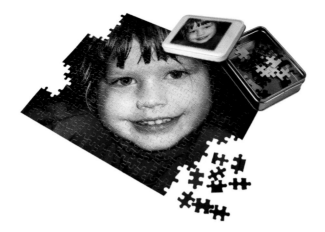

Visit Our Website

You can download the many templates featured in this book from the Reader's Corner at DigitalFamily.com. Just respond to a simple question you'll find the answer to in this book and you'll gain instant access to templates, artwork, updates, and links to help you get the most out of these lessons.

FIND MORE ONLINE
You'll find templates, artwork, and other goodies at DigitalFamily.com.

GIFTS YOU CAN MAKE WITH YOUR PHOTOS
Throughout this book you'll find fun gift ideas and websites where you can easily order cool stuff online, such as a puzzle you can make with your own photo at Shutterfly.com or a beautiful wooden box with your photo printed on a ceramic tile at ImageSnap.com

Easy Enough for Everyone in the Family

Let me reassure you right away that you don't have to be an expert with a computer to make these beautiful designs. As I wrote *Digital Family Album Special Occasions,* I worked hard to develop projects that are elegant and timeless—yet still easy to create—by combining simple instructions with predesigned templates and tons of helpful tips.

My goal with this book is to inspire you to create digital memories your family will cherish for years to come, but I also want to help you learn quickly and easily so you can focus on the fun parts and on spending time with your family. I understand that learning everything there is to know about complex computer programs is too time-consuming for most busy families, and even pros run into problems keeping up with new technology.

To help keep things simpler, most of the projects in this book were created with Adobe Photoshop Elements, one of the most popular and versatile image-editing programs designed for consumers. You'll also find projects that feature online services where all you need to create digital memory projects is an Internet connection and a Web browser. And finally, you'll find techniques and projects that feature three popular scrapbooking programs: Scrapbook Factory Deluxe, Scrapbook Designer, and Scrapbook Max. If you're new to digital scrapbooking, I recommend you use the lessons on these three programs to help you decide which program is best for you. Although the instructions for each of the projects in this book are specific to the featured program, the tips and design ideas will help you with almost any program you choose.

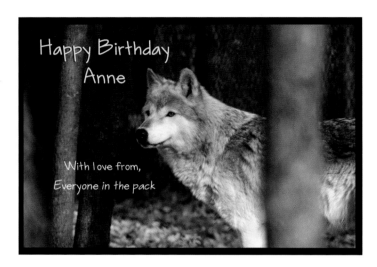

TURN ANY PHOTO INTO A GREETING CARD
Graphic design and image-editing programs such as Photoshop Elements make it easy to edit and embellish a photo (like this picture I captured of a wolf on a recent trip to Wisconsin) and turn it into a unique card.

Jump Ahead to the Projects You Want to Create

After an overview of the tools and materials you'll need to get started and an introduction to Photoshop Elements, this book is divided into chapters by season—spring, summer, fall, and winter—and you'll find designs and projects in each of these chapters that focus on holidays during that time of year. The last chapter features many other special occasions, including birthdays, Bar and Bat Mitzvahs, quinceañeras, christenings, and other traditional family gatherings.

I've organized this book to teach a wide range of skills across many different holidays and designs. For example, the instructions in the spring chapter for creating a cookbook for Passover can also be used as the basis for a collection of Thanksgiving recipes. The tips for creating cartoon bubbles for Halloween cards will also work with your Fourth of July designs. And you can mix and match the birthday card and party invitation designs in these pages to your heart's content.

All that is to say, you don't have to read this book from cover to cover before you get to work on your first designs. Skip around until you find a project that looks interesting to you, go back and forth between chapters focusing on the techniques you need most, and use what you learn to create your own special designs anytime.

My hope above all else is to inspire you to experiment and try new things and to mix and match designs, templates, and programs until you find the perfect combination to create digital memory projects that are uniquely yours.

CREATE CARDS FOR ANY OCCASION
Even a simple card design with a photo framed and centered on the front can bring a smile to those you love.

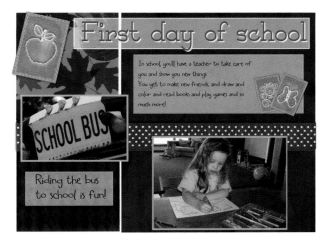

READY FOR THE BIG DAY?
Holidays aren't the only special occasions. Help your children get ready for a big event like the first day of school by creating scrapbook pages to help explain what they can expect when they get there. This design was created using a template from the Education and School collection in Scrapbook Factory Deluxe. (Photos by Stephanie Kjos-Warner.)

Understanding the Step-by-Step Instructions

Throughout this book, you'll find step-by-step instructions for techniques and projects. Here are a few tips for following those directions:

- Follow the steps in order (computers are very particular about order).

- The instructions in this book are designed for Windows-based computers. Where possible, I've included alternatives for Macintosh computers. You'll usually find these as parenthetical instructions, such as, "Press Enter (Return on a Mac)."

- If you see an arrow, such as this one >, it indicates the option you should select. For example, "Select File>New" means you should select the File menu at the top of your screen and choose the New option from the pull-down list.

- If you see the command "right-click," it means that you should press the right button on your mouse. If you are using a Mac, the same option is often available by holding down the Control key while pressing the button on the mouse.

Personal Postage Stamps

No matter what the occasion, you can add a little pizzazz to your packages (and amaze your friends and family) by using personalized postage stamps on your cards, letters, and special packages. Thanks to a deal with the U.S. Postal Service, you can order stamps with your own pictures at almost any postal rate—all you have to do is upload the photo you want to use over the Internet.

To create your own stamps, visit any of the many websites that provide this service and follow the site's instructions to upload your photos and order stamps. Beware, however, that although many websites now sell personalized stamps, you need to make sure the one you choose is officially sanctioned by the post office. Don't be confused by companies that offer stickers that just look like postage stamps. If they don't come with the official U.S. Postal Service seal, your cards will come back marked "postage due."

At a Glance

Online Services: Zazzle.com, Photo.Stamps.com, Real-Photo-Stamps.com
Size: Sizes are determined by the U.S. Postal Service.
Image Tips: You can turn nearly any photo into a postage stamp, but because the photos are relatively small, a close-up of a face or clearly identifiable object works best.

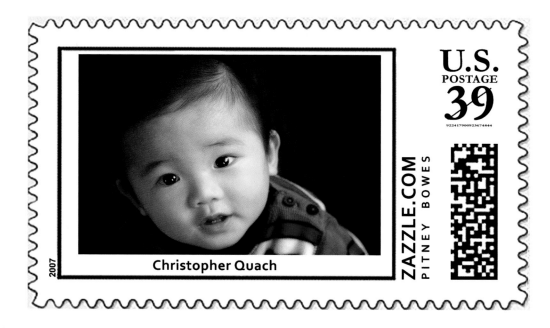

STAMP OF APPROVAL
You can create your own postage stamps by simply uploading a photo to www.zazzle.com and many other websites. (Photo by Nick Quach.)

1. Make sure you're connected to the Internet and then open a Web browser, such as Internet Explorer or Firefox. Enter the address of any website that offers postage stamp services, such as Zazzle.com, and look for a link to order custom postage stamps.

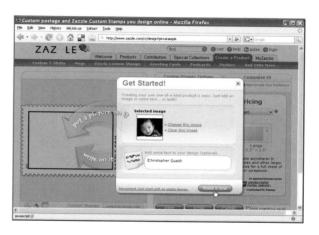

2. Upload your photos through the website. Most sites include an Upload button that makes it easy to select an image on your computer's hard drive and then upload it to the website with the push of a button.

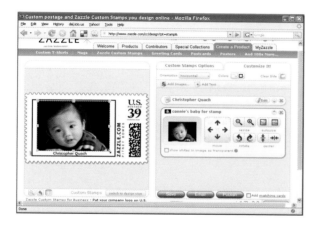

3. Use the site's online image-editing tools to resize and position the photo the way you want it to appear on the stamp.

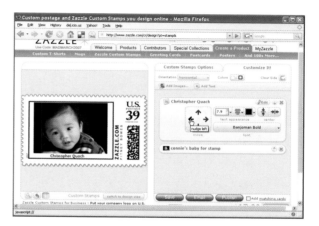

4. If you want to include a brief message, use the site's text tools to add and format text. Again, options vary from site to site, but most services provide easy-to-use text-editing tools like the ones shown here.

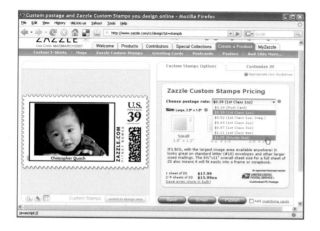

5. Choose the postage rate you want and pay for your order online. Then, all you have to do is wait for your mail carrier to bring your stamps to your door.

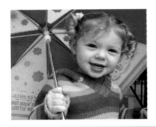
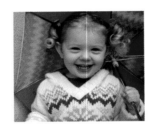

2007
April Showers

Sunday **April 8**	Easter Egg Hunt at Grandma's!
Monday **April 9**	Preschool party, bring cupcakes
Tuesday **April 10**	
Wednesday **April 11**	Take kitty to the vet 10 a.m. appointment
Thursday **April 12**	Diana has business dinner at 8 p.m.
Friday **April 13**	Family movie and BBQ night!
Saturday **April 14**	

ONE WEEK AT A TIME
Create a collection of weekly reminder calendar pages and
then update them each week to keep your family on track.
(Photos by Diana Day.)

 YOU make it

Weekly Reminder Calendar

Creating your own calendar pages is a great way to keep track of all the special occasions your family celebrates throughout the year. If you frequently need to make changes to your calendar, you will appreciate this design, which you can easily update and print each week. It fits on a standard 8½- by 11-inch sheet of paper so you can print this calendar on any standard printer. You'll also have lots of room to record events and appointments as an entire row is dedicated to each day.

Although this calendar is designed for easy updates, you may want to start by creating fifty-two page designs, one for each week, and entering the dates you know won't change, such as holidays, anniversaries, and birthdays. Saving your collection of weekly page designs in an easy-to-find folder on your computer will make it easier to go back and quickly add new details (such as dental appointments and dance classes) before you print the new calendar each week.

You'll find a template for this project on our website at www.digitalfamily.com. If you download the template, you can simply replace the text and images in this design. If you don't have access to the Internet or want to hone your design skills by creating your own calendar template, you can start from a blank page with step 1.

At a Glance

Software: Microsoft Word
Template: Follow the steps here to create a calendar from scratch or download the template called weekly-calendar.doc at www.digitalfamily.com.
Size: Fits on a standard letter-size page (8½ by 11 inches).
Font: Sproket BT
Image Tips: Use one long, horizontal image or two small square ones to fit the top area of this design. If you use one long image, you'll need to move the date to the left or right instead of centering it at the top.

Tip
Weekly calendars can also serve as a kind of family journal. Save each week's calendar and then add more photos, ticket stubs, and other mementos to create a memory book, or add the most interesting weeks as pages in your scrapbooks.

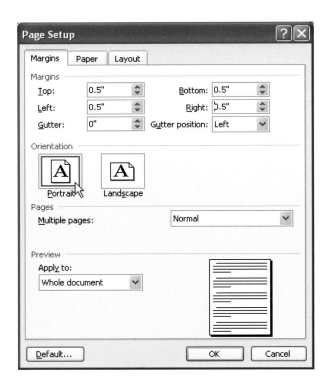

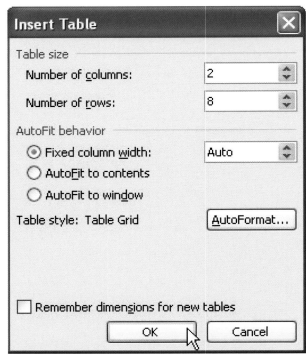

1. In Microsoft Word, create a new document by selecting File > New and then choosing New Blank Document. Once the new file is created, choose File > Page Setup.

On the Margins tab, set the Top, Bottom, Left, and Right margins at 0.5 inches. This allows you plenty of margin for printing.

Set the orientation of the page to Portrait. Unless you've altered the settings in your word processor, that should set the page size at 8½ by 11 inches (letter size). If you're not sure, choose the Paper tab at the top of the dialog box and make sure the page is set to your desired size. Then click OK. (If you're using a Macintosh computer, choose Format > Document to set the margins, and then choose File > Page Setup to set the page size and orientation.)

2. Now you want to add a table to create the borders for the calendar. Place your cursor at the top of the page and choose Table > Insert > Table. In the Insert Table dialog box, define the basic properties of your table. For this calendar, I set the number of columns to two and the rows to eight, to create a calendar with seven days and an extra row at the top for photos, the year, and the month.

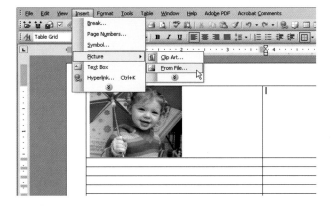

3. Place your cursor in the top left cell of your table and choose Insert > Picture > From File. Browse to find the image you want, click to select it, and click Insert.

When the picture appears on the page, use your cursor to click and drag a corner to resize the photo as needed (press and hold the Shift key to maintain the photo's proportions). To position the photo, click the Align Left button in the toolbar at the top of the page.

To insert a second image, place your cursor in the top right cell and choose Insert > Picture > From File. Browse to find the image you want, click to select it, and click Insert.

Again, use your cursor to click and drag a corner to resize the photo and click the Align Right button to position it.

Positioning Photos in Word

If you want to be able to move a photo around the page, double-click on it to open the Format Picture dialog box, choose the Layout tab, and select a wrapping style. Each style option provides a different kind of functionality. For example, if you choose Square, the text will wrap around the image. If you choose Behind Text, you can overlap the image with text. Experiment to find the option that works best for your design.

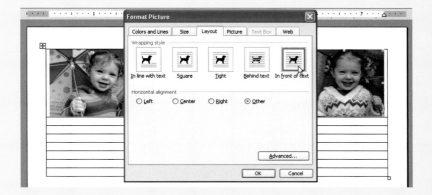

POSITION YOUR IMAGES ANY WAY YOU WANT

Use the Layout options in Word to wrap text around an image or to position an image in front of or behind your text.

4. Click the Text Box tool on the Drawing toolbar and notice that your cursor becomes a crosshair. (If the Drawing toolbar is not visible, choose View>Toolbars>Drawing.) Click to insert your cursor on the page where you want to add the name of the month and year, and drag down and right to draw a text box.

Type the month and year in the text box, and then format the text, adding color or changing the size as desired.

5. To size the remaining rows for dates and notes, float your cursor over the vertical line between the two columns. Notice that your cursor becomes a two-headed horizontal arrow with two vertical lines between the arrowheads. Click and hold to grab the vertical line and drag it to the left.

6. To add lines with color, select the entire table (an easy way to do this is to choose Table > Select > Table). With the table selected, you can change the border options by using the Tables and Borders toolbar. (If this toolbar is not visible, choose View > Toolbars > Tables and Borders and it should appear on your screen.)

Use the arrow to choose a border style from the Line Style drop-down menu. Then use the Line Weight and Border Color controls to format the lines that divide your calendar sections. In the example shown here, I used a solid, 1½-point line with the color set to aqua).

7. To assign your selected formatting to the vertical line between the columns, click the Border button and choose Inside Border on the drop-down menu.

Click anywhere on the page to deselect the table and you should see the new line as you have formatted it.

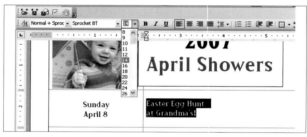

8. Click and drag the bottom border with your cursor and drag it up or down to expand or contract the row. You can adjust the size to fit each row's contents, making some rows larger for days when you have more appointments to squeeze in. If you want to even out the rows, click and drag to select all of the rows you want to even out, and then click the Distribute Rows Evenly button on the Tables and Border toolbar to flow the space equally into all seven rows.

9. To add dates and notes, click in the left-hand column of the first row and type the weekday name and date; then press the Tab key to move your cursor into the second column and type a description of an event or appointment. Continue pressing the Tab key and typing to enter more dates and events.

You can format your text by clicking and dragging to select it and then changing font, size, color, and alignment, using the regular formatting tools in the Formatting toolbar at the top of your screen.

10. To add artwork or photos to go with your dates, click in the cell where you want to add an image and choose Insert>Picture>From File. Find and select the photo you want and click Insert.

Click and drag a corner point to resize the photo (press and hold the Shift key to maintain its proportions). Use your cursor or the arrow keys on the keyboard to nudge the photo into position within the table cell.

Dress Up Your Designs with Photos, Colors, and More

If you're creating a weekly calendar with dates for more than one family member, here are a few tips for keeping track of everyone.

- Use a different color for each person. For example, make all of Mom's appointments green and Dad's blue and then let each child choose a favorite color for appointments, deadlines, and special dates.

- Add pictures to personalize listings for appointments or special dates, such as inserting a picture of your pet next to a note about a vet appointment or using your children's pictures on their birthdays.

- School logos, pictures of sports team mascots, and even favorite quotes and sayings are also great design elements for calendars.

ADD A LITTLE COLOR TO YOUR CALENDAR
You'll find a wonderful collection of colorful images created by my uncle Tom McCain, such as the ones shown here, at www.digitalfamily.com.

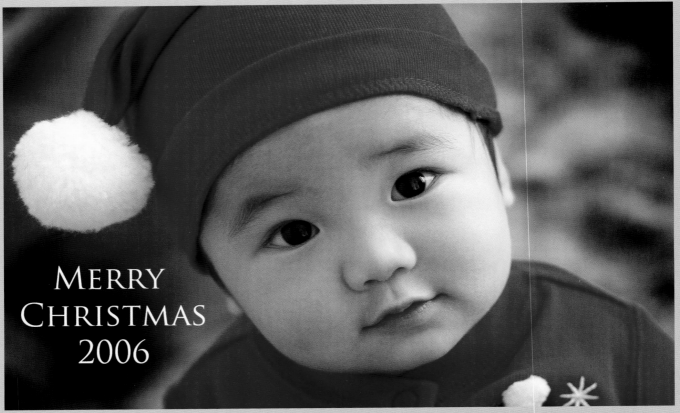

MERRY
CHRISTMAS
2006

Season's | Greetings

Love you,
Trey Thompson

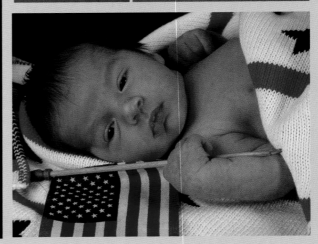

1

Getting Started:
Gather, Protect & Share Your Digital Memories

From your great-grandparents' holiday portrait to your most recent birthday pictures, no personal possessions are more cherished than family photographs. And nothing is more heartbreaking than losing those precious pictures in a natural disaster, such as a fire or flood, or simply from wear and tear. This chapter is designed to help you preserve your family treasures and to get you ready to start creating digital projects. You'll learn how to:

- **Gather all the tools you need to get started**

- **Choose the best papers, printers, software programs, and more**

- **Find a digital camera that fits your needs**

- **Download images from the Internet and share them via e-mail**

- **Scan, archive, back up, and protect your treasures**

Once you've gathered all of materials you'll need and protected your family treasures, you'll be better prepared to create the greeting cards, scrapbook pages, websites, and other family projects featured in the rest of this book.

Tools of the Trade: What You'll Need

What will you need to make the move from paste and scissors to digital? Here are a few items you'll want to have handy before you start working.

Computer

A computer is essential for almost every project in this book, but you don't need anything fancy or high powered. That said, if your computer is more than five years old, I suggest you consider investing in a new one. Even bottom-of-the-line computers (which retail for under $500 these days) are better than a machine you may have paid as much as $2,000 for a few years ago. Although you may be happier with a faster machine and a bigger monitor, you don't need a lot of power to create the designs in this book.

Although you can use a Macintosh computer to create the projects, the instructions are designed for PCs that use the Windows operating system and may not work as well for Macintosh users. Similarly, some of the software, such as the digital scrapbooking programs featured in some of the instructions, are available only for Windows computers. As a general guide, most of the programs featured in this book require a computer that meets these minimum requirements:

- Microsoft Windows Vista, Windows XP, or Windows Media Center Edition

- Intel Pentium 4 or Intel Celeron (or compatible) 1.3-GHz processor

- At least 512 MB of RAM (1 GB recommended)

- A color monitor with a 16-bit color video card

If you already have a Mac, don't hesitate to try creating the projects in this book, but if you're buying a new computer, a PC might be your best bet.

A HANDHELD COMPUTER
I use computers all the time and I love having a laptop that's small enough to take with me wherever I go, but for most the projects in this book, you can use almost any computer that's not more than five years old. (Photo by David LaFontaine.)

Digital Camera

Most people who've invested in a digital camera report that the money they save on buying and developing film more than covers the cost of the camera. If you haven't invested in a digital camera yet, I recommend making it a high priority. People who use digital cameras almost always take a lot more photos, and that's one of the best tips you can learn from professional photographers, who routinely shoot dozens of photos of the same scene. Taking more pictures gives you more choices and a better chance of getting just the right image for your projects. (You'll find tips for choosing a digital camera later in this chapter.)

Scanner

When it comes to saving old photos, the best thing you can do is to scan them into a computer. A scanner is a device you connect to your computer that lets you capture images and save them to your hard drive. Many people scan photographs so that they can turn them into digital images. You can buy a good quality scanner for as little as $100, and they've become so easy to use it's almost like working a copy machine—and we all know how to use those!

Scanning is not only important if you want to use digital images in your projects; it's also an excellent way to make copies of pictures to protect and save them. In addition to scanning photos, a scanner can be used to scan drawings, paintings, and other artwork. You can scan diplomas, certificates, and awards to preserve them and use them in your computer art projects. You can even scan three-dimensional objects such as coins or small keepsakes, and fabrics to use as background patterns. (You'll find more detailed suggestions for scanning later in this chapter.)

Tip

If you dread the idea of using a scanner, or you don't have time to scan dozens of photos yourself, there are services that will do this for you. The process is called digitizing. Most photography shops and stores that develop film also offer scanning services. Just bring in your prints or negatives, and, for a fee (depending on how many images you have), they'll scan your images and save them to a CD or DVD.

Internet Access

An Internet connection is essential if you plan to e-mail your creations to others or if you want to create a website. You'll also need Internet access to download the templates, artwork, and other goodies created for this book from the DigitalFamily.com website. Although you don't have to have the high speed of a cable modem or DSL line, you'll love what it can do for your Internet experience—and you're likely to use the Internet a lot more if you have a faster connection. An Internet connection also makes it possible to access the online services featured in this book, such as digital scrapbooking and photo album sites, and to share photos and stories via e-mail.

SHARE YOUR MEMORIES ONLINE
With just an Internet connection and a browser, it's easy to create an online photo album at sites like Shutterfly.com.

Color Printer

Color printers are getting more powerful all the time. You can even get printers today that will print on 12- by 12-inch scrapbooking paper. (Epson makes some of the best printers for digital scrapbooking. Check them out at www.epson.com).

The cost of color printers has dropped dramatically, but beware of the high price of ink cartridges. Always compare the cost of the ink, as well as the cost of the printers themselves, when making a purchase. Spending a little more money up front can save you money in the long run if you get more prints per cartridge. Also, note that many consumer-priced printers create images that will fade with time. If you want to create prints that will last for a long time, consider investing in a printer that creates archival-quality prints or guarantees print quality for at least 100 years.

CD or DVD Burner

Creating CDs or DVDs is a great way to make back-ups of your digital photos and other creations. It's also useful for sharing images with friends and family. Most new computers come with a CD or DVD burner built in, but you can buy one separately and connect it to your computer. The main advantage of DVDs is that they hold far more content than CDs. The added storage space on a DVD is especially helpful if you want to save lots of high-resolution photos or video files. (You find instructions for creating CDs and DVDs later in this chapter.)

Image-Editing and Design Software

Professional graphic designers may use five or six different programs in a single afternoon. They may use Photoshop to edit images, Illustrator to create illustrations, Dreamweaver to design a website, InDesign to create a brochure or lay out a magazine spread, and then Flash to create animations. If you have access to all of these professional programs, you have an advantage, but you'll also face a steep learning curve if you want to learn to use any of these high-end tools.

To keep things simple, I've limited the software used in this book to consumer-oriented programs, such as Photoshop Elements and Microsoft Word. To help you find the best software solutions for your projects, you'll find detailed descriptions of a variety of image-editing and digital scrapbooking programs later in this chapter.

Papers and Albums

Walk into the paper section of any large office supply or craft store and you may be amazed at all of the options available today. Most modern printers can handle specialty papers just fine, so you won't need any special printing equipment (just read the packaging to make sure the papers will work with your printer).

If you haven't explored the possibilities lately, here is a sampling of what you can expect to choose from when you purchase papers for ink-jet and laser printers.

■ High-gloss paper has a shiny surface and is ideal for printing color and black-and-white photographs. You'll find many grades of high-gloss paper available these days. The higher the grade, the richer the colors and the smoother the finish of the final print.

LITTLE SANTA
An image-editing program like Photoshop Elements makes it easy to create simple designs like this adorable Christmas card. (Photo by Nick Quach.)

■ Matte paper also works well with color or black-and-white photographs, but the prints will have a flat, not glossy, finish.

■ If you want to create prints that will last 100 years or more, look for archival, or acid-free, papers, which are designed to resist fading.

■ At the high end of the paper spectrum, you'll find specialty papers made with silk and other special fibers. These fine papers work especially well for artwork and images that you want to look like paintings, but you will pay a premium price for them.

■ Want to create your own T-shirts or add a photo to a favorite apron or cloth bag? Look for printable iron-on or sew-on fabrics that you can use with ink-jet and laser printers. Simply run the fabric square through your printer like a piece of paper and then use it to customize clothing, pillows, and more.

■ A variety of greeting card packages are available. These generally include papers made from a heavier stock that is precut and prefolded for greeting cards.

■ Binding kits, scrapbooking kits, and specialty photo albums are available at craft stores, art supply stores, and office supply stores. These kits and packages are ideal for creating baby books and other special keepsakes with your printed pictures.

Although many people still use film cameras, I strongly recommend that you go digital. Most people who switch to a digital camera quickly find that it more than pays for itself because of the money they save on film and developing costs. As an added benefit, you'll be helping the environment because developing print film involves hazardous chemicals.

Professional photographers buy cameras that cost hundreds or even thousands of dollars. Fortunately for the rest of us, an inexpensive point-and-shoot digital camera is usually more than enough for family photos and snapshots.

If you're considering buying a digital camera, I recommend that you visit a camera store and test out a few models to see how they feel, how things look through the lens, and how quickly each camera responds when you press the shutter button. With most digital cameras, there is a slight delay between when you press the shutter-release button and when the picture is taken. This is generally because of the time it takes to save the image to the memory card. Some have a longer delay than others—the more professional cameras have little or no delay; the cheaper cameras tend to have a longer delay.

When you're comparing digital cameras, there are a few things to consider.

Some Helpful Terms

When you start looking around at digital cameras, you may encounter a number of unfamiliar terms. Here are some definitions to help you better understand your options.

Pixels and Megapixels
Digital images are made up of pixels—small dots of color that combine to create an image. A megapixel is one million pixels—and the more megapixels a camera captures, the sharper the images are. Digital cameras today range from 1 to 10 or more megapixels (most cell phone cameras capture only .03 to 1 megapixel).

Resolution and Pixels per Inch
Resolution describes the quality of an image and is measured in pixels per inch (ppi). The higher the resolution, the sharper the image.

Dots per Inch
Print quality is measured in dots per inch (dpi). The more dots of ink per inch, the better the print quality.

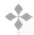

Tip

If you prefer to shoot film, consider using a photo lab that will save your pictures on a CD or DVD in a digital file format, in addition to providing prints (most offer this service now). You can also bring in old negatives, slides, and prints and have them scanned and saved to a CD or DVD so you can use them in your computer creations.

Digital images are made up of pixels—the more pixels an image has, the higher the quality. But the more pixels a camera captures, the more expensive it is. How many pixels (or megapixels) you need depends on what you want to do with your images and how important print quality is to you. For the most part, any digital camera will take images that are good enough to put on a web-site or e-mail to friends, because you don't need a lot of pixels on a computer screen (you'll find more about preparing images for the Internet in Chapter 2). The number of pixels in an image matters most when you're printing, because images with fewer pixels don't look as good.

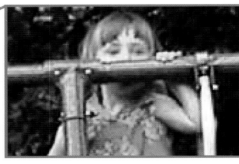

THE MORE PIXELS THE MORE DETAIL
When you enlarge a section of an image you can quickly see the limitations of low resolution. There are fewer pixels per inch in the enlarged image, and the fewer the pixels the more the image looks blurry or incomplete.

How Resolution Affects Print Quality

This chart is designed to give you an idea of how many megapixels you need depending on how large you want to print your photos.

Number of megapixels	Image Resolution	Print Quality		
		Photo	Excellent	Good
0.3	640 x 480	n/a	n/a	2" x 3"
1	1,024 x 768	2" x 3"	4" x 6"	5" x 7"
2	1,600 x 1,200	5" x 7"	—	8" x 10"
3	2,048 x 1,536	5" x 7"	8" x 10"	—
4	2,400 x 1,600	8" x 10"	—	11" x 14"
5	2,592 x 1,644	8" x 10"	11" x 14"	—
6	2,036 x 3,060	11" x 14"	16" x 20"	—

Photo quality means that the image would look as good as an image that was taken with a film camera and printed from a negative. *Excellent quality* looks nearly as good as photo quality, especially to someone who is not used to scrutinizing images. *Good quality* would not make it in a professional magazine, but may still be okay for most family projects.

Optical Versus Digital Zooms

Digital cameras feature optical and digital zoom lenses, and many offer both. The difference is that an optical zoom uses the optics (or lens) of the camera to control the zoom function. A digital zoom isn't really a zoom at all in the traditional sense. Digital zooms manipulate pixels to create the illusion of getting closer to your subject, thus making it seem like you have a longer lens. But beware that the quality of a digital zoom won't be nearly as good as an optical zoom. That's because a digital zoom essentially just crops out the center of the image area and enlarges it, much like you can do with any image-editing program. If you use an image-editing program like Photoshop Elements (covered in Chapter 2), you're better off avoiding the digital zoom and doing your own cropping and enlarging on the computer, where you have more control and can get better results.

Looking for Digital Camera Reviews?

One invaluable resource for learning about digital cameras is Digital Photography Review, at www.dpreview.com. This website features in-depth reviews of current makes and models, galleries of sample photos taken with various camera models, a comprehensive glossary of terms, a buying guide so you can search for cameras based on a variety of features, side-by-side comparisons of camera models, and public discussion forums about cameras and techniques. Other sites you may find helpful are the Digital Camera resource page at www.dcresource.com, the product reviews at www.image-acquire.com, and the many reviews at www.cnet.com.

Manual Controls

Today's point-and-shoot cameras do a great job of taking care of all the settings for you, but if you want to be able to override those settings and have more control over your photos, you should choose a camera that has manual focusing, flash, and speed controls as well as automated controls.

Video Capabilities

These days most digital cameras can also capture short video clips. Even if your camera can capture only thirty to sixty seconds of video at a time, this feature still makes it possible to record moments you can't do justice to with a still image—like a baby's first steps, a child's ballet class, or your friend's best joke. Short video clips like these work especially well on websites where long video takes too long to download, and they can bring the wonder of sound and motion to your Web pages.

Audio Capabilities

Most cameras that capture video also capture audio, a feature you can use to record the sounds of your subject or to make notes for yourself. This is a handy way to keep track of important details, like names and places, when you're out taking pictures and don't have a pen handy.

Macro Features

If you love photographing flowers or anything else up close, you'll appreciate having macro features, which enable you to focus at a closer distance than most lenses. Macro lenses can also be great for shooting details, like a baby's hands or a fiancée's engagement ring.

Panoramic Features

Many digital cameras offer special features that enable you to take a series of pictures and then stitch them together to create one long image. If your family vacations take you to places like the Grand Canyon you may have fun with a camera that offers panoramic features.

Image-Editing Programs

You'll find many great image-editing programs on the market today, but with so many choices it's easy to get overwhelmed. My goal in this section is to make you aware of your options so you can find the tool that's best for you.

Adobe Photoshop CS

By far the most popular image-editing program in the history of computer design, Photoshop CS (www.adobe.com/photoshop) is a powerful tool that enables you to create, edit, and manipulate images in extraordinary ways. This is a professional product, with a professional price tag (about $650). Unless you're a serious photographer or designer, or you have a huge budget, it's probably not necessary for you to buy this high-end program.

Adobe Photoshop Elements

Photoshop Elements (www.adobe.com/elements) features many of the same powerful editing abilities of its big brother, Photoshop CS, but Elements is easier to use and costs less than $100. Elements provides more than enough power for all of the projects featured in this book and it's a good tool to start out with if you're new to working with images on a computer. You'll find an introduction to Photoshop Elements in Chapter 2 to help you get started with this great program.

CS Versus Elements

The difference between the two versions of Photoshop boils down to this: The expensive version (CS) is used by professional photographers and graphic designers who do painstaking, exacting work, such as preparing photos that have to look flawless on the cover of a magazine or a billboard. Given enough time, you can use Photoshop CS to cross a giraffe with a turtle or make it appear that a giant truck can fly through the sky. For the rest of us, who just want to clean up a few photos, or maybe make it look like the cat was riding a motorcycle, Photoshop Elements offers more than enough features.

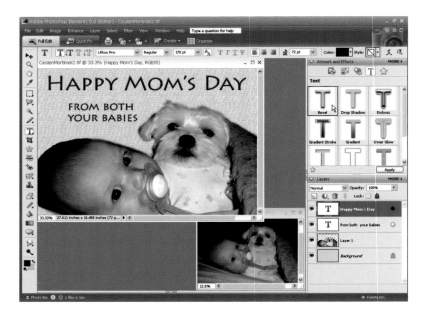

WE LOVE YOU, MOMMY!
With a program like Photoshop Elements, you can easily combine photos and words to create your own special greetings. (Photo by Ann Witherspoon.)

Adobe Fireworks

This image-editing program has many general editing features, but it is especially suited to creating images that download quickly and look good on the Web. Fireworks (www.adobe.com/fireworks) was designed to create Web graphics and it's fully integrated with Adobe's Web design program, Dreamweaver. If your goal is to create the best website possible, consider Fireworks and Dreamweaver, but be prepared to pay professional prices for these professional programs.

CorelDRAW Graphics Suite

Although not as popular as Adobe Photoshop, CorelDRAW (www.corel.com) is a professional-grade image-editing program that is rich in features. This suite of programs costs a little less than Adobe Photoshop CS but a lot more than Photoshop Elements. Professional designers who favor Corel appreciate its excellent drawing tools, but both versions of Photoshop also include drawing features.

Ulead PhotoImpact

This image-editing program is often bundled with the software that comes with digital cameras and scanners. PhotoImpact (www.ulead.com) is easy to use and has a wide range of features, including several automated correction features. The ExpressFix Photo Wizard, for example, helps correct common photography mistakes, such as red-eye and lens distortion. Although not as advanced, or popular, as Photoshop Elements, if you already have a copy of Ulead PhotoImpact you can use it to create most of the projects featured in this book.

Apple iPhoto

Often bundled with Apple computers as part of the iLife suite, iPhoto (www.apple.com) is a simple image editor designed for Mac users. If you have iPhoto, you can use it for the projects in this book. If you prefer, you can purchase the more feature-rich program, Photoshop Elements, in a version for Macs.

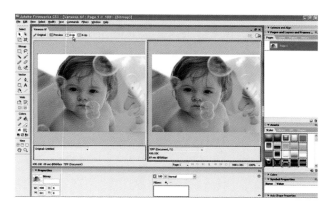

BLOWING BUBBLES
Adobe Fireworks includes many features for optimizing images for use on the Internet, including the ability to split the screen and preview the same image in different resolutions. (Photo by Christian Oliver.)

Any Image Program Will Do

Although I recommend Photoshop Elements because it is a feature-rich program that's not too complicated or too expensive for most beginners, almost any image program will work for the exercises and examples in this book. If you have another image editor, such as Ulead PhotoImpact, you don't have to buy a new image editor. Just beware that some of the instructions in this book are specific to Photoshop Elements, and if you work with another program you may have to make some minor adjustments to the order of the steps or look for menu items and other features under different names.

Programs for Digital Scrapbooking

If you spend more time scraping glitter and glue off your desk than you spend on creating your scrapbook designs, digital scrapbooking may be for you. As more and more of us bring our memory-making skills to the computer, more companies are creating programs designed to make digital scrapbook pages. Here are a few of the most popular.

Scrapbook Factory Deluxe

The best-selling scrapbooking program on the market, Scrapbook Factory Deluxe (www.novadevelopment.com) features 5,000 templates and 40,000 graphics. The program combines a simple image editor with a layout program that is similar to Microsoft Publisher, except Scrapbook Family Deluxe is easier to use. If you're a graphic design professional who has worked with a program like Quark or InDesign, you may get frustrated because you won't have as much control. But if your goal is to create scrapbook pages without spending weeks learning a complicated program, you're going to love this tool.

Some of the layouts and artwork are simplistic, but many are beautifully designed by professional graphic artists. You can alter any of the templates as much as you like, adding images and text and changing backgrounds, fonts, colors, and borders. You can even start with a blank page and create your own designs from scratch.

When you're finished, Scrapbook Factory Deluxe offers the greatest range of options for saving your designs, including PDF (the Portable Document Format common on the Web) or an image format such as JPEG or TIFF.

Here are a few things to keep in mind when considering Scrapbook Factory Deluxe:

- The program features 5,000 customizable templates and designs.

- You can create your own designs or customize any of the templates.

- There are more than 40,000 ready-to-use graphics, background textures, buttons, and frames.

- The software comes with 1,000 different fonts.

- The program sells for $36.99.

- The software is available only for Windows computers.

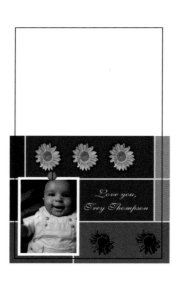
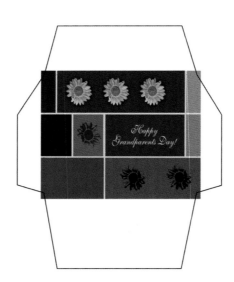

Tip
When you print a design like this one, print the card on high-gloss photo paper and the envelope on heavy card stock. Card stock lacks the sheen that makes photos look professional, but it folds better, goes through the postal system with less damage, and does a good job of protecting your glossy image until it reaches your loved ones.

TEMPLATES MAKE COMPLEX DESIGNS EASY
The ability to create a card and envelope to match makes this design one of my personal favorites for home printing. You just print the envelope and follow simple instructions to glue or tape the flaps in place. You'll find several designs like this featured in Scrapbook Factory Deluxe. (Photo by Anissa Thompson.)

Scrapbook Designer Deluxe

Scrapbook Designer Deluxe (www.scrapbookmax.com) also features a large collection of templates, images, and fonts, but most of them are very simple. Although you can create completely original designs with this program, the editing tools are not as intuitive to use or as advanced as the tools in Scrapbook Factory Deluxe. That said, this is an easy-to-use program that comes with many useful features and it definitely wins on price, coming in at a much lower cost than the others.

The main points to consider when looking at Scrapbook Designer Deluxe are:

- The software features more than 4,500 professionally designed templates.

- There are over 25,000 images and 500 layout examples included.

- It comes with more than 500 fonts.

- The program sells for $19.95.

- The software is available only for Windows computers.

Scrapbook Max

This program has a fun, sophisticated style, but overall it's not as powerful as Scrapbook Factory Deluxe or Scrapbook Designer Deluxe. You'll also find far fewer templates and designs in Scrapbook Max (www.scrapbookmax.com) than in the other two, but this program shows great promise, and future versions may be more competitive.

Here are a few important points about Scrapbook Max:

- It includes a few dozen templates and designs.

- The program features more than 4000 graphics, including background images, embellishments, word art, photo shapes and paper scraps.

- The program sells for $39.95.

- The software is available only for Windows computers.

Scrapbooking Resources on the Web

Among the many advantages of using your computer for scrapbooking are all of the great resources you can find on the Internet—from page designs and layout examples that are sure to get your creative juices flowing, to papers, stamps, and so much more. Although some of these online services charge for their template designs and other scrapbooking goodies, you'll find lots of free ideas on these sites as well.

The following is just a sampling of the many great websites that can help you in your digital scrapbooking efforts.

Scrapbook-Elements.com
One of the most popular digital scrapbooking sites on the Web, Scrapbook-Elements.com is dedicated to the art of digital scrapbooking. On this site you'll find lots of tutorials, tips, and a wide range of page layouts and other products you can purchase from their online store.

Memorymakersmagazine.com
Another big player in the world of traditional scrapbooking, Memory Makers offers loads of design ideas and other resources on their website, as well as books and magazines.

Creatingkeepsakes.com
In addition to publishing one of the most popular magazines on scrapbooking, the Creating Keepsakes has a website that features a wide range of resources and products.

Scrapbook-bytes.com
The slogan on this site, "Changing the scrapbooking world one computer at a time," speaks to their dedication. In addition to the many great templates and design packages you can purchase on the site, you'll find a gallery of designs submitted by visitors. This site offers more interactivity than most, with a chat room and discussion area where you can compare notes with other scrapbookers.

Printing Your Digital Designs

Here are a few ways you can share the love with your family when you want to print your digital creations. Remember, the higher the resolution, the better the print quality, especially when you want to make big prints. (See Chapter 2 for more information about resolution.)

Printing on a Home Printer

Most printers come with detailed instructions for installation, and although I can't include all the possible ways to set up printers in this book, I can tell you that printers have gotten fairly easy to connect to computers (just make sure you install the software that comes with your computer before you connect it).

When you're ready to print a document created in Word, Photoshop Elements, or almost any other program you might use, simply choose File>Print. In the Print dialog box that opens, specify the number of copies you want and which pages you want to print. Depending on the printer, you may also have settings for print quality. Choose File>Page Setup to adjust settings for paper size and orientation. You can also usually print by clicking the Print icon on the Standard toolbar at the top of the screen.

Using a Printing Service

If you don't have a printer, or you want a very high quality print, or you want to print something special, like a poster-sized print, consider taking your digital images to a copy center or professional printer. You can even send images and complete projects to professional printers over the Internet.

Once you choose the service you want to use, make sure you study the submission guidelines that describe the best resolution, sizing, etc., for the image or project you are printing. To submit your images, you'll need to e-mail them, upload them through the printer's website, or save them to a CD that you bring to the printer or send via snail mail.

BORN IN THE U.S.A.
When you capture a photo as precious as this one, consider using a professional printing service to create a poster-size print. (Photo by Mary Bortemas.)

Tip
Many online photo sites, such as Shutterfly.com and KodakGallery.com, also offer printing services. For as little as a few cents you can have small prints made. For a higher price, you can order poster-sized prints and even have photos printed on canvas to make them look like paintings.

Send or Print the Best Version

The most important thing to consider as you prepare your projects for print or display on the Internet is the format. The basic concept is this: If you're going to print a picture, you want the highest possible resolution so the print looks good. If you're going to e-mail a picture or post it on the Internet, you want the smallest file size so it downloads quickly. In Chapter 2, you'll find a detailed explanation of image formats and how to convert images to higher and lower resolution.

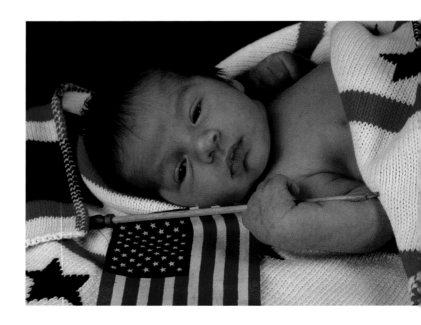

Sharing Digital Creations over the Internet

E-mail, family websites, and online photo albums have become increasingly important ways to share photos and stories with those we love, especially those who live far away. In this section, you'll find tips for attaching images to e-mail messages, as well as directions for inserting pictures into a message. You'll also find instructions for downloading images off the Internet and saving files that are sent to you via e-mail.

Saving Files in Easy-to-Open Formats

If all you're sending in an e-mail is text, your words will usually arrive as you intended. But as soon as you start adding images and any of the fancy formatting options used in the projects in this book, not everyone on your list may be able to view your designs the way you intended for them to look. A scrapbook page that seems perfect on your PC may end up all askew when viewed on your mother's Macintosh. Here are a few suggestions to help you avoid problems that can happen when you send attachments.

First, find out which programs your friends and family have on their computers. If you send a document created in Photoshop and saved as a PSD file to Aunt Mary Ellen and she doesn't have Photoshop, she may not be able to open it. However, if you use Photoshop to save the same photo as a JPEG (one of the most universally supported image formats), she may have no trouble viewing it at all.

Another widely supported format designed for sharing over the Internet is the Portable Document Format (PDF). You can convert pages from Microsoft Word, Photoshop Elements, Scrapbook Factory Deluxe, and other programs into PDFs using Adobe's online conversion tools (available at www.adobe.com) or by using the Adobe Acrobat program. PDFs can be viewed in most recent versions of browsers or you can download a viewer for free.

> **Tip**
> Most e-mail programs will let you save a message without sending it by choosing File>Save. When you're ready to send it later, simply open the saved message, make any changes or additions you want, and click Send. (You should find your saved message in a folder in your e-mail program called Drafts or Saved Messages.)

Sending Images and other Files via E-mail

When you send an image with an e-mail message you have the option of attaching it so that it has to be opened separately from the message, or inserting the image, so that it will appear in the body of the message. If you just want to share an image quickly, inserting it may be the easiest way to show it off; if you want to send several images or you want to include big image files, attachments are the better option.

Most e-mail programs handle attachments the same way: You "attach" a document, like an image file, to an e-mail message, and when you send the message, a copy of the file goes along for the ride. When the message is opened, the attachment must be opened separately to be viewed. The difference with inserting an image is that it displays in the message itself when it arrives.

In this exercise, you'll learn to create a message and attach a photo. I've used Microsoft Outlook in this example, but, with minor adjustments, these general instructions should help you with any e-mail program you use.

E-mail Everyone on Your List

If you want to e-mail several people at once, consider creating a distribution list. If you're using Microsoft Outlook, choose File>New>Distribution List and enter as many e-mail addresses as you want. When you send other news in the future, you can use this same group address so you don't forget anyone! (Because e-mail programs vary, consult the Help menu in your program for instructions on building a group list.)

1. Launch your e-mail program and create a new message. The most important things to fill in are the address and subject lines.

Compose your message. Most e-mail programs have easy-to-use tools for formatting text. After you've typed in some text, click and drag on the type to select it; then click the formatting icons to change type size and color or to add bold or italic styling. You also can pick a fun typeface, or font.

Click on the Attach Files button on your e-mail program. This option differs from program to program, but you should find a button or pull-down menu at the top of the e-mail screen. (Hint: The Attach Files button often looks like a paper clip.)

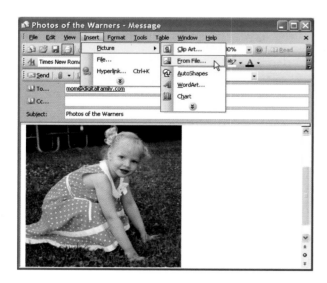

3. If you want the photo to appear in the body of the e-mail message instead of as an attachment, choose Insert > Picture > From File and find the photo.

Click Open and the photo will appear in the body of your e-mail. If you need to resize the photo, click on it and drag a corner point. Hold the Shift key while you drag so that the height and width proportions stay the same.

2. Browse through your hard drive for the image or file you want to send. (Choose View > Preview > Thumbnails to see previews of your images on a PC.) After you have clicked on the file you want, it is attached to your e-mail, and the name will appear in the attachments field, usually just under the subject line of your e-mail message.

Sharing Files Between Macs and PCs

If you're sending files from a Macintosh computer to a Windows PC, it is a good idea to add a file extension to the end of the file name before you send it. File extensions are usually three or four characters and represent the format of the file. For example, JPEG image files use the extension .jpg (or sometimes .jpeg), while Microsoft Word files use .doc.

Problems arise because PCs need file extensions to identify file types and Macs don't. If you create a document on a PC, the extension is automatically added. Mac OS X computers give you the option to add the extension when you save a file, but older Mac systems do not. Adding .gif or .doc to a file on your Mac won't change anything on your computer, but on a PC those few letters may be all it takes to identify the program needed to open the file and may make it easier for the person who receives your file via e-mail to open it.

Downloading Images from the Internet

You can copy nearly any image you see on the Internet to your own computer in just a few easy steps. But just because you can doesn't mean you should, or that it will be worth your effort. First, you should respect copyright, meaning you should not use someone else's photos, cartoons, or other images without permission. And second, it may not be worth your effort anyway, because images on the Internet are usually in a very low resolution; they download faster, but it also means that they don't look very good if you print them or try to enlarge them.

All that said, if you see an image on a Web page that you want to download (and you know it's okay to do so), here's how you do it:

1. Use a Web browser to view the image you want on the Internet.

2. Place your cursor directly over the image and right-click (in Windows) or click and hold (on a Mac).

3. In the pop-up menu that appears, choose Save Picture As.

4. Change the name of the file to anything you want to name it, choose a location on your hard drive to save it, and click Save.

That's it. Once you've saved the image, you can use it as you would any other image on your hard drive.

❖ Note
If you follow these steps and the Save Picture As command is dimmed, the site's designer has protected the image from copying and saving, and you won't be able to download it to your hard drive.

The Northern California coast

FREE IMAGES FOR YOUR DIGITAL CREATIONS
You can easily save photos from a Web page to your computer's hard drive. The DigitalFamily.com site offers readers free images to download.

Downloading Images from E-mail

If friends or family send you pictures via e-mail, you can also save them to your computer to print out and use in your projects. How you save them to your computer depends on what kind of e-mail program you use, but they generally all work in the same way. Here are a few tips for some of the most common e-mail systems.

If you receive an e-mail with a photo that is attached and want to see what the image looks like, double-click on the image icon; it should automatically open in a viewer or image program. If you want to save a photo that is attached to an e-mail, right-click on the image icon and choose Save As and then save it where you want it on your hard drive.

If you receive an e-mail, and the photo is inserted into the message so that you can see it in the body of the message, like the one you see here, follow these steps to save it to your hard drive:

1. Open the e-mail message.

2. Place your cursor directly over the image and right-click (in Windows) or click and hold (on the Mac).

3. In the pop-up menu that appears, choose Save As.

4. Change the name of the file to anything you want to name it, pick a destination on your hard drive to save it using the arrow in the Save As window, and click Save.

SAVE E-MAIL PHOTOS FOR FUTURE PROJECTS
You can save photos inserted into e-mails to your hard drive to use for digital projects or just to make sure you can access them any time you like.

Protect & Preserve Your Digital Treasures

Most of us don't even think about preserving photos until it's too late. We keep piles of printed pictures stuffed in drawers, packed away in boxes, or collecting dust in some corner of the attic, pulling them out only on special occasions. In this section, you'll find tips and instructions for sorting, scanning, and saving your family treasures so they can be enjoyed for generations to come.

Sorting and Organizing Photos

The first step in protecting these treasures is to gather all of the photos you want to preserve. This can be a fun family project, going through old albums and boxes to find everyone's favorite photos. You might not need to save every snapshot from every family vacation, or scan all of the blurry images of the dog's tail, but sorting through all of the photos in your home can help you identify the ones that mean the most to your family. As you sort through albums and boxes, try to handle the prints and negatives as little as possible, and touch them only by the edges (the oils on your hands can damage the delicate surface of photos over time).

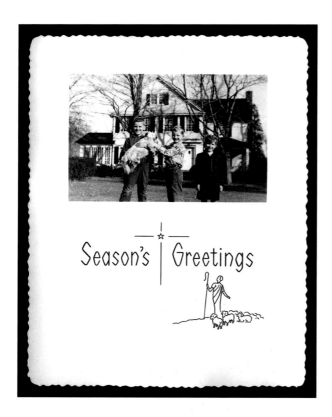

PRESERVE FAMILY MEMORIES
My grandparents sent photo Christmas cards every year, and we are fortunate to still have copies of all of them. And, yes, of course I've scanned them all and made backups of the copies. (Photo by Grandpa Warner.)

Scanning Images and Objects

Scanning is a great way to preserve printed photos, mementos, and other irreplaceable family treasures. Once you have scanned them, you can save the digital images on a CD or DVD, external hard drive, or other memory device as a backup.

Scanners have become exceptionally easy to use. With most modern scanners, all you have to do is connect the scanner to your computer and install the scanner software. Every scanner is different, so you should follow the instructions that come with your system, but they all essentially work by taking a picture of whatever you place on the bed of the scanner.

To scan an image, place it so that it faces the scanner's glass plate (be careful not to scratch the glass plate, as this is the most delicate part of the scanner). Position the image or object you want to scan by following any symbols (such as arrows or dots) or picture instructions (icons that look like a sheet of paper) that appear along the edges of the plate.

As a general rule, you have two primary options for scanning: You can use the scanning software that came with your scanner, or you can scan directly into an image editor, such as Photoshop Elements. I prefer the latter option, as you often get more choices for controlling the scan. (For details, follow the specific

instructions that came with your scanner or your image-editing program.)

When you scan an image or object, you usually have the option to preview the scan before you activate it. This is an important step because it enables you to adjust the boundaries of the scanned area for a cleaner and more efficient scan.

You can scan just about anything you can fit on the glass plate of a scanner: printed photographs, certificates and diplomas, greeting cards, invitations, even three-dimensional objects, such as medals, coins, ceramic plates, and fabrics.

You can scan your images at a high resolution to preserve as much detail as possible, or you can scan at a low resolution, creating a smaller file with less detail. If you plan to edit the image or you want to print it, scan it at a higher resolution (300 ppi is a good choice; see Chapter 2 for more on resolution).

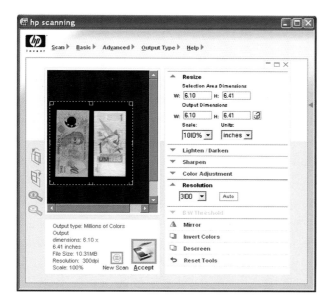

INCLUDE SOUVENIRS IN YOUR PROJECTS
Dress up your travel photo books with scans of currency (like these Brazilian *reais*) and other souvenirs from your trips.

Photographing Oversized Keepsakes

If your piece is too big for a scanner, you may find it easier to take digital photos of it than to scan it. This technique works well for awards, large pieces of artwork, and other memorabilia. Again, once you have a digital image in the computer, you can edit the image with a program like Photoshop Elements and include it in your designs.

Saving Files to an External Hard Drive

Although technology is more reliable than ever before, computers do get broken and hard drives can crash without warning, destroying all of the photos, stories, and other files they store in an instant. There are specialty services that can recover the contents of of a crashed hard drive, but these services are expensive (often thousands of dollars), and there's no guarantee that you'll ever get all of your data back after a hard drive crashes.

One of the simplest ways to protect your data is to save a copy of everything on your computer hard drive on an external hard drive. With the cost of computer memory dropping more every day, you can buy large, external hard drives for as little as $100 and connect them to your computer with a simple cable that makes it easy to copy files from the computer to the hard drive and back.

Using an Online Backup Service

One of the safest ways to back up photos and other files on your computer is to upload them to an online photo site or digital storage service over the Internet. With your files backed up on a remote server, you can access your information from any computer anywhere in the world and rest assured that you'll be able to get your files back even if your house burns down.

Most online storage services provide special software to make it easier to upload files and keep track of changes that may need to be backed up over time. You can also schedule regular backups with these services, for example, automatically backing up your files every Friday night. Then if something happens to your computer, you can always download the files to any computer (just make sure you remember your user name and password). Several companies, including Backup.com and Ibackup.com, now provide online storage services. The biggest challenge with these services is the potentially prohibitive cost, as much as one dollar per megabyte for some services. If you run a small business or you really want to make sure your files are safe, these services provide an excellent way to protect your digital data.

For a simpler, and free, solution, you can set up an online photo account at a site like Flickr.com and keep copies of your favorite images online where they are safely protected and easy to access when you need them.

Creating CDs and DVDs

You can share photos and anything else that can be displayed on a computer or TV screen by burning them to a CD or DVD. You can save hundreds of pages to one CD, and even more to a DVD. Once you have your photos and projects on these little plastic discs, you can carry them to the homes of family and friends where you can "play" them on a computer or DVD player. Blank, writable CDs and DVDs are available at any office supply or computer store.

Think of "burning" a CD as similar to saving a file to a disk or printing a page—it's really that easy. There are a variety of programs available for creating and copying DVDs and CDs, but most new computers have these features built in. If your computer does not have a CD or DVD burner, you can buy one separately and plug it into your computer. You must have a CD drive that is capable of reading and writing CDs. This is usually indicated by the letters CD/RW (meaning Read Write) or the words CD Writer on the door of the CD drive.

Whether your CD or DVD burner came with your computer or you bought it separately, the manual that came with it should include instructions for creating CDs. Each system is slightly different and the steps will vary depending on the program, but the instructions below for creating a CD in Windows XP should give you the general idea of how it works, even if you're not using Windows.

Before you burn a CD, you need to prepare the files you want to copy. You may want to copy all of your images into one folder or a collection of folders to get them organized before you copy them to a CD.

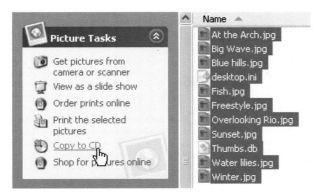

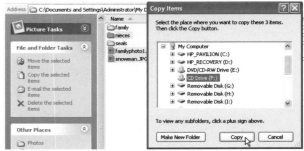

1. Insert a blank, writable CD into the CD drive on your computer. Open the folder where you stored your files and select the files or folders you want to copy. Click to select the files or folders you want to copy. To select more than one file or folder, press and hold down the Control key while you click the files.

If your images and other files are in the My Pictures folder, you can click Copy to CD or Copy All Items to CD under Picture Tasks and skip to step 3.

2. If Copy to CD is not an option, look under File and Folder Tasks and click Copy This File, Copy This Folder, or Copy the Selected Items.

In the Copy Items dialog box, click the CD recording drive and then click Copy. In My Computer, double-click to open the CD recording drive. Windows will display a temporary area where the files are held before they are copied to the CD-ROM.

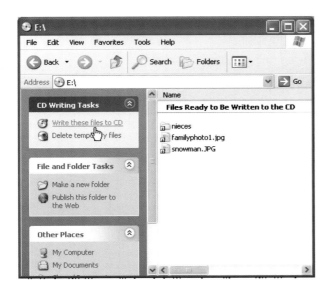

3. Verify that the files you intend to copy appear under Files Ready to Be Written to the CD.

Under CD Writing Tasks, click Write These Files to CD. Windows will display the CD Writing Wizard. Follow the instructions in the Wizard.

After you create a CD, it's always a good idea to click the CD icon and open the CD to confirm that your files copied correctly.

Extra Copies Keep Backups Extra Safe and Secure

I recommend you back up all of your images, text, and other important files and save your backup copies in multiple places. Compact discs wear out and get scratched, hard drives crash, and, tragically, houses burn down—the list of ways you can lose your keepsakes is heartbreakingly long.

Once you've backed up your work, I strongly recommend you get a copy of it out of the house. For example, keep copies of all your photos on CDs at a friend's place so you can rest easy knowing your memories are extra safe. By taking these precautions with your family photos, you'll be able to protect and share your beloved pictures, and, even if the worst disaster strikes, your memories will be safe and sound.

Owls
in flight
on a Marin

summer night

2

Photo Magic:
Edit & Enhance Your Digital Images

If you're not happy with the way your photos came out after a special occasion or a once-in-a-lifetime event, you may be pleased to learn how easily you can repair, restore, and enhance almost any image. In the following pages you will find a solid introduction to digital photo editing, including how to:

- **Crop, rotate, and resize images**

- **Clear up red-eye and remove blemishes**

- **Add and edit text to create special messages**

- **Use layers to combine images and create photo montages**

- **Choose the best image format for printing, e-mailing, or posting on the Web**

- **Optimize images so they download fast on the Internet**

Modern software programs have made it possible for anyone to do subtle—and not so subtle—image editing with remarkable ease. With a little experience and a program such as Photoshop Elements, you can do almost anything you can imagine—even make it look like your pet ferret can walk on the Moon.

Introducing Photoshop Elements

Adobe Photoshop Elements, like other image-editing software, has a seemingly endless array of tools and tricks, but I've found that most of us don't need to know how to use all of the features in a program like this to create beautiful designs. So in this section, I'll introduce you to the features I think will be most useful for the kinds of projects featured in this book.

I recommend you begin by exploring the program, looking at the options under the various menus, opening palettes, and trying out different tools. If you've worked with any other software program before, many of the items in the Menu bar, Shortcuts bar, and Toolbox may look familiar to you. For example, when you select the Text tool you'll find options across the top of the main work area that work much like similar features in Microsoft Word to help you make text bigger, bold, centered, and more.

Other features may not be as familiar, such as the options in the Toolbox, which runs down the left side of the screen and provides quick access to all of the main tools in Photoshop Elements. To help you get started, one of the first things you'll find in this chapter is a quick reference to all of the tools in the Elements Toolbox. As you follow the exercises in this chapter, you will be introduced to more features and learn more about how to use these tools.

Most Image-Editing Programs Are Similar

For the techniques in this chapter and throughout this book I used Photoshop Elements version 5. Although other programs may use different names for the tools, palettes, or menus, you should be able to apply the basic concepts and instructions in this chapter to any image editing program you may use.

I chose to feature Photoshop Elements in this book because I think it's the best image-editing program for the price. It has most of the features of Photoshop CS, the professional version of Photoshop, yet it's easier to use and costs a lot less. You can even download a free trial version for Mac or Windows by visiting www.photoshop elements.com. The trial lasts for thirty days, which should give you plenty of time to test it out on the exercises in this chapter.

THE PHOTOSHOP ELEMENTS WORK AREA

Here are the major components of the Photoshop Elements work area. They will be referred to throughout this book.

1 The **Menu bar,** with pull-down menus for tasks.
2 The **Shortcuts bar,** with common commands you can complete with one click, such as Save and Print.
3 The **Toolbox,** which provides easy access to drawing and other tools.
4 The **Active Image area** is the main work area where you create and open images to work on.
5 The **Options bar,** which features settings for each tool as it is selected (in this image the Text tool is selected, revealing the text formatting options).
6 The **Palette Well,** where palettes such as How To, Artwork and Effects, and Layers display (all three of these are shown open).

The Photoshop Elements Toolbox

One thing you have to get used to when using Photoshop Elements is that before you can do something, like enlarge or crop an image, you have to select the correct tool from the Toolbox.

Selecting a tool is easy: Just click on the icon that represents the tool you want, such as the T for adding text to an image. The tricky part is knowing which tool to use for the job (which is kind of like understanding the difference between a flat-head and a Phillips-head screwdriver).

The following list of tools is designed to help you appreciate all of the options in the Toolbox.

1 Use the **Move** tool to select any part or all of an image, to move an image, to copy and paste one image into another, or to apply a filter to a selected area.

2 The **Zoom** tool enlarges or reduces the display size of an image.

3 The **Hand** tool allows you to move around within an image.

4 Use the **Eye Dropper** to select any color on your screen.

5 Use the **Rectangular** and **Elliptical Marquee** tools to make square or circular selections.

6 The **Lasso** tools are used to select a section of an image in any shape.

7 Use the **Magic Wand** tool to automatically select areas in an image with the same or similar colors.

8 The **Selection Brush** tool enables you to select an area of an image by clicking and dragging, or "drawing," over it.

9 Use the **Type** tool to add text to an image.

10 The **Crop** tool is used to cut an image.

11 Use the **Cookie Cutter** tool to crop an image in any of several special shapes, including a heart, butterfly, and star.

12 Use the **Straighten** tool to adjust the alignment of an image or layer.

13 The **Red Eye Removal** tool removes (you guessed it) red-eye.

14 Use the **Healing Brush** tool to fix minor defects in an image, clear up blemishes, and make other corrections.

15 The **Clone Stamp** tool allows you to sample any part of an image and then use that sample to paint over other areas.

16 Use the **Eraser** tools to remove parts of an image to reveal the background color, an underlying layer, or transparency.

17 The **Pencil** tool is used to draw hard-edged, freehand lines. The **Paintbrush** tools share this area and enable you to draw with a soft edge and create other effects.

18 The **Paint Bucket** tool enables you to fill in a selected area of an image with a solid color or a selected pattern.

19 Use the **Gradient** tool to create a range of colors in one area of the image.

20 Use the **Shape** tools to draw lines, rectangles, and other shapes within an image.

21 Use the **Smudge** tool to blur the edges of any part of an image.

22 The **Dodge** and **Burn** tools are used to lighten or darken an area of an image, and the **Sponge** tool is used to change the color saturation.

23 Click on a **Color Well** to select colors that can be applied using the other tools described above.

A TOOL FOR ANY JOB

This quick overview of the Toolbox will help you figure out which tool to use. Keep in mind that some tools, such as the Lasso tools, have different options that are revealed when you click on the tool.

Basic Image Editing

Image-editing programs enable you to do everything from fixing cracked and torn photos to more common tasks, such as resizing and cropping photos and adding text to create greeting cards. This section gives an overview of a few basic image-editing tasks.

Keep in mind that retouching photos takes practice and that the best results often require a process of trial and error. Remember too that there is almost always more than one right way to edit your images. Your best bet is to try one technique or setting with a photo, see how that looks, and then try another, building slowly until you find what works best for the image you are working on.

The saving grace in all of this is that Photoshop, like most software programs, allows you to "undo" your steps so you can easily back up if you make a mistake. You can even back up multiple steps in Photoshop Elements. Under the Edit menu, you'll find options to Undo and Redo, and you can use them repeatedly, going backward or forward through multiple steps. That means you can experiment with different options knowing that you can always go back a step or two if you don't like how it affects your image. To go all the way back to the last saved version of an image, choose Edit>Revert.

Opening an Image

Now that you have a sense of the tools and options in Photoshop Elements, it's time to dive in and start editing images. But before you can edit an image, you have to open it. To open an existing image, choose Open from the File menu. Find the photo you want in your image gallery, click to select that image, and then click Open. The picture will appear in a new window ready for you to edit.

Note

If you know a particular photo should be there but it doesn't appear in the Open dialog box, change the Files of Type field at the bottom of the dialog box to read All Formats. Every image in the folder should now appear in the file list and become selectable.

Creating a New File in Photoshop Elements

You can also create completely new images in Photoshop Elements, using the drawing tools to create artwork or the text tools to create headline images. To create a new document in Photoshop Elements, choose File>New. In the New dialog box, enter a name for your file and specify the Height, Width, Resolution, Color Mode, and Background Contents. (See the section on resizing and optimizing images later in this chapter for more on resolution options.) Set the Color Mode to RGB if you want to use color.

PREVIEW IMAGES AS THUMBNAILS
You can choose to see a preview of your pictures when you open a folder by choosing Thumbnails from the View menu.

Rotate a Little or a Lot

You may need to rotate a photo a lot if it was taken vertically and displays sideways on your screen, or you may just want to rotate an image a little because the lines aren't quite square. Without a tripod, it can be tricky to get all the elements in an image lined up properly in-camera.

Fortunately, Photoshop Elements makes it easy to fix these problems. If you have an image that was taken with the camera held vertically, choose Rotate from the Image menu, then use the Rotate 90° option and choose Left or Right. In some programs you may have to choose Clockwise or Counterclockwise, but the effect is the same. The image will flip 90 degrees. If you want to flip it again, just choose Image>Rotate and choose the amount and direction you want to rotate it.

Perhaps the most useful option, and the most complicated to get just right, is the Custom option (called Arbitrary in some programs), which enables you to rotate an image a little or a lot by entering any number to control the degree of rotation. I find it doesn't take much for most photos, even ones that are noticeably out of alignment. Try rotating an image 5 degrees or even 2 to start. Just this small amount can go a long way toward straightening out the sides of buildings (or the lamppost sticking out of someone's head).

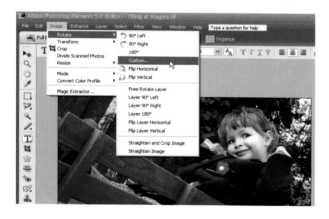 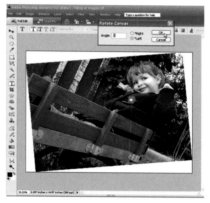

RIGHT SIDE UP
As you can see in these before-and-after images, rotating an image just a few pixels can make a big difference. You can use the rotate options to straighten images or to tilt them to create special effects. (Photo by Stephanie Kjos-Warner.)

Tip
After you rotate an image using the Arbitrary option, crop off the edges to square the corners (see "Cropping Your Photos" on the next page).

Edit Copies of Your Images

It's a good habit to work on copies of photos when you're making changes in a program like Photoshop. You can use the File>Save As option to create a copy of any image simply by giving it a new name. I do this routinely, often ending up with two photos named something like, Dave.tif and Dave-edited.tif. Then I make changes to the copy with the confidence that I can always go back to the original picture if I really mess up.

To further protect your images, I strongly recommend you make backup copies. You'll find tips for protecting and archiving your images on external hard drives, CDs, DVDs, and even online in Chapter 1.

Cropping Your Photos

Cropping is a very useful tool and it's an easy way to fix a composition by getting rid of distracting background elements and helping focus the viewer's attention on the subject.

Before you start using the Crop tool, take a good look at the photo you're considering cropping. In some cases you may just trim a bit off the edges to clean up a photo after aligning it. Or, you may want to remove as much of the background as possible to put the emphasis on your subject, as I did in the example shown here. Don't be afraid to experiment; you can always choose Edit >Undo and try again if you're not happy with the result.

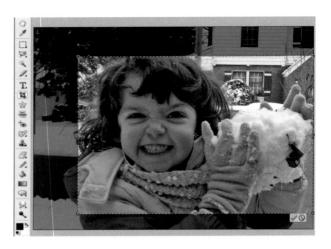

GOTCHA NOW!
Cropping in close creates drama in an image. The cropping tool makes it easy to get right in your subject's face.
(Photo by Stephen Perrotta.)

Flip or Flop

When designing a scrapbook page or any design, you want to help the viewer's eye move easily through your composition. For example, if you use a photo in which someone is looking to the side, your viewer is likely to look in the same direction. Therefore, it usually helps if your photo subject is looking into the page layout.

What do you do, then, if the subject is looking the wrong direction? Flip it! (Some programs may refer to this with the terms Flop or Mirror.) From the Image pull-down menu, choose Rotate and Flip Horizontal. You can also flip images vertically—a clever way to make it look like Grandpa is standing on his head.

Tip

If your photo contains type, as on a T-shirt or sign, you don't want to flip it, or the type will be backwards. Also, look for recognizable background items such as a skyline or building shape, or subtle items such as a birthmark, a wedding band, or the valves on a musical instrument that might look strange after the image is flipped.

WHICH WAY DID THEY GO?
If your design would look better with them going the other direction, just flip the photo.

As you get comfortable with Photoshop Elements, you should feel more daring about trying more advanced editing techniques to remove red-eye, adjust and balance light and shadows, remove blemishes, and even combine images to create photomontages. In this section, you'll find instructions for these and other editing features.

Easing Those Red, Irritating Eyes

Does anything ruin a photo more than a pair of ghoulish red eyes? Fortunately, with Photoshop Elements redeye (which is caused by a camera's flash) is pretty easy to eliminate. In the Toolbox, you'll find the Red Eye Removal tool, designed exclusively for this common task. Just select the tool as you see in these images and click in the red area of the eye.

Tip

If you're not happy with these automated results, just choose Edit > Undo. You'll find instructions for how to make more precise adjustments with the Clone tool later in this chapter.

Undo Until You Get It Right

The Undo feature in a program like Photoshop Elements enables you to back up one or many steps. Knowing this, you should feel confident to experiment with any image because you can always undo your actions if you're not pleased with the results, and then try something else. In most programs, you'll find the Undo command under the Edit menu. You can also use a key command to undo by holding down the Control key and pressing the letter Z (in Windows) or holding down the Command key and pressing Z (on a Mac).

GET THE RED OUT
The Red Eye Removal tool makes it easy to put the color back in your little girl's eyes.

If you've ever wished you could remove that zit from the end of your nose in a school picture or clean up the run in your mascara in a wedding photo, you're going to love the Clone Stamp and the Healing Brush tools. You can also use these tools to replace a missing portion of an image, content you've accidentally deleted, or even a section of a photo that was torn or creased.

The Healing Brush tool is great for fixing areas with patterns, like the sky in the photo shown here. I couldn't believe it when I got back from a rare chance to get close to a pair of osprey in the wild to find that a hair on my lens had left a dark line across all of my images. Thanks to the Healing Brush, I was able to erase the line while preserving the color and texture of the sky.

1. Open the image you want to work on in Photoshop Elements and select the Healing Brush tool from the Toolbox. Use the Zoom tool to enlarge the area you want to work on.

2. In the Options bar at the top of the screen, set the size of the brush to be relative to the area you want to fix. Make it too big and the repairs will be more obvious, too small and it will be tedious to apply or leave fine lines in the image.

Position the cursor over an area of the image you want to use to replace the bad part, and press the Alt key and click at the same time to select an area of the image that you want to replicate.

3. Move your cursor to the area you want to cover and click and drag to paint the area with the selected pattern. The Healing Brush not only paints the pattern, but it adjusts the pixels around the area to help it blend in.

4. In the final result, only a well-trained eye would notice that anything was changed. Anyone else would think this bird was flying into a clear blue sky. Another photo saved by Photoshop Elements.

Correcting Imperfections with the Clone Stamp Tool

The Clone Stamp tool can be used to make a precise replica of a selected area that you can paste into another area to create such a perfect patch even your best girlfriends won't notice you've cleaned up the mascara that was running under your eyes. In the example shown below, I cleaned a little baby food off of my friend Trey's mouth. I don't think his mother would want to remove his adorable spittle, but it serves as a good example of what's possible with the Clone Stamp tool (and none of my girlfriends would agree to let me feature a photo of them with a zit that needed to be zapped, which is one of the best uses of this tool).

To use the Clone Stamp tool, open the image you want to work on in Photoshop Elements and follow these steps:

1. Select the Clone Stamp tool from the Toolbox. In the Options bar at the top of the workspace, set the size of the stamp area relative to the spot you want to fix.

Position the cursor over an area of the image you want to sample. To see more detail, select the Zoom tool and click to enlarge the area you want to work on. Don't forget to reselect the Clone Stamp tool when you're done with the Zoom tool.

2. Place your cursor over the area you want to copy and press the Alt key and click at the same time to select it.

Move your cursor to the area you want to cover and click and drag to paste. The sampled content will automatically fill in the area.

If you're still having trouble getting the edges of the cloned area to look smooth, click to select the Smudge tool or the Healing Brush tool and click and drag around the cloned area to smooth the edges.

Tip
It's a good idea to zoom out periodically to check your progress and see the overall effect. Pixels can look very different when you zoom in and out on the details.

Balancing Colors and Contrast

When the color and contrast in your photos aren't balanced, nothing looks quite right. Overexposed backgrounds lack details, and dark foregrounds make it hard to see people's eyes and expressions. Fortunately, Photoshop Elements offers a Quick Fix button to help you adjust several light settings at once.

Start by clicking the Quick Fix button at the top of the main application window. Experiment with the manual and auto settings on the right side of the Quick Fix window until you find the combination that works best for your image.

- Use the Smart Fix option to make several adjustments at once, automatically altering the color and light. Or, you can click and drag the Amount slider to manually control these changes.

- Use the Levels button to automatically adjust the contrast between the lightest and darkest pixels in your image (this made the most difference in the example shown here). Use the sliders to manually adjust Shadows, Highlights, and Contrast settings.

- The Color settings let you manually adjust settings such as Saturation and Hue, or you can click the Auto button to let Photoshop work its magic for you.

- And finally, you can use the Sharpen options to clear up blurriness in your image.

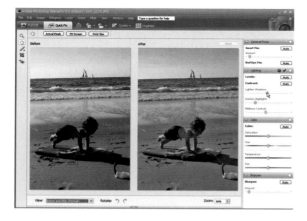

SURF'S UP!
By adjusting the contrast, brightness, and midtones of a backlit image like this one, you can bring out the details (and the personality) of the subject without losing the beauty of the background. (Photo by Sam Prasad.)

Selecting Part of an Image with the Lasso Tools

The red tube in this playground photo made a great frame for my brother and niece, but the pink light on their faces made them look strange until I fixed the color in Photoshop Elements. The trick was adjusting the color on their faces without changing the color in the rest of the image. It may seem confusing at first, but you can select a portion of an image using the Lasso tools and change the color in just that part of the picture. You can use this same technique to make other adjustments, such as changing brightness or contrast in only part of an image.

Here's how to select a section of an image and adjust the color only in that area.

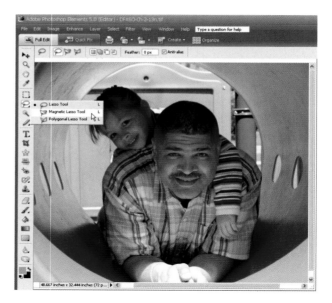

1. Select the Lasso tool from the toolbar and then choose the Magnetic Lasso tool from the drop-down list. (You have to right-click on the small arrow in the bottom right-hand corner of the Toolbar icon to reveal all of the Lasso options. Or Option-click if you're on a Mac.) You can use any Lasso tool for this kind of selection, but the Magnetic Lasso is often easier to use because it "sticks" to the edge of your selection.

2. Click to insert your cursor into the image where you want to begin your selection. In this example, I want to select the faces of the father and daughter but not the rest of the image so I can remove the red color reflected on their faces without losing the red color of the tube or the red colors in their clothes.

Drag your cursor, then click again, then drag again, then click again until you've gone all the way around the area you want to select.

Make your final click in the same spot as the first click to close and complete the area.

Make It Bigger

It's easier to see what you're doing on an enlarged image, especially when you're working on only one section of an image (as I am here). To enlarge your image, select the Zoom tool from the toolbar and click anywhere on the image.

With the Zoom tool still selected, you can click again to enlarge the image more and then click again to enlarge it even further. To reduce the image size, hold down the Alt key (the Option key if you're using a Mac) and click. Note: This does not affect the actual size of the image, just the display size on your screen.

SEE WHAT I MEAN?

When you zoom in on a section of an image you can see details better and make more subtle adjustments.

3. With the area of the image you want to change selected, choose Enhance ▸ Adjust Color ▸ Adjust Hue/Saturation. (Notice the many features you can use to adjust color, brightness, and other options in an image.)

4. In the Hue/Saturation dialog box, use the sliders to adjust the color.

Make sure the Preview button in the bottom right-hand corner of the dialog box is checked so you can see the effect of the adjustments on the image as you make them. (For most images, it doesn't take much to make a big difference, so try moving the sliders just a little at a time.)

Experiment with the three sliders until the color is the way you want it. Click OK to apply the changes. Choose Edit ▸ Undo to remove the changes if you're not happy with the results.

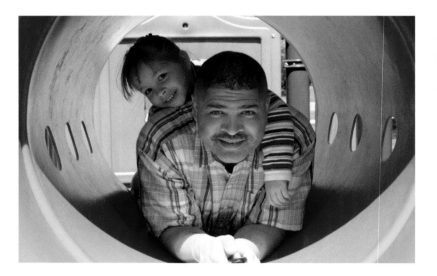

Warning: Undoing a Selection Can Be Tricky

Using the Lasso tools to make a selection can be tricky because if you make a mistake, you can't undo it until you've completed the selection. To complete a selection, even if it's not the way you want it, click again on the same spot where you started the selection to close the loop (you'll know you've completed the selection when it displays as a dotted line). Then you can choose Edit > Undo Magnetic Lasso to remove it and try again.

Here's another way to undo a selection: With the Lasso tool still activated, move your cursor to the toolbar and click on the Move tool, and Photoshop will automatically complete the selection. Then you can use the Undo option or choose Select > Deselect.

START OVER
Before you can select a new area of an image, you have to deselect any area that's already selected. To do so, just choose Select > Deselect.

Crop Out the Background with Magic Extractor

If you don't have the right tools, cropping a section out an image can be tricky and tedious, especially if you want to crop out something with as many edges as the colorful mask shown in this example. But Adobe has come to the rescue with one of the coolest features you'll find in Photoshop Elements. Magic Extractor (available in versions 4 and 5) has the extraordinary ability to "recognize" similar elements in a photo. With just a few clicks of the mouse, you can distinguish between the part of an image you want to remove and the part you want to keep, and Photoshop will take care of the rest automatically.

The more complex the image and the more subtle the differences between the background and the subject, the more you need to mark up the image, but you'll still save loads of time and get better results with Magic Extractor than with many other options. If you don't have Magic Extractor or you want to refine the results, you can always use the Eraser tool, available in many programs, to remove the background. It's a more tedious process to erase every pixel around an image, but the Eraser trick works in most popular consumer-based programs (especially if you zoom in and remove the pixels very carefully).

Follow these steps to use Photoshop Elements' Magic Extractor to make a clean crop, even around uneven edges.

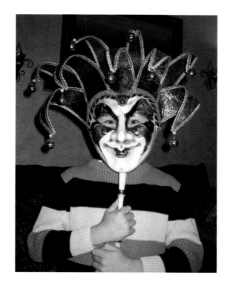

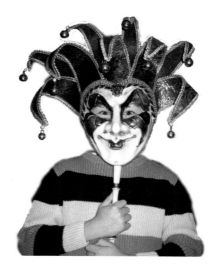

GET RID OF THE BACKGROUND NOISE

This photo becomes even more dramatic when the subject has been cropped carefully away from the background so the masked character gets all the attention. (Photo by Barbara Driscoll.)

1. Choose File > Open to open the photo you want to crop. Choose Image > Magic Extractor.

In the Magic Extractor window you'll find a variety of tools you can use to identify to Photoshop Elements which parts of the image you want to keep and which parts you want to remove, or extract.

2. First, click to select the Foreground Brush tool (located in the top left-hand corner of the Magic Extractor window). Click on the parts of the image you want to keep. In this example, you can see by the red marks that I've clicked in many places on the mask, dragging to completely paint over the bells and some of the edges.

Next, click to select the Background Brush tool (located just below the Foreground Brush in the top left-hand corner). Use this tool to identify the parts of the image you *don't* want to keep, again by clicking or dragging in different areas of the image. The areas you select will be blue.

Tip

As you use the Foreground and Background Brush tools, your goal should be to leave dots in any areas that look similar, such as the large areas of yellow on the wall in the background of this image. In areas where the colors vary or have textures, you'll get better results by clicking and dragging to select larger areas. The simpler the image, the easier it is to use this tool. In a complex image like the one in this example, you'll want to use lots of dots, lines, and even shading to distinguish between the foreground and background.

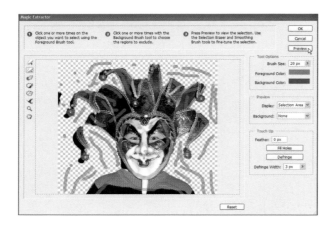

3. Once you have drawn all of your dots and lines, click the Preview button in the top right-hand corner of the window to see how the image will look after the extraction is complete.

Note

Using the preview before you do the actual extraction is optional, but getting this tool right on the first try is hard. Previewing is a highly recommended step because it gives you a chance to refine your selection.

4. To remove more background in the preview window, you can use the Eraser tool on the left side of the screen or you can use the Background Brush tool.

 If you use the Eraser tool, you'll immediately see the results of your actions as you click and drag over the image.

 If you use the Background Brush tool, more of the background color will be added to the image. Click on Preview again and any new areas marked with the Background Brush tool will be removed.

5. To restore parts of the image, use the Add to Selection tool, which looks like a paintbrush.

 You can also use the Foreground Brush tool to add parts back to the image, but you won't see the results until you click on the Preview button again.

 This is a rather delicate process and you may have to try it a few times to get the extraction just the way you want it. Also note that you can use the Undo option, but only for the most recent action in the Magic Extractor window.

6. If you want to remove some of the background or foreground color, you can use the Point Eraser tool. Just click to select it and then click and drag over the blue or red areas left by the Foreground and Background Brush tools. (Note: This eraser only removes the temporary markings of the Brush tools; it does not remove any of the image itself.)

7. To see the effects of your changes, choose Preview again. You can switch between the original image and the selection area by clicking on the arrow next to the Display field—a helpful way to get a better look at which parts of the image you have extracted.

8. Choose OK to complete the extraction and close the Magic Extractor dialog box. Even after you finish the extraction, you can continue to remove areas by using the Eraser tool from the Toolbox in the main window.

If you're not happy with the results, choose Undo and try the Extraction tool again.

Change Zoom and Brush Sizes to Be More Precise

As you're working on an extraction or doing any other delicate work in Photoshop, you can get more precise by using the Zoom tool to move in close on your subject and by changing the brush sizes so you can work more carefully on the details. You can even set the brush to 1 and zoom in super close to remove one pixel at a time.

ONE PIXEL AT A TIME
To make really minute selections, zoom in close so you can see every pixel of detail.

Adding & Editing Text

You can make your scrapbook creations, Web pages, and other digital projects uniquely your own by including headlines and text. Using the Type tool, just place your cursor anywhere on the image and start typing. The Options bar provides easy access to fonts and other formatting options. And you can use the Move tool to drag text around until you get it just where you want it.

The Options Bar

You can adjust the style and format of your text quickly and easily in the Options bar at the top of the screen when the Type tool is selected.

- Choose the T for horizontal text or the T with the small arrow next to it for vertical text. (You can set your text at an angle using the Move tool after you've entered it on your page.)

- Use the drop-down menu to choose a font. In the example at right, I've chosen the Liorah BT font.

- Specify the size of your text. In example shown here, I've chosen 56 point, which is a relatively large text size, suitable for a headline.

- Leave the Anti-aliased button (the icon with the two A's) selected. This smoothes the edges of text.

- Click to select the Bold, Italic, Underline, or Strike Through icons if you want to apply these formatting options.

- Select an Alignment icon to align your text left, center, or right.

- The Leading option enables you to adjust the space between lines of text. It is set to automatically correspond to the font size you specify, but you can use the drop-down menu to increase or decrease this number.

- Click in the Color Well to open the Color Picker dialog box, where you can select the color you want for your text.

- Choose the Create Warped Text option to make your text curve up or down.

1. Choose File > New to create a new, blank file or open an existing file.

 Select the Type tool. Specify the settings you want in the Options bar at the top of the Workspace (see box at left for a description of these settings).

 Click to insert your cursor where you want to enter text. Begin typing and letters will appear where the cursor is blinking.

2. If you want to change the font or other formatting option after you enter your text, make sure the Type tool is selected, click and drag your cursor across the type to select it, and then make any adjustments you want in the Options bar.

One of the most confusing features in a program like Photoshop Elements is the way it divides different parts of an image into layers. Essentially, layers enable Elements to separate an image into different sections, which is what makes it possible for you to do things like edit without affecting the photo underneath it, and move separate photos in a photomontage independently.

This is useful, for example, if you open a photo, add text on top of it, and then decide you want to edit the text or move it to another place on the picture. Without layers, your text would get "stuck" on the photo after you type it and you wouldn't be able to change it again without damaging the picture. With layers, you can select just the text and edit it independent of the photo.

Follow these steps to create a design that includes text and a combination of images. This is the kind of project that will help you appreciate the advantages of keeping different parts of an image on different layers so you can move and edit them separately.

1. Open a photo in Photoshop Elements. Click to select the Type tool from the Toolbox and adjust the settings the way you want them in the Options bar (see "The Options Bar" on the previous page for more on these settings).

Click to insert your cursor where you want to add text on the page and type your text.

2. If it's not already open, choose Window › Layers to open the Layers palette. Then, if you want to make changes to a block of text after you've added it to the page, you can click to select the corresponding layer in the Layers palette to select it. The active layer is shaded gray and appears darker than the other layers. Note that you still have to make sure you have chosen the correct tool from the Toolbox, such as the Move tool to change the position of a layer or the Type tool to edit or reformat text.

You can switch from one layer to another by clicking the desired layer, and you can even move layers in the Layers palette by clicking and dragging. If you want one layer to overlap another layer, for example, you can control which one is on top by moving it higher up the list.

3. With the image you want to add a photo to still open in Photoshop Elements, choose File › Open and open another image that you want to add.

Select the Move tool from the Toolbox.

Click anywhere in the image you want to copy and choose Select › All to select the entire image. With the image selected, choose Edit › Copy.

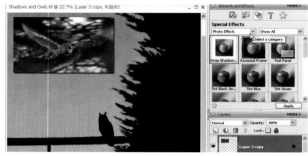

4. With the Move tool still selected, click to place your cursor back into the first image where you want to add this new image and choose Edit>Paste.

With the Move tool selected, you can click and drag to move the pasted content around on the main image.

5. Add definition to your design by creating a drop-shadow around an image. To do so, click to select the image in the montage.

If the Artwork and Effects palette is not open, choose Window>Artwork and Effects to open it.

Tip
To add two different kinds of text, enter the text, choose the Move tool, click in another area of the page, and then select the Type tool again. Otherwise, when you change the formatting options to reflect what you want for the second area of text, you'll apply those to the first text you entered.

6. Choose the Apply Effects, Filters, and Layer Styles button. Choose Photo Effects from the drop-down list under Special Effects. Choose Show All from the drop-down list to the right of Photo Effects. Double-click on the Drop Shadow button to add a drop shadow to the image in the selected layer.

If you want to add more images, repeat steps 3 through 6 for each additional image. When you're finished, don't forget to save your work by choosing File>Save.

Tip
You can resize an image in a montage by first selecting the Move tool from the Toolbox and then clicking and dragging on any corner.

You'll find a wide range of filters, special effects, and other features in Photoshop Elements that you can use to make your photos look like watercolor paintings, stencils, and so much more. Experiment and explore the many special effects by applying them to text and images until you find the best effects for your designs. Here are a few more examples of what's possible with Photoshop Elements features and effects.

WATERCOLORS ON THE WATER

This photo I took of a sea otter in Northern California looks like a watercolor painting because I treated it with the watercolor filter. You can apply a watercolor effect to any image by choosing Filter > Artistic > Watercolor.

TURN SNAPSHOTS INTO WORKS OF ART

This photo of an egret transforms into something that looks hand-drawn when you apply the Colored Pencil filter. Some of the more advanced filters include settings for specifying the strength and style of the filter effects.

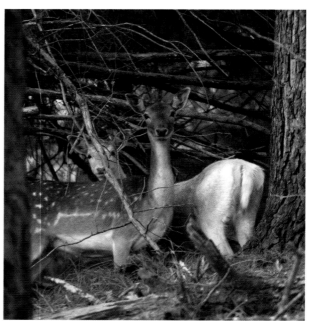

MAKE NEW PHOTOS LOOK OLD

Applying the Sepia Tint and Old Paper effects to this photo of fallow deer I took recently makes it look like a picture you might have found in your grandmother's attic. You'll find Sepia and many other photo effects in the Artwork and Effects palette when you choose the Photo Effects category and the Image Effects subcategory.

So Many Options

Photoshop Elements and most other software programs usually provide more than one way to use almost any feature. In many cases, an option that is available in the menu at the top of the screen will also be available in a palette, and you can often use keyboard shortcuts as an alternative—a choice many professionals find more efficient. For example, you can copy text by selecting the text and choosing Edit>Copy, but you can also copy text by selecting it and then pressing the Control key and the letter C key at the same time (on a Mac you would press the Command and C keys). To paste a copied image or text, choose Edit>Paste, or press the Control and V keys simultaneously (Command and V on a Mac).

Command	Windows	Macintosh
Cut	Control + X	Command + X
Copy	Control + C	Command + C
Paste	Control + V	Command + V
Undo	Control + Z	Command + Z

COMMON KEY COMMANDS

The commands to cut, copy, paste, and undo all have keyboard shortcuts that make them even easier to use.

Understanding Resolution, Size & Optimization

Simply put, resolution indicates the quality of an image created by a digital camera or a scanner, often referred to in pixels per inch (ppi). Pixels are tiny building blocks arranged in rows and columns that combine to create a bigger picture. Each pixel may be a distinct color it blends with other pixels in an image to create the illusion of solid areas of color and gradual color changes in a way that appears as a single image to the human eye.

As you zoom in on an image, you can see the pixels more distinctly, which may help you appreciate the basic rule that the more pixels per inch in an image, the better the quality of the image, the higher the resolution, and the more you can enlarge it and still have it look good.

If you're starting to understand all that, you might immediately assume that more pixels is always better, but, because each pixel adds to the size of an image file, having more pixels also means the photo will take longer to send over the Internet. When you're preparing an image for the Web, you want a low resolution, because that's what makes the file size small and the image download faster. Because a computer monitor can only display an image at 72 pixels per inch, no matter what the actual size of the image, there is no reason to use a higher resolution for an image you want to display on a computer.

However, when you're preparing an image for printing, the opposite is true. Images with higher resolution print with much more clarity. When you buy a printer, you may notice that the quality it is capable of producing is measured in dots of ink per inch (dpi), not ppi, and that does make it more complicated to compare, but the basic rule is that the more dots per inch in a digital picture, and the more pixels per inch in a printer, the higher the image quality and the better the print will look.

These differences in quality become especially evident if you try to print a small 72-ppi image that you downloaded off the Internet on a high-quality printer. You can either print a tiny image that looks good, or print an enlarged image that looks fuzzy and lacks detail because it doesn't have enough pixels per inch. Unfortunately, you can't easily add pixels to a digital image to make it print better. Thus, if you want to print an image that you're sending over the Internet, you're best off sending a higher resolution version of the image, but if you're only going to display an image on the Web, it will download a lot faster if you reduce it to 72 ppi.

In the following pages, you'll get to explore these concepts further with instructions that demonstrate the different approaches you can take when saving images for print versus optimizing them for fast downloading over the Web.

Saving Photos and Artwork to Be Printed

If you're creating a design that you want to print, you want to use a high-resolution image. How high? For most printers, your best results will come from files saved at 300 ppi, but 150 to 200 ppi is often more than enough for consumer printers.

In the following exercise, you'll learn how to take a JPEG captured with a digital camera and change the resolution from 72 ppi (which is how many cameras save images) to 300 ppi, which is much better for printing.

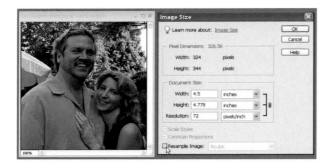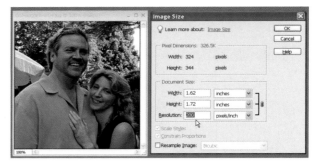

1. Open the photo in Photoshop Elements and choose Image>Resize>Image Size to open the Image Size dialog box.

To change the resolution, make sure that the Resample Image box at the bottom of the window is not checked (you don't want to resample when you're changing resolution).

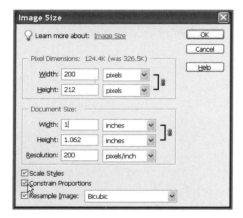

3. Before you change the document size, click to select the Resample Image box and make sure that Constrain Proportions is also checked. These two settings ensure the image keeps the same proportions as it is reduced. (The brackets that appear next to the Height and Width boxes indicate that these fields are locked together so that changing one field automatically changes the other.)

In the Width field, enter the size you want your image to be. I entered 1 inch and the height automatically adjusted to 1.062 inches to maintain proportions. Changing the document size also changes the display size of an image.

2. Change the Resolution value. In my example, I changed it from 72 to 200. Notice that when the resolution is changed the Document size changes from 4.5 inches wide to 1.62 inches wide (the height also adjusts proportionately).

At this size, you can create a tiny little print for my wallet, but you'll never be able to make a big print of this image, because at a resolution that's high enough for good print quality, 200 ppi, the document size is less than 2 inches. To make this photo print even smaller, such as to fit in a locket, you can now change the document size.

4. To save the image in a different format, choose File>Save As and, in the bottom of the Save As dialog box, use the drop-down arrow in the Format field to choose any available format. In this example, I'm saving this JPEG in TIFF format with its new resolution settings.

Note

On a Macintosh computer, your best format options for printing are generally PICT or TIFF files. On a PC, you should use TIFF or BMP files. Although most cameras save images in JPEG format and that is a great format for sharing photos over the Web, you'll get better results with one of these other formats when you're saving files for printing.

Optimizing and Saving Images for the Internet

Photoshop Elements includes a special feature that makes it easy to optimize images for faster downloading over the Internet. If you're a little confused about pixels per inch and resolution at this point, don't worry. The good news is that Photoshop Elements pretty much takes care of everything for you when you use the Save for Web dialog box (available from the File menu). Since you're preparing images for display on a computer when you save them for the Web, what you see is really what you get when you go through this process (in contrast to images you want to save for print, which can look quite different on the computer than they do when they come out of the printer).

In this section, you'll learn the difference between the two file formats most commonly used on the Internet—GIF (Graphics Interchange Format) and JPEG (Joint Photographic Experts Group)—and find step-by-step instructions for the Save for Web dialog box. As a general rule, the JPEG format is best for photographs and other images with many colors, and the GIF format is best for drawings, cartoons, and other images with fewer colors. This is because you can reduce the download time of a GIF by reducing the number of colors, and you can make JPEGs download faster using compression, which works better with images that need many colors to display well.

Saving Drawings and Artwork as GIFs

The idea that you can reduce the number of colors in a GIF file may seem strange at first, but you're essentially taking away the colored pixels you don't really need in order to reduce the file size of the image. This works because the smaller the file size, the faster an image downloads.

If you take away too many colors, the change can be drastic; but if you limit the image to only the number of colors it really needs, you won't even see the difference in quality and the image will download much faster. Follow the steps below to reduce the resolution and the number of colors as you save an image in GIF format.

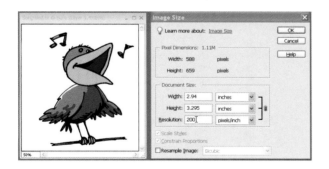

1. Open the photo in Photoshop Elements and choose Image > Resize > Image Size to open the Image Size dialog box.

If the image is set to a resolution higher than 72 ppi, you'll want to reduce it before following the rest of these steps. Make sure that the Resample Image box at the bottom of the window is not checked (you don't want to resample when you're changing resolution) before you change the resolution.

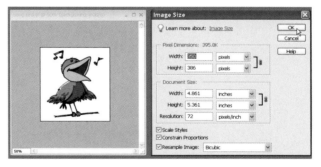

2. You can see that when I changed the resolution from 200 ppi to 72 ppi, the document size increased. To change the size the image will display, click to select the Resample Image box and make sure that Constrain Proportions is also checked and then change the document size or the pixel dimensions. In this example, after I changed the resolution to 72, I changed the pixel width to 350.

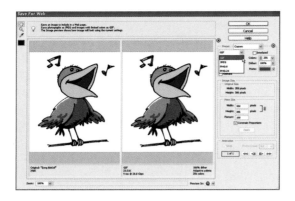

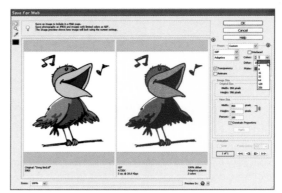

3. Choose File > Save for Web to open the Save for Web dialog box. From the File Format drop-down list, choose GIF. (Remember, GIF is ideal for images like this songbird that use only a few different colors.)

4. From the Colors drop-down list, choose the lowest number of colors you think the image can be reduced to and still look good. The fewer colors, the smaller the file size and the faster the image will download, but if you go too far, as I have in this example, you'll remove too much color from the image. The challenge is to find the lowest number of colors that still produces a good-looking image.

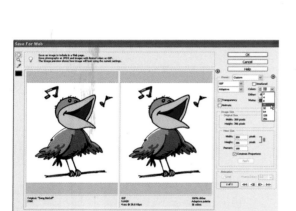

5. Change the color settings until you find a number that looks good. When I set this example to only two colors, the image looked terrible, but with only sixteen colors, the image looks almost unchanged. Look closely at the bottom left corner of the before-and-after images in the Save for Web dialog box, and you can see that limiting this image to sixteen colors reduced the file size from 396K to only 9.84K.

Unless you have a lot of experience with creating images for the Web, leave the remaining settings unchanged. Click OK and the Save Optimized As dialog box will open. Enter a name for the image and save it to your hard drive.

E-mailing Images to Print

If you're e-mailing an image to friends and you want them to be able to make a good print, send a larger, higher-resolution image in a format like TIFF that's best for printing. Just make sure your recipients have a high-speed Internet connection or are prepared for a long download time when they receive your message.

Saving Photos as JPEGs

The JPEG format is ideal for images that use lots of colors, as well as images that are made up of many shades of gray, such as black-and-white photographs. JPEGs use a compression method to remove information from an image in a way that is designed to "trick" the human eye, taking advantage of the fact that most of us are better at noticing brightness and contrast differences than minute changes in color tone.

Elements uses a compression scale of 0 to 100 for JPEG, with 0 being the lowest possible quality (the highest amount of compression and the smallest file size) and 100 the highest (the least amount of compression and the biggest file size). The challenge with JPEGs is to compress them as much as possible without losing too much quality. In the following steps, you see how the Save for Web dialog box makes it easy to optimize a JPEG so that it downloads faster and still looks good.

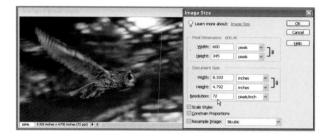

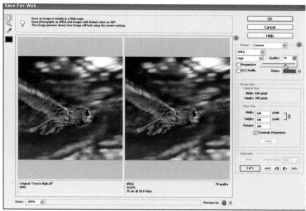

1. Open the photograph that you want to save as a JPEG using File>Open. Choose Image>Resize>Image Size to open the Image Size dialog box and lower the Resolution to 72 ppi. (Make sure that the Resample Image box at the bottom of the window is not checked when you're changing the resolution).

To change the size the image will display on a computer screen, click to select the Resample Image box and make sure that Constrain Proportions is also checked and then change the document size or the pixel dimensions. In this example, after I changed the resolution to 72, I change the pixel width to 600.

Tip

Make sure you do any color correction, brightness adjustments, or other editing before you use the Save for Web dialog box. You'll get much better results when you edit an image at the highest quality before going through the optimization process.

2. Choose File>Save for Web to open the Save for Web dialog box. In the file format list, choose JPEG.

Next, change the Quality setting by clicking on the arrow next to the Quality field and using the slider to adjust the number. The lower the Quality setting, the more compression is applied to the image and the faster it will download. You can use the drop-down list under JPEG to select any of the preset options: Low, Medium, High, Very High, or Maximum.

Leave the other settings unchanged (unless you really know what you're doing). Click OK, and the Save Optimized As dialog box will open. Enter a name for the image and save it to your hard drive. Repeat these steps for each image you want to prepare for your site.

Don't Stop Now

Armed with the tips and suggestions in this chapter, you are ready to begin your own experimentation and learning with Adobe Photoshop Elements, or whatever image-editing software you choose, to create your family projects.

As you have seen, there are nearly limitless choices for applying tools and techniques. The important lessons to remember are these:

- Explore all the options and try out different tools and dialog boxes to test the different effects.

- Be prepared to do, undo, and redo again as you learn.

- Experiment and then experiment some more. This is the best way to learn, and as long as you're working on copies, you can't hurt anything.

- Most important, have fun!

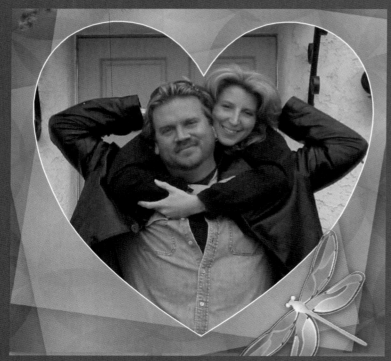

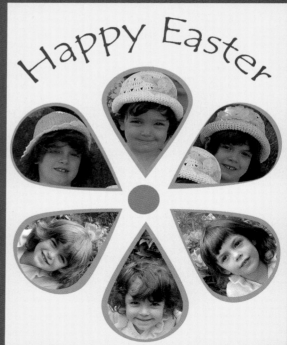

Happy Easter

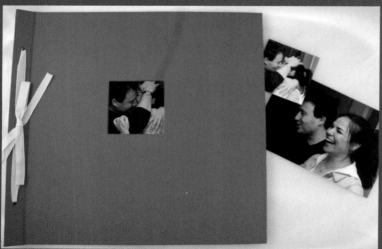

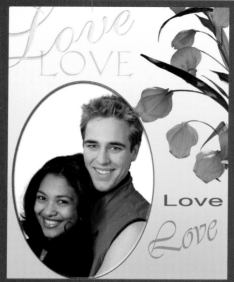

Love
LOVE
Love
Love

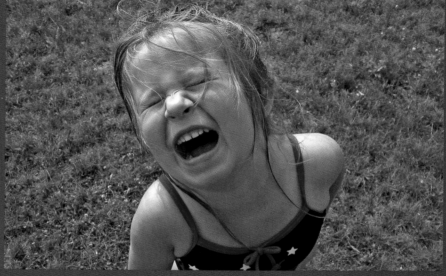

3

Spring Holidays:
Filled with Hidden Treasures

Spring into creating digital memory projects with loving cards for your favorite valentines, treasures you won't want to hide for Easter, delicious treats for Passover, and more. In this chapter, you'll learn some photo tricks and design concepts, and you'll discover how to:

● **Create beautiful Valentine's Day cards**

● **Make a family cookbook to commemorate Passover**

● **Design digital scrapbook pages that feature your favorite Easter photos**

● **Create the perfect Mother's Day gift**

April showers may bring May flowers, but if you don't take the time to preserve your memories, precious moments can wash away like the rain. The designs and ideas in this chapter will help you ensure that never happens.

Capturing the Best Spring Photographs

The days get longer throughout the spring, giving you more daylight hours to capture photographs of your loved ones. Here are a few tips to help you take the best photos possible this spring.

Get 'em Comin' and Goin'

Add a little visual interest to your images by breaking out of the traditional straight-on photos and moving around your subjects. Follow your children as they play in a playground, climbing where they climb or crawling around with them to shoot from a low angle. Just be careful—you may not be as agile as your four-year-old, especially with that big camera around your neck.

CLIMB TO THE TOP
This view from the top of the slide helps create the feeling of sliding down. (Photo by Stephanie Kjos-Warner.)

LOOK UP!
If you're taller than your subject, just looking down from above can help you capture a fun new perspective of a familiar face.

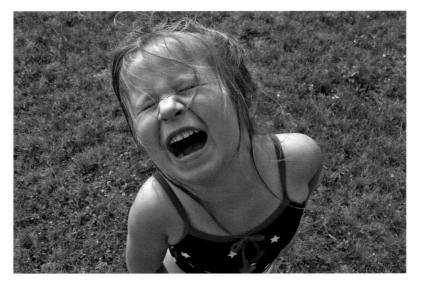

Catch the Action

Anticipate the arrival of your subjects when they come around a corner or drop out the other side of a water slide. If your camera has a continuous shutter setting, you can take a series of photos in rapid succession (as many as three to six shots per second), increasing your chances of getting the best expression, and even capturing an action series like these photos of my friend Trey on a water slide. His mom, Anissa, has a quick shutter finger and she knows what makes him smile.

BE READY AT THE BOTTOM
If you know your child is about to come around a corner or down a water slide like this one, get there in advance and get ready—you may have only a second to get that perfect picture—or two or three. (Photo by Anissa Thompson.)

Be My Valentine

'Tis the season of love and flowers, and even if you think candy is dandy, nothing says "I love you" in a more personal way than a custom valentine. Create your own designs by simply adding photos to a template like the one shown here. (You'll find this one and more on the DigitalFamily.com website.) If you want to use more photos to commemorate this special day, make a digital photo album or go online and order a truly personal gift, like a box of chocolates with your own photo on the top.

VALENTINE'S DAY CARD
Just add a picture and this valentine is ready to print or e-mail. You'll find this card frame (called love-and-flowers.tif) on the DigitalFamily.com website. You can also use this and any of the other card designs in this book as digital scrapbook pages or as covers for a photo album. (Design by Davi Cheng.)

Give Them a Gift That's Good Enough to Eat

You can still give your sweetheart chocolate, but this year put your own photo on it. Send your love a box of chocolates personalized with a favorite photo or create a special collection of valentines for school or work by adding your images to chocolate lollipops or truffles. You can personalize a wide range of chocolate gifts at www.chocolategraphy.com.

A SWEET IDEA
Just upload a picture online and you can personalize a heart-shaped chocolate box filled with chocolate truffles, as well as many other tasty treats, at www.chocolategraphy.com.

Create a Photo Treasure Book

Taking digital photos doesn't mean you can't still create a photo album. Even if you don't have a color printer at home, you can have your photos and any of the designs in this book printed online at sites such as Shutterfly.com or KodakGallery.com.

You can purchase a photo album like the one shown here at a stationery or craft store and then fill it with your digital designs. I especially love this book because the bold red cover is so dramatic and includes a window where you can showcase a small photo or part of a larger image.

REMEMBERING OUR LOVE
Sometimes the most striking photo album covers feature only a small image.

Tip
When you're limited to such a small space, choose an ultra close-up like the one shown here, or crop a bigger image to get tight on your subjects' faces.

CREATE A CARD WITH LOVE
Programs such as Scrapbook Factory Deluxe feature greeting card designs
you can mix, match, and customize to create cards for any special occasion.

Personalized Valentine

Walk into any office supply store these days and you'll find a wide range of software programs designed to help you create your own greeting cards. Most of them have greeting card features similar to those in Nova Development's Scrapbook Factory Deluxe, which is featured here. Other popular programs for creating greeting cards include Broderbund's Creating Keepsakes Scrapbook Designer Deluxe and Ulead's MyScrapbook, which are featured in later chapters. All of these programs include a variety of designs to choose from and let you mix and match background images, change text-formatting options, and add your own images. Follow the steps below to create a greeting card with Scrapbook Factory Deluxe.

At a Glance

Software: Scrapbook Factory Deluxe
Template: The Old School design, selected from the Events & Occasions Card collection
Size: 8½ by 5½ inches
Font: Morning Limerick
Image Tips: You can add more images to a design, even if the original template includes space for only one picture.

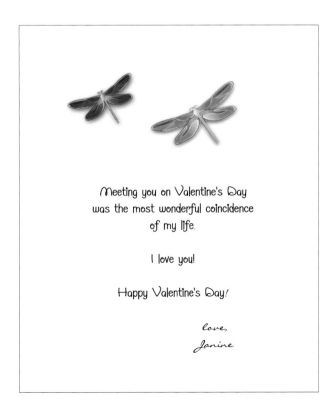

LOOK INSIDE
The inside of this design gives you space to record all your loving thoughts.

1. When you open the Scrapbook Factory Deluxe program, the Choose a Project screen appears. Choose the Photo Cards category and then choose a subcategory. For this design, I selected Events & Occasions.

Select the design you like from the thumbnail images (use the arrow at the bottom right to scroll through your options).

Click on the Next button to customize the text. In this example, I changed Happy Birthday to Happy Valentine's Day.

Click Finish to generate the card.

2. Once the card is generated, click on any element of the card to alter it. In the example shown here, I clicked on the text and used the Rotate bar to change the angle.

To change the size of an element, such as the frame around the text in this example, click and drag on any corner of the element.

To edit the text, double-click on it to open the text editor and select the text. You can specify the font, type size, and other options.

3. Double-click on the image placeholder to add your own image to the design in its place. If you want to add more images than are included in the template, choose Insert>Image to add additional images.

Double-click on any image to open the image-editing options, where you can select from several photo-cropping shapes, including this heart shape.

Click and drag on any side of the crop shape to enlarge or reduce the area to be cropped.

Click OK to apply the image-editing options. Double-click on the image again to make further edits or adjustments.

4. To add an accent such as the dragonfly shown here, click on the Scraps tab in the top right-hand corner of the screen and choose from the long list of images.

Click on the arrow to scroll through the options under the Scraps tab. When you find one you like, click on the thumbnail image and drag it into the design area.

You can easily move, resize, and rotate accents by clicking and dragging them.

5. To personalize the inside of the card design, click on the Inside tab at the bottom left of the screen to open that part of the card.

Double-click on the text to open the text editor and alter the text. Click and drag any of the accents from the Scraps tab to add images such as the two dragonflies shown here.

When you finish creating the card, you can choose File>Print to print it or save it in any of the formats featured under the File menu. (See "So Many Options for Saving Your Designs" for all your choices.)

So Many Options for Saving Your Designs

When you have finished creating your page, you can save it in a variety of formats depending on what you want to do with the design, such as:

■ If you simply choose File>Save, your page will be stored in Scrapbook Factory Deluxe and you can open and edit it from within the program any time you want.

■ If you choose File>Save As, you can save your page with a new name, creating a copy and leaving any earlier saved version unchanged.

■ Choose File>Save as PDF, and your page will be saved in Adobe's Portable Document Format, which is a good option if you want to e-mail your page as an attachment.

■ Choose File>Export as Image if you want to save your page in an image format such as GIF, JPEG, or TIFF. This option is best if you want to further alter the page in a program such as Photoshop Elements after you've created it in Scrapbook Factory Deluxe. This is also the only option that enables you to specify the resolution of your design. (See Chapter 2 for more information about image resolution.)

■ The Publish as HTML option is a bit misleading. You can't publish a complex scrapbook page as HTML (the language behind a Web page). Instead, when you select this option, you are offered the chance to select a new HTML template from a more limited list of options.

■ Choose File>Double-Sided Print Wizard and the program will print test pages based on your specified printer options, which you can then use to determine how to place a piece of paper to print on the second side after the first side is printed. This is especially useful if you are creating a book from your designs and want to print on both sides of the paper.

■ Choose File>Envelope Setup Wizard to adjust the program's settings to print envelopes. Note, however, that you can't automatically create an envelope based on your page design. You'll have to choose from the envelope templates.

The Flavors of Passover

Passover is a spring holiday celebrating the time in history when the Jewish people were freed from slavery in the land of Egypt. Passover traditions include many special foods, especially matzo, a flat, unleavened bread the Israelites ate after their hasty departure from Egypt. The Passover seder takes place on the first evening of Passover and can last into the early hours of the morning, as participants eat together, study the Torah, and sing special Passover songs. Unlike other traditional holidays that are held in a synagogue, the seder is most often held at home.

Pesach: To Pass Over

At the bottom of this cookbook cover design on the next page is the word *Pesach,* the Hebrew name for Passover, repeated over and over in different fonts. Special words like this, presented in a different language or special font, add a great design element and can make your designs more authentic. The name *Pesach* (pronounced PAY-sahch, with a "ch" as in the Scottish *loch*) comes from the Hebrew root Peh-Samech-Chet, meaning to pass through, to pass over, to exempt, or to spare. Pesach is also the name of the sacrificial offering (a lamb) that was made in the Temple in Jerusalem on this holiday.

From our family to yours on Passover. Shalom!

PASSOVER GREETINGS
A simple, elegant design that features a favorite photo is sometimes all you need to get your message across.

 YOU make it

Family Cookbook

Every year the Witkoff family hosts a Passover dinner for a dozen or more of their closest friends and family. Laughter fills the family's home as the guests arrive, and everyone knows they are in for a special treat, because the Witkoffs take great care in preparing the table and all the wonderful food they share with their guests.

There are many ways to commemorate an occasion such as Passover, but the cookbook design in this section is a personal favorite. The recipes in this example come from the Witkoffs' family collection, and, having been a guest in their home, I can attest to how wonderful they are. But don't take my word for it: The Witkoffs' family table is so well known in southern Florida that it's been featured in the *Miami Herald* along with many of their wonderful recipes.

Although this design was created for Passover recipes, you can easily adapt it to create a cookbook for any other holiday. Follow these instructions to create a design like this one in Photoshop Elements.

At a Glance

Software: Photoshop Elements
Template: You'll find a collection of cookbook templates in the Reader's Corner at www.digitalfamily.com. For the cover of this design, use the file called cookbook1cover.tif. If you prefer, you can select the file called cookbook1cover.doc to edit this template in a word-processing program. For the interior, use the file called cookbook1recipe-page.tif or cookbook1recipe-page.doc.
Size: Fits on a letter-size page (8½ by 11 inches).
Fonts: Warnock Pro, Papyrus, and Trojan Pro
Image Tips: Honor the cook with a photo on the cover of your recipe book. Photographs of the centerpiece and table settings, plates of food, or even a counter spread with ingredients also make great cover art.

THE LANGUAGE OF FOOD
The design for the Witkoff family's Passover recipes includes words in Hebrew to add an interesting design element and make the book more meaningful. (Design by Davi Cheng; photos by the Witkoff family.)

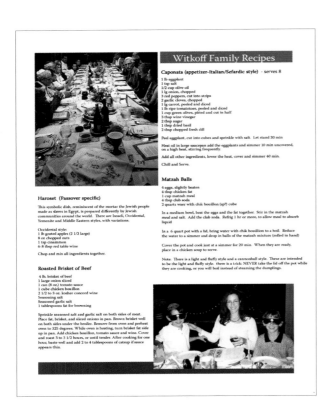

Collaborate Online to Create a Cookbook for the Entire Family

The Morris Press Cookbooks company (www.morriscookbooks.com) offers a Web-based system for creating cookbooks. Set up an account and you can let anyone you want log in and add recipes. When you have a nice collection of recipes, you can order as many printed copies as you like. It's so easy that anyone in the family can contribute. All they need is a connection to the Internet and a Web browser such as Internet Explorer.

DINING WITH FRIENDS AND FAMILY
Add photos to the recipe pages of your family cookbook to create a book that is as much fun to look at as it is to cook with.

Creating the Cover

The cover of your cookbook sets the tone for the design and should welcome all your cooks to peek inside and learn from the chef (or chefs) of the house who have decided to share their delicious secrets. You can use many small pictures on the cover, or one big one to focus on the chef of honor. Then add text and color to complete the design, as you'll learn in this lesson.

1. Download the template called cookbook1cover.tif from www.digitalfamily.com. Open Photoshop Elements or another image-editing program that supports layers, and then choose File>Open to open the template.

Choose Window>Layers to open the Layers palette.

2. To change any of the text in this design, click on the layer that contains the text you want to edit. Select the Text tool in the Tools palette, and then click and drag to select the text. Type the new words and phrases you want and the selected text will be replaced. For example, you could change the word *Passover* to *Thanksgiving* or *Easter*, if you'd like to use this design for a different occasion.

Repeat these steps until you have edited all of the text areas you'd like to change.

Tip

If you type a word that is significantly shorter or longer than the text in the template, you may need to change the font size by using the options in the Text Options bar at the top of the screen. You can also select the Move tool from the Toolbox and click and drag to change the position of the text on the page.

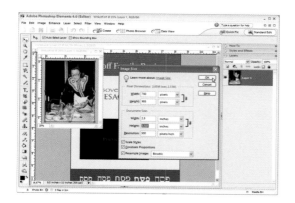 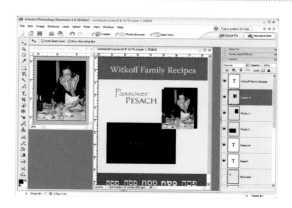

3. To add your own images to this design, select the Move tool from the Toolbox and then choose File>Open. Select the name of the image you want to add and click the Open button. You should now have both images open at once in Photoshop.

4. With the Move tool still selected, choose Select>All and then Edit>Copy to make a copy of the image you want to add to the design.

Click to place your cursor in the template image where you want to add the new image and choose Edit>Paste.

When the new image appears in the template, click and drag the image into place.

Tip

You can resize an image after you paste it into place by simply clicking and dragging on any corner until it is the size you want. You can reduce the size of an image as much as you like with this technique without losing much quality, but if you try to enlarge an image too much this way it may look blurry or pixelated, and it may print badly. That's most likely to happen if the resolution of the image isn't as high as the resolution of the template. (Learn more about resolution in Chapter 2.)

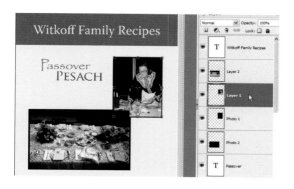

5. If your design features two images that overlap, as I've done in this example, you can switch whichever image is on top by moving its layer in the Layers palette.

To place the photo of the cook so it overlaps the photo of the table, I clicked on Layer 1, which represents the photo of the cook, and dragged it up above Layer 2, which is the layer that represents the photo of the table. The effect is immediate and you should see that the image that appears first in the list of layers is on top of any elements that come lower on the list.

6. In the cookbook1cover.tif template, one of the layers is called "Flat Bread." In the last two steps, that layer was invisible in the figures because it was turned off in the Layers palette. You can turn layers on and off by clicking on the small square just to the left of each layer. You'll know you've turned it on because an eye icon will appear in the square and the contents of the layer will become visible in the design. Click on the eye again and you can turn the layer off. In this example, the "Flat Bread" image appears next to the words *Passover* and *Pesach*.

When you're happy with the design, make sure to save your work by choosing File>Save. If you send the file to print, only the visible layers will appear in the design.

Throwing Away Layers

You can throw a layer away by dragging it to the trash, or you can make it invisible by clicking the eye icon. In either case, the layer will not display on the screen and will not be visible if you print the image. So why would you want to keep an invisible layer? If you are thinking of discarding a layer, such as the black boxes that serve as image placeholders, but you're not yet sure, clicking the eye icon to turn it off gives you the option to easily add the layer back to your design later. If you throw a layer away, you remove it completely from the image.

Making the Recipe Pages

Creating an inviting cover is just the beginning. The meat and potatoes of a good cookbook are all the pages that feature your recipes. If you prefer, you can create recipe pages in Microsoft Word even if you use Photoshop to make a nice cover. Photoshop can be a little tricky with large amounts of text, but it does give you the better options if you want to add pictures and color like you'll learn to do here.

1. Download the cookbook1recipe-page.tif template at www.digitalfamily.com. Open Photoshop Elements or another image-editing program that supports layers and then choose File>Open to open the template. Select Window>Layers to open the Layers palette.

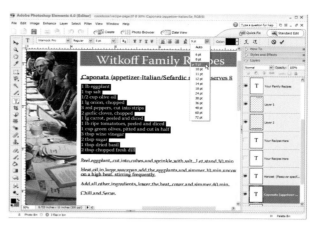

2. To add photos or other images to this design, follow steps 3 and 4 for the cover, above. To best fit this design, resize your vertical images to 3.5 inches wide and horizontal images to 3.8 inches wide, 300 pixels/inch, before adding them to the template. (You'll find instructions for resizing images in Chapter 2.) If you prefer, you can resize them after you copy them into the template by clicking and dragging on any corner.

Tip

You can easily add more images to these pages or use fewer images. Just make sure you remove the black boxes that represent where the images should go if you're not using them as frames.

3. To change any of the text in this design, click on the layer that represents the text you want to edit, select the Text tool, click and drag to select the text you want to replace, and type the new text to replace it.

To add more text, select the Text tool, click anywhere on the image, and start typing to create a new layer with text.

Format the text by using the Text Options bar at the top of the screen. Notice in the example that I am changing the line spacing. This text is 8 points but I made the line spacing 9 points to create just a little more space between the lines. Adding space between lines of text makes the text easier to read, especially when you're trying to follow directions as in this recipe.

When you've completed the design, make sure you save your work.

Word Processors Make Better Text Editors

When working with more than a few words of text, as is the case with most recipes, I prefer to use a program such as Microsoft Word to type and edit the text. When I have it written the way I want it, I use copy and paste to move the text to my image file in Photoshop. To do so, click and drag to select the text you want to move and choose Edit > Copy. Next, open Photoshop Elements, select the Text tool from the Toolbox, place your cursor on the page where you want your text, and then choose Edit > Paste. You can specify the font, size, and color and other text options by using the Text Option bar at the top of the screen. To move the text layer to a different place on the page, select the Move tool from the Toolbox, and then click to select the text layer. With the layer selected, you can click on the text area and drag to reposition the text on the page or click and drag any corner of the text box to resize the text.

Easter Egg Hunts & Other Great Adventures

Easter egg hunts offer many great photo opportunities, and a collection of images from such an outing makes for some of the cutest digital scrapbook pages you can imagine. In this section, you'll find instructions for creating interesting visual effects, such as cutting out photos into flower-petal shapes or cropping an image so tightly you catch only the edge of a child's face. Photoshop Elements includes several shape tools that make it easy to turn your images into hearts, clovers, and even punctuation marks—fun elements for any design. And remember, you can use these techniques for other designs, as well.

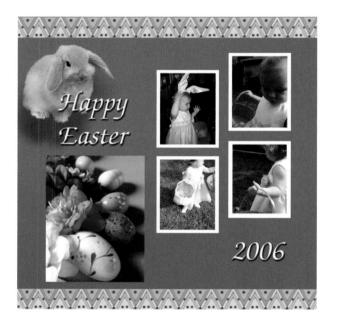

I FOUND IT!

Tightly cropped images, bright colors, and just a few words get the message across in this Easter design. Download the template called Easter.tif from www.digitalfamily.com to easily customize this scrapbook page using Photoshop Elements or another image-editing program that supports layers. (Photos by Ed Philbrick.)

Tip

Don't throw out a photo just because you didn't get everything in the frame. A collection of tightly cropped images like the ones featured in this first design can help create a feeling of motion and energy.

CROP IT TIGHT

The extreme cropping of the photos used in this design helps create the feeling that this child was in constant motion as she hunted for Easter eggs. This design is made for vertical images, but using the tight cropping featured here you can easily cut a vertical image out of a horizontal one.

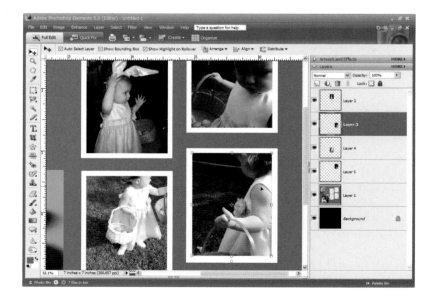

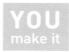

Flower Power Card

The three little girls featured in this design have such beautiful faces they seem to belong in this flower design. Their father, Stephen Perrotta, has a talent for capturing their smiles, and Photoshop made it easy to bring the design together. You can create many different shapes with images in Photoshop Elements and combine them to create your own photo flowers or other designs.

At a Glance

Software: Photoshop Elements
Template: Download the template called Easter-Flower.tif from www.digitalfamily.com or create your own design using the Shape tool, as explained in the steps below.
Size: 8 by 10 inches
Font: Tempus Sans
Image Tips: Look for photos that you can crop into flower petal shapes without losing the most important elements of the image. Close-ups of a child's face, like the ones shown here, work well.

EASTER GREETINGS
You can create designs like this one in Photoshop Elements by using the Shape tool to crop images into shapes and then rotating layers to adjust the position of each image. (Photos by Stephen Perrotta.)

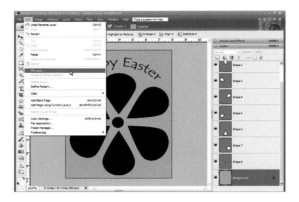

1. Open Photoshop Elements or another image-editing program that supports layers and select File>Open to open the Easter-Flower.tif template.

You can alter the background and other colors in this or any other template design. First click on the color well at the bottom of the Tools palette. Look for two small squares: The top one represents the Foreground color well and the bottom one, the Background color well.

When you click on either the Foreground or Background color well, the Color Picker opens. Choose a color by clicking on the corresponding area in the Color Picker. In this example, I've clicked on the top color well, which corresponds to the Foreground color to select yellow. Switching back and forth between the two color wells makes it easy to have two different colors available as you work on a design.

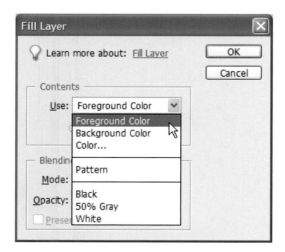

3. In the Fill Layer dialog box, choose a color option. In this example, I've chosen the Foreground color from the Contents drop-down list to apply the color I specified with the Color Picker in step 1.

2. To change the background color of an image, choose the color you want from the color well and then choose the layer that represents the image background in the Layers palette at the right of the screen. (You can tell the Background layer is selected in this example because it is shaded.) Choose Edit>Fill Layer.

Note:
Changing the colors in this template is optional, but the next few steps will teach you a few things about how colors work in Photoshop Elements.

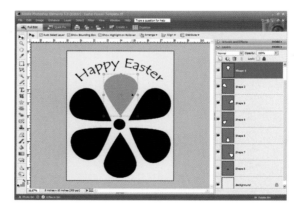

4. To change the color of other elements in the design, such as the flower petals, first select a color from the color well, as described in step 1.

Select the element you want to change in the image. In this example, I selected the petal at the top of the design.

Choose Edit>Fill Layer and specify the color you want to use. I've chosen the Background color that I specified in the Background color well. Look closely at the lower left-hand corner to see the Background color well.

Click OK to apply the color to the selected element. Repeat this step to change the color of the other petals.

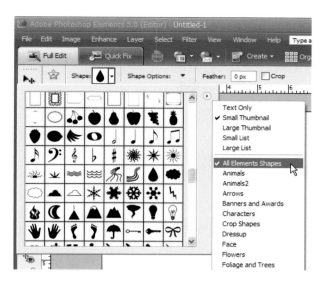

5. Open the first photo you want to add to this design (File>Open) and select the Shape tool from the Tools palette.

From the Shape tool Options bar, which appears at the top of the screen, choose the shape you want to use. Notice that you can add more shapes by choosing from the drop-down list that appears when you click on the small arrow in the top right-hand corner of the Options bar. In this example, I selected a flower-petal shape.

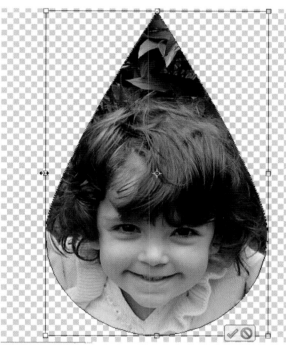

6. Click and drag over the image where you want to create the shape. Once you've created the shape, you can click in the middle of it with the Move tool and drag to adjust the positioning. To resize the shape, click on any corner of the shape area and drag.

When you have the shape the way you want it, double-click in the middle of the image to complete the crop of the image.

7. Finally, you'll want to copy the cropped image into the template design. First, select the Move tool at the top of the Toolbox and then choose Select>All and then Edit>Copy. Switch to the template design and choose Edit>Paste.

If the photo appears behind the colored petals when you paste it into the template, right-click on the image and choose Bring to Front so it appears on top.

Tip

Use the Photo Bin at the bottom of the work area to easily switch between images. Just click on the thumbnail of any open image to make it active in Photoshop. If the Photo Bin is not open, click on the arrow at the bottom of the work area to open it.

8. Click in the center of the photo you pasted into the template and drag until you have it lined up with a petal. Click and drag on any of the edges if you need to resize the image.

To rotate an image you're pasting into an angled petal shape, move your cursor over any corner of the image and then move it just a little way away from the corner until a curved double arrow appears. Click on the arrow and drag to rotate the image.

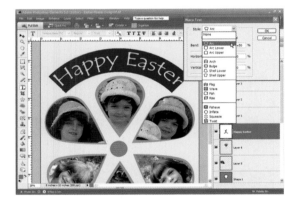

9. Repeat the previous steps to continue cropping photos with the Shape tool and copying and pasting them into the template until you have added all the images you want to the design and positioned them the way you want them.

To edit the text, choose the Text tool from the Tools palette, select the text, and use the editing tools in the Options bar at the top of the workspace to specify the font, size, color, and other elements. In the template, the text is already in an arc, but you can change the settings to any design you want with this feature.

When your design is complete, save the file. You can then print it and add it to a scrapbook, upload it to a website, or send it to someone via e-mail. (You'll find tips for sharing your designs in Chapter 1.)

Rotating Images

You can rotate the shape area before you crop a photo to create a cropped image aligned in any direction. This helps make sure your subjects look their best when you add them to the template (so you don't end up with anyone's face upside down, for example). Just click outside any corner to reveal the Curve tool. You'll know you've selected the right tool because a curve with an arrow will appear. Just click and drag and you can rotate the image to any point along a full circle.

If you're not happy with the way you cropped an image after you paste it into the template, you can redo it. Just select the layer with the image you pasted and press the Delete key to remove it. Then go back to the original photo and choose File>Undo to undo the crop so you can crop it again.

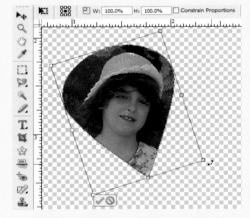

ROTATE A LITTLE OR A LOT
Rotating images will help them fit into the shapes you choose and make your designs more interesting and dynamic.

The best card for Mom is the one with photos of her favorite little ones. Here are a few designs for cards you can easily create from templates. You can also give Mom a gift that lets her take her favorite photos to the office in the form of a custom mouse pad or coffee cup. Gifts that feature photos are great for all your family members, but especially Mom on her special day, and they are so easy to create online.

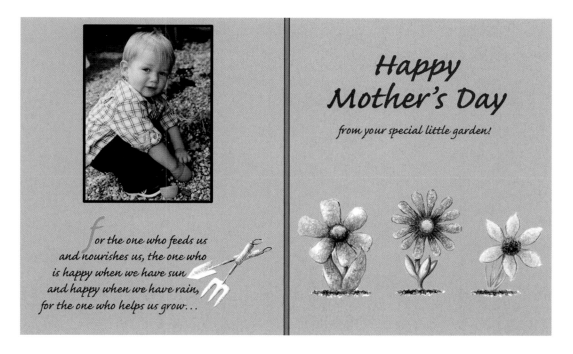

FOR ALL THE FLOWERS YOU'VE TENDED
You can easily add your own photos and text to this colorful design. Just download the template called Mom-Garden.tif from www.digitalfamily.com. (Design by Tom McCain; photo by Barbara Driscoll.)

FRAME THE PHOTOS
Here's a quick Photoshop tip: If you want to add a frame around a photo you've copied into a card, select the layer with the photo and then choose Edit>Stroke. Specify the color and the thickness of the stroke you want to appear around the image and click OK to get a nice border like the one shown here.

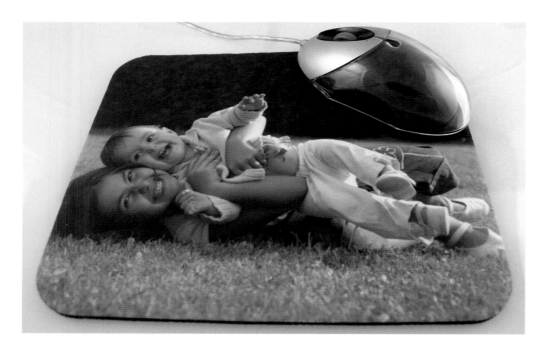

A GIFT SHE CAN SHOW OFF AT THE OFFICE

Keep your favorite photos close at hand with a custom mouse pad. Many websites that make custom mouse pads require you to buy large quantities, but you can order just one at www.snapfish.com, www.photoworks.com, www.personalcreations.com, or www.cmphotocenter.com (part of the Creative Memories company). Most services offer standard 8- by 7-inch mouse pads, but some allow you to order mouse pads in different shapes and sizes. (Photo by Ismael Nafria.)

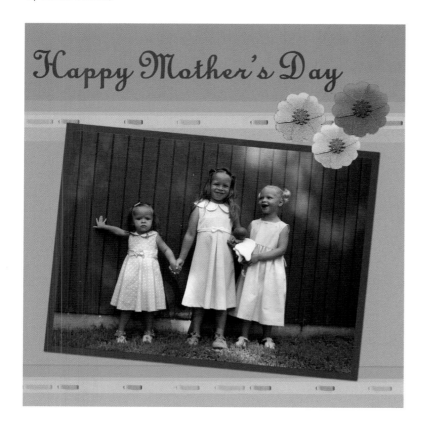

WE LOVE YOU, MOM!

Here's a Mother's Day design that was created by altering one of the page layouts in Photoshop Elements. You can find inspiration and get a great head start from the templates and designs included with programs such as Photoshop. Just click on the Create button at the top of the work-space to open the template designs, and remember, you can change the colors, move photos around, and copy and paste to repeat elements such as the stripe across the top and bottom of this design. (Photo by Stephanie Kjos-Warner.)

 YOU make it

A Mother's Day Gift You Can Frame

This is a great design that Dad can help create for Mom, or a grandparent can make with the kids' involvement. Let your children choose the photos, and use their words and ideas to make the message even more meaningful. Pull up a second chair at the computer and let your little one sit with you while you work on the design (just don't let anyone spill hot chocolate on the keyboard). This design is relatively easy if you use the template I've created for you. You can print it on one 8½- by 11-inch sheet of paper and either leave it as one piece or crop it into two images and then frame it for a more finished look (and a great gift that will look good on Mom's desk or bookshelf).

At a Glance

Software: Photoshop Elements

Template: framed-award.tif or framed-award.doc (available at DigitalFamily.com)

Size: Fits on a letter-size page (8½ by 11 inches); size can be adjusted to fit frame).

Font: Occidental

Image Tips: You can change the sizes of the images to suit your taste and use more images if you prefer. For example, if there are three children in your family, you could insert three images in the left side of this design, but you should make them smaller.

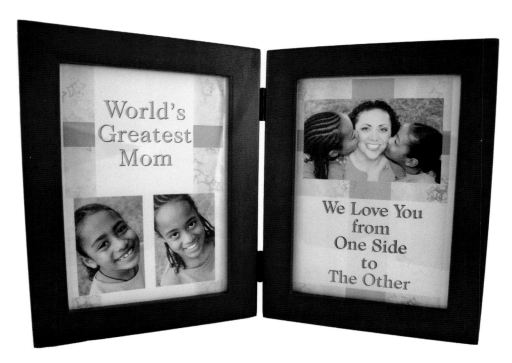

BEST MOM AWARD
Make it easy for Mom to show off her gift by framing it after you print it. (Design by Davi Cheng.)

1. Download the template called framed-award.tif at www.digitalfamily.com. Open Photoshop Elements or another image-editing program that supports layers and then choose File > Open to open the template.

If the Layers palette is not already open, choose Window > Layers to open it.

2. To change the text, click on the layer labeled "World's Greatest Mom" to select it. Then select the Text tool in the Tools palette, and click and drag to select the text you want to change.

Type new words to change the text or use the Options bar at the top of the screen to change the font, color, or size of the text. In this example, I'm changing the color by clicking on the Color Picker at the top of the screen and then selecting the new color.

Tip

The text in this design has a dark background, called a drop shadow, created by a copy of the same text. If you change one layer of text, you'll need to select the other layer and change it to match. If you prefer, you can delete the second layer and remove the dark background by clicking on the eye icon to the left of the layer.

3. To add your own images to this design, select the Move tool at the top of the Tools palette and then choose File > Open. Select the image you want to add and click the Open button. Choose Image > Resize > Image Size to open the Image Size dialog box.

For best results with this design, set the two small vertical images in the left side of the design to 2.3 inches wide and the larger horizontal image on the right side to 5 inches wide.

4. If you want to frame this design, you can resize the entire image to fit in the frame by selecting Image > Resize > Image Size and changing the width and height percentages under Document Size. For example, to get this design to fit into the 5- by 6-inch double frame shown at the beginning of the project, I reduced the image by 80 percent and then cut the design down the middle so both pieces would fit in the frame. You should adjust the size based on the size of your frame.

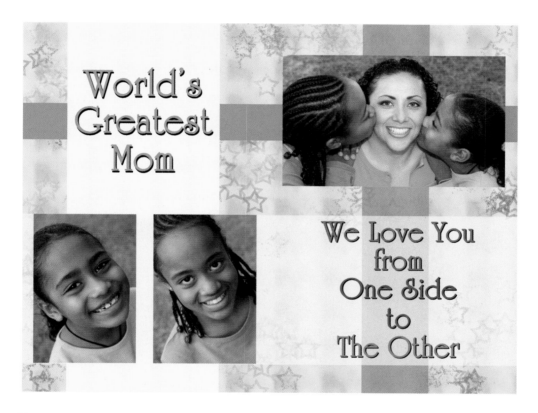

5. Save the file and print your award design. You can print this design on a standard 8½- by 11-inch piece of paper or reduce it to fit in a frame as described in step 4.

The Perfect Card for the Perfect Gift

Make all your loved ones feel special with the personalized Mother's Day gifts, the loving Valentine's Day designs, and the customized family cookbook featured in this chapter. And don't stop there. You'll find many more great design ideas and projects as you read on. Remember, you can mix and match these templates and design tips to create your own unique digital memories for any occasion.

Happy

4th of July

We went to see the Capitol this year!

Trey was impressed by the big white building and all the monuments.

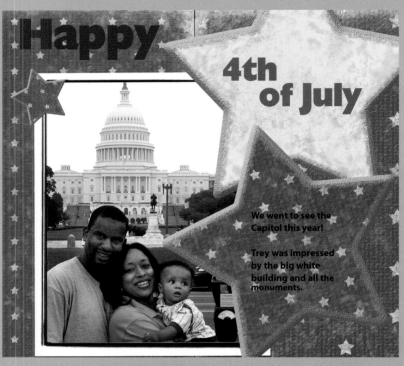

Breakfast with Daddy

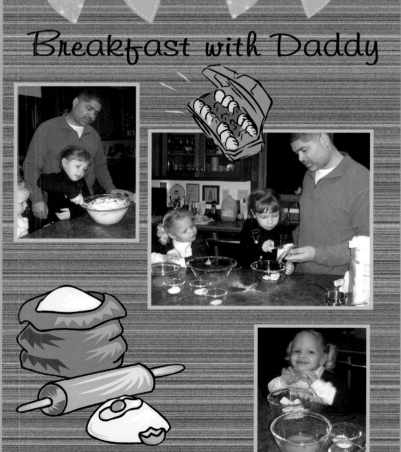

For the man who puts BOUNCE in our lives...

4

Summer Holidays:
Fun in the Sun

Celebrate the longer, warmer days of summer, and the carefree holidays that go with them, with fun designs and projects. In these pages you'll find step-by-step instructions for working with images in Photoshop Elements and editing templates in Broderbund's Scrapbook Designer. No matter what projects you'd like to create, the tips and tricks featured here can help you take your designs to the next level. In this chapter, you'll discover:

- **Photo tips for taking great family pictures**

- **How to create an online photo gallery you can share with the whole family**

- **Colorful designs to celebrate the Fourth of July**

- **Awards and brag books for Father's Day that Dad will cherish**

Bright colors and rich textures help make these summer designs so real you can almost feel the warmth of the sun.

Taking Bright, Beautiful Summer Photos

Summer is one of my favorite seasons for taking pictures because the longer days give you more opportunities for outdoor photography. Here are a few photo tips for taking family pictures that go beyond the basic "say cheese" pose.

Turn 'em Around

Although I don't usually recommend photographing the back of someone's head, you can add visual interest to your pictures and make your designs more interesting if you turn your subjects around once in a while.

ARMS AROUND YOU
They may have adorable faces, but the flop of a hat from behind and the sight of one's arm around the other make these little ones extra cute, even when they're not looking at the camera.

CAN YOU SEE ACROSS?
Although my sister-in-law took many photos of her daughter's faces on their summer vacation, this shot of the three looking out over the water is one of her favorites.
(Photo by Stephanie Kjos-Warner.)

Get 'em All Together

Whenever families gather, they always seem obliged to take a group photo of everyone in one place—especially one of all the grandkids. But that doesn't mean you have to line them up in the same old pose every time. Look for unusual places and ways to pose your little ones together and you'll end up with a more interesting collection of images.

HOLD STILL
When you gather a bunch of youngsters, ask some to sit and others to stand, and get the older kids to hold the little ones (if they can). (Photo by Stephanie Kjos-Warner.)

IN THE SWING OF THINGS
This swing was just big enough for all the young ones to share. (Photo by Stephanie Kjos-Warner.)

Family Fun on the Fourth of July

The Fourth of July is one of the few holidays unique to the United States. For this commemoration of the signing of the Declaration of Independence, most people watch fireworks, eat hot dogs and hamburgers, and wear red, white, and blue.

Of course, many other nations also have similar celebrations, such as Mexico's celebration of independence from Spain on September 16th and France's July 14th—better known as Bastille Day. The online photo album, digital scrapbook pages, and gifts featured in this section are specific to the Fourth of July holiday, but like all of the designs in this book, you can easily alter them, change their colors, and edit their text to commemorate any holiday or Independence Day celebration.

Show Patriotic Colors Wherever You Go

These days, if you can iron it, you can add a photo to it, and there are many online services that offer customized clothing, including Zazzle.com, KodakGallery.com, and PersonalCreations.com.

At most office supply and craft stores, you can buy special papers that you run through your ink-jet or laser printer to print an image and iron on your clothing at home. There are also photo papers that have silk or cotton cloth attached to them, allowing you to sew your designs to quilts, curtains, and even cloth furniture.

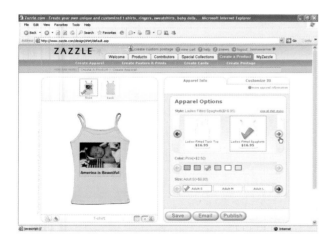

CREATE YOUR OWN DESIGNS ONLINE
Websites such as Zazzle.com, shown here, make it easy to add your own images to a wide variety of T-shirts, tank tops, sweatshirts, and more.

WEAR YOUR HEART ON YOUR SLEEVE
You can create your own custom clothes at home by using iron-on photo papers. (Photo by Mary Bortemas.)

YOU make it

Online Photo Album

The fun family activities associated with the Fourth of July—from parades, to picnics, to fireworks displays—make it a perfect time to capture great photos. Kodak's online photo site at www.kodakgallery.com makes it easy to upload images for free and to share your photo album with friends and family. Like other photo sites, KodakGallery.com makes money by charging for prints and personalized products such as coffee cups and ornaments. It might not surprise you that one of KodakGallery.com's claims to fame is the archival quality of their prints, which means your printed photos will look good for years to come.

KodakGallery.com offers basic image-editing and cropping tools so you can clean up your prints online if you don't have your own photo-editing software. You can send access information to anyone you want to be able to view your pictures online and create and order prints, calendars, photo books, and more, personalized with your pictures. Follow these steps to see how easy it is to use Kodak Gallery.

At a Glance

Online Service: Kodak.Gallery.com
Image Tips: Organizing your photos in individual galleries makes it easier to showcase collections.

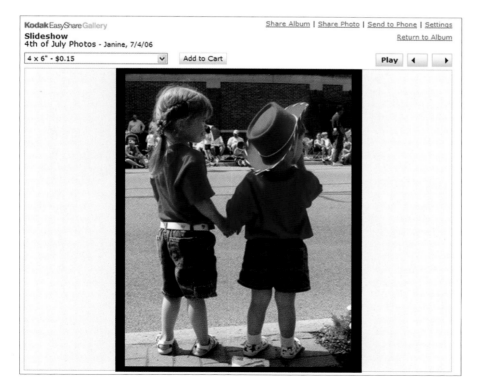

LOOK, I'M ONLINE!
Once you've uploaded and edited your photos, you and all your friends and family can log in and play the slideshow through a Web browser. (Photo by Stephanie Kjos-Warner.)

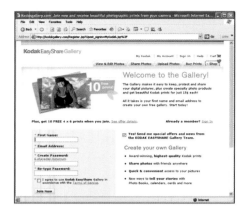

1. Open a Web browser, such as Safari or Internet Explorer, and enter the address www.kodakgallery.com to access the website.

Fill out KodakGallery.com's short registration form to set up a free account or log in if you're already a member.

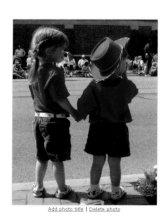

Tip

This may be a good time to go get a cup of coffee. If you've selected more than a few photos or if they are large, high-resolution images, the uploading can take a while.

2. Click the Upload Photos tab at the top of the page and click one of the Browse buttons. Alternatively, you can choose to install a special drag-and-drop tool to upload your images by just clicking the Easy Upload button. (Note: If this link is not visible when you visit the site, you may not be using a computer that is compatible with this special upload feature and will have to use the process described here.)

In the Choose File dialog box, find a picture on your computer you want to include in your online album and then click Open to select it. Repeat this step until you've selected all the photos you want to upload to the site. Click Continue to upload your pictures.

3. Once the pictures are uploaded, you can click on the Options button to edit your images, add captions, and more. In this example, I chose the Edit & Borders option. (Keep in mind that you can also edit your images in a program such as Photoshop Elements first, which will give you more control.)

4. Use the Rotate buttons to change the orientation of an image. You can rotate your images to the left or right, crop them, flip them, fix red-eye, or choose the Instant Fix button, which makes many automatic adjustments.

At the bottom of the picture in this dialog box, you can click on the Add Photo Title link to add a caption to your image.

5. Click to place your cursor in the Title box and then type your text. When the text is ready, click Save.

7. If you're not finding an image you're sure you already uploaded, it may be in a different album. To access other albums, choose the View & Edit Photos tab at the top of the screen and then select the album you want to work on.

9. Gather the e-mail addresses of people you want to view your online photo gallery and list them in the To box. You can also personalize the subject line and body of the e-mail message they will receive.

If you want to invite people to view more of your photo albums, click the Add More Photos or Albums link at the bottom of the You Are Sharing area on the right side of the screen to select more albums.

You have the option of requiring people to sign in to view your photos. If you uncheck this small box at the bottom of the message area, you will disable this option. However, KodakGallery.com recommends you keep track of everyone who views your images.

When you're ready, click the Send Invitation button to automatically send an e-mail message with a link to the photo albums you selected.

6. Use the Forward and Back arrows at the top of the screen to move through the images in your photo album and repeat the previous steps to edit or add captions to other images you've uploaded.

8. As soon as your pictures are uploaded, they become available to anyone you want to invite to view them. Choose the Share Photos tab at the top of the screen.

Click the Select Album button next to the albums you want to share and then click the Continue button.

Stars & Stripes Scrapbook Page

This digital scrapbook design was created with Scrapbook Designer by Broderbund. A strong competitor to the best-selling scrapbooking program Scrapbook Factory Deluxe (featured elsewhere in this book), Scrapbook Designer provides a wide range of templates, images, and fonts you can use to easily personalize predesigned scrapbook pages or to create completely new designs from scratch.

At a Glance

Software: Scrapbook Designer
Template: Scrapbook Designer's Celebrating Together template from the Fourth of July category
Size: Fits on a letter-size page (8½ by 11 inches)
Fonts: CK Cursive and Calibri
Image Tips: You can add more images to any template in Scrapbook Designer and resize, crop, and make other edits with the program's built-in editing tools.

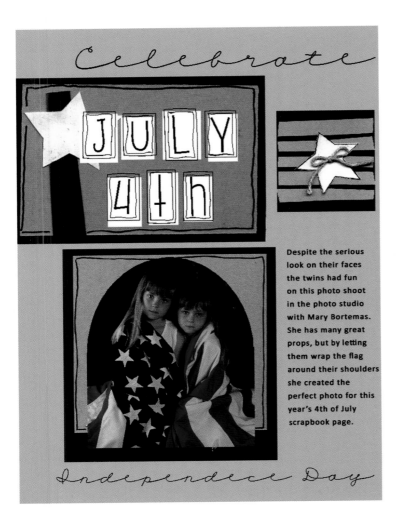

Despite the serious look on their faces the twins had fun on this photo shoot in the photo studio with Mary Bortemas. She has many great props, but by letting them wrap the flag around their shoulders she created the perfect photo for this year's 4th of July scrapbook page.

WE LOVE THE FLAG

This scrapbook page was saved as a PDF (Adobe's Portable Document Format). If you want to attach the design to an e-mail message or add it to a website, saving it as a PDF means that the design will not be altered when it is sent over the Internet or printed. (Photo by Mary Bortemas.)

Tip

Although the step-by-step instructions in this project are specific to Scrapbook Designer, you'll find that Scrapbook Factory Deluxe and Scrapbook Max (featured in Chapter 7) works similarly and you can apply the same tips and tricks.

1. Launch Scrapbook Designer and choose Customize a Ready-Made Scrapbook Page to use one of the predesigned templates. Note that several other options are available as well, such as Explore Other Ready-Made Projects, which includes designs for cards, gift tags, stickers, and even family trees.

2. Double-click on a project category folder to open it and then click on the folder for any of the subcategories. In this example, I chose the Holiday category and then the Fourth of July subcategory.

Scroll through the thumbnails and double-click to choose a design, such as the Celebrating Together design I've selected here.

3. Double-click on any placeholder image to add or change images in the template. In the Art Gallery dialog box that appears, choose any of the artwork or images included in Scrapbook Designer or choose File>Open from Disk and then browse your hard drive to find the photo you want to add to the design.

4. Scrapbook Designer includes basic photo-editing tools you can use to crop images and add special effects, borders, and more. To use these tools, first click on the image you want to edit.

Then, click on the small arrow next to Photo Tools in the list on the left side of the work area and choose one of the photo-editing options. The Photo Workshop option opens a dialog box that features many of the photo-editing tools in one window.

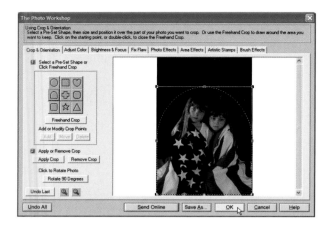

5. Click on the tabs along the top of the Photo Workshop dialog box to reveal the different editing options.

To use an editing option, select the feature you want to apply. In this example, I'm using the arched cropping tool.

6. To add or change any of the graphics or other elements in these page designs, double-click on the image to open its corresponding dialog box. In this example, I've selected the Americana Bow. You can easily replace any element like this simply by clicking to select another graphic and then clicking OK.

To add or change text, double-click on any text area to open the text editor.

7. Once you've completed the design, you can save it in a wide variety of formats. Choose File>Save as PDF to save it as a Portable Document Format, which is a good choice if you plan to e-mail the design as an attachment. You can also choose File>Export As and choose from several image formats, including JPEG and TIFF.

 YOU make it

Independence Day Card

This patriotic card features a family photo accented with red, white, and blue stars. The star embellishments and the red and blue background are from a Digital Scrapbook Memories CD. If you're looking for well-designed background images, textures, and other embellishments for your digital scrapbook pages, greeting cards, and other designs, consider purchasing one of their many CDs. Carefully designed with the avid scrapbooker in mind, these CDs are packed with goodies and feature themed collections such as the Holiday designs shown here. This is an example of what's possible when you combine the graphics from the Digital Scrapbook Memories Seasons and Holidays CD with Photoshop Elements.

At a Glance

Software: Photoshop Elements
Template: The background and stars in this design came from the Digital Scrapbook Memories Seasons and Holidays CD.
Size: 8 by 7 inches
Font: Herald
Image Tips: You can combine any photos with the graphics on Scrapbook Memories CDs and you can create fun effects like the stars overlapping the edges of the photo in this design.

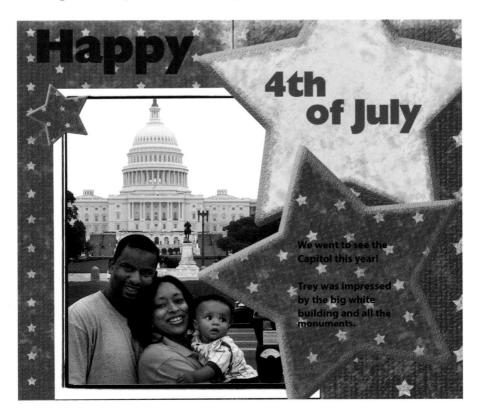

A CAPITOL IDEA
Show off your favorite photos against textured papers and other embellishments from Digital Scrapbook Memories.

1. Open the graphics you want to use from the Scrapbook Memories CD and choose Select > All and then Edit>Copy. Open or create a new file in Photoshop Elements (File>Open or File>New) and choose Edit>Paste. Finally, select the background paper and drag it into position. In this example, I copied two background images and dragged them into place until each one covered half of the design area.

2. To add embellishments, like these stars, select the Marquee tool from the Toolbox, click and drag to select the image you want, and select Edit > Copy.

Switch to the new Photoshop file you created and choose Edit>Paste. Again, you can click in the center of an embellishment and drag to position it or click on any corner and drag to resize the image.

3. To view or change the order of images in Photoshop Elements, use the Layers palette on the right side of the screen (choose Window>Layers to open it).

To change the stacking order so that one image, such as this red star, overlaps another image, such as this photo, select the layer in the Layers palette that corresponds to the image you want to appear on top and drag the layer until it appears higher on the list.

Note

One of the advantages of Digital Scrapbook Memories CDs is that the patterned papers, alphabet sets, icons, and other graphics will work with any image-editing program that supports the PNG format (which is most programs, including Adobe Photoshop Elements, Ulead PhotoImpact, or CorelDRAW). You can also use these wonderful graphics with digital scrapbooking programs such as Scrapbook Factory Deluxe and Scrapbook Designer.

Celebrate your dad with brag books, awards, and personal Father's Day cards he will cherish for years. This section is dedicated to projects designed to show Dad how much you care and to give him a chance to show off your best photos in beautifully designed packages.

The designs in this section were created with Photoshop Elements, and in these projects you'll find step-by-step instructions that will help you work with an image editor, no matter what kind of project you want to create.

Don't forget, you can alter this design to create an award or brag book for Mother's Day or any other special occasion.

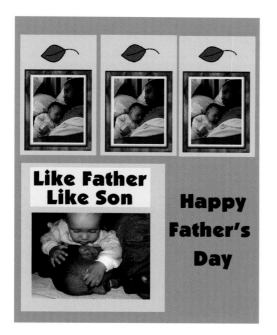

HEY, SLEEPYHEAD

Here's an example of how repeating the same image (in this case, the sleepy father and son across the top of this design) creates great impact. (See the Father's Day card project on page 115 for instructions on duplicating photos.) This is also an example of how you can combine the strengths of two programs. This design was created from a template called Leaves that I edited in Scrapbook Designer, changing the size of the main image and the frames around the images at the top. After I finished the design in Scrapbook Designer, I made a few more edits in Photoshop Elements to get it just the way I wanted it. (Photos by Anissa Thompson.)

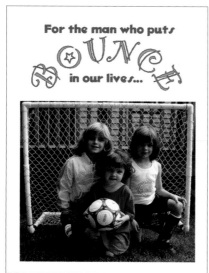

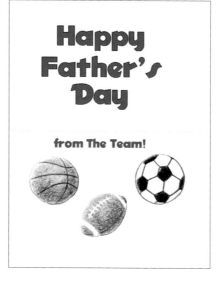

FOR THE SPORTY DAD

This card design is included as a template at www.digitalfamily.com. Just download sporty-dad.tif, add your images, edit the text as you see fit, and it's ready to share with your favorite sport. (Photos by Stephen Perrotta.)

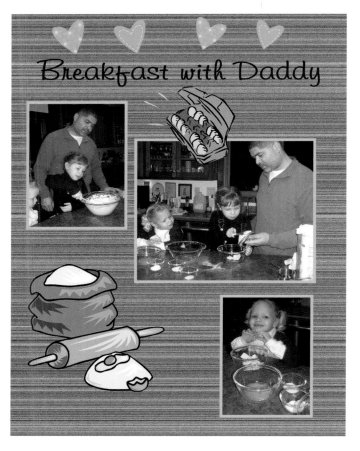

SOME DADS ARE GREAT COOKS, TOO

My oldest brother, Kevin, is a great cook who loves to spend hours in the kitchen. With three small children in the house, he's rarely in the kitchen by himself anymore, so I made sure to include photos of him with his crew of assistants in this cookbook design I created with Scrapbook Factory Deluxe (using the template called Cooking from the Food category. Because his daughters are still very young and because I know they are among his biggest fans, I chose a design I thought they would enjoy, too. (Photos by Stephanie Kjos-Warner.)

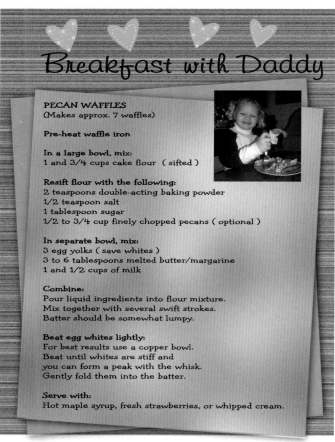

YUMMY!

Sometimes the best photo for a cookbook is a snapshot of a satisfied customer. (Photos by Stephanie Kjos-Warner.)

World's Best Dad Certificate

When my friend Tait turned thirteen, he decided his father had worked hard enough to earn a certificate for being the #1 father in the world. The certificate Tait designed congratulates his father on his thirteen years of fatherhood and states that receiving this certificate is "better than being awarded the Grammy." I'm sure Tait is right: His father, Paul, wouldn't have been as happy with a Grammy or an Academy Award. Remember, you can easily replace the words in this template and even change the colors if you want to alter this design to create an award for your mom or any special someone.

At a Glance

Software: Photoshop Elements
Template: Use the template called parchment.tif available at DigitalFamily.com
Size: 8½ by 11 inches
Font: Vivaldi
Image Tips: Using a textured background, such as the one featured in this design, makes it look like the certificate is printed on parchment paper.

BEST DAD OF THE YEAR
The textured background behind this design makes it look as though you printed this certificate on parchment paper.

Congratulations

This certificate goes to the #1 father in the world. We would like to congratulate you on your wonderful thirteenth year of being a father.

This certificate award goes to Paul Viskovich

This is a very special award for the Best Father of 2005 and, yes, it is better than being awarded the Grammy. Besides, this one you can hang on your wall and even frame.

Awarded by Tait Viskovich

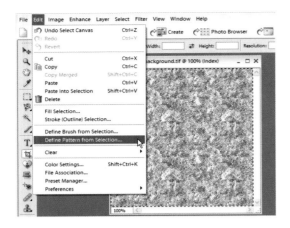

1. Download a textured image, such as parchment.tif, at www.digitalfamily.com. Open Photoshop Elements or another image-editing program that supports layers and that has the Overlay option for filling in color.

Choose File > Open and open the textured image. It is a 1- by 1-inch square with a pattern that can be repeated to fill any background size.

With the image file open, select the Move tool. Choose Select > All and then choose Edit > Define Pattern from Selection.

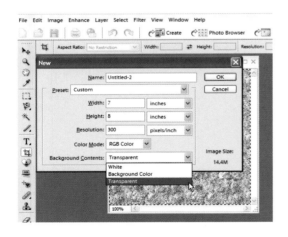

3. Choose File > New > Blank File, and in the New dialog box, enter the size and resolution you want. In this example, I'm creating a page that is 7 inches wide by 8 inches in height, but you can create a file that's any size for this project. (If you're going to print this design at home, set it to 150 or 300 dpi if you want a higher-quality print.) Set the color mode to RGB and the background to Transparent.

Tip
If you make your certificate 8½ by 7 inches, it will fit in the Father's Day brag book from page 110.

Textured Backgrounds Look like Expensive Papers

Background images and textures add impact to your designs and can make them look more professional. To help make it easy for you, I've included the background image for this design in the collection of templates for this book at www.digitalfamily.com. Using the instructions in this project, you can change the color of this or any other background by adding a color overlay—a cool trick that changes the color without losing the texture of the image.

2. In the Pattern Name dialog box that appears, enter a name. In this example, I'm calling this parchment-background-blue.tif because I'm going to give it a blue color. (What you type here will be the name of your pattern, so remember what you call it.)

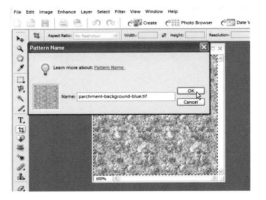

4. Choose Edit > Fill Layer. In the Fill Layer dialog box, choose Pattern from the Contents pull-down menu, and then select your new custom pattern from the pull-down palette below it.

Click OK and the parchment pattern will repeat to fill the entire area of the new image.

5. Next, you're going to choose the color you want. Click to choose the Foreground color well at the bottom of the Toolbox.

In the Color Picker dialog box, select the color you want. (I've chosen a blue color for this example.)

Click OK, and the color you selected will fill the small color well in the Toolbox.

6. Now you're going to fill the new page with the color you selected, but you're going to do it with an Overlay so the texture of the parchment will still be visible. First, choose Edit > Fill Layer.

In the Fill Layer dialog box, choose Foreground Color from the Contents pull-down menu. From the Mode pull-down menu, choose Overlay. Click OK, and the color will fill the image, with the parchment pattern still visible.

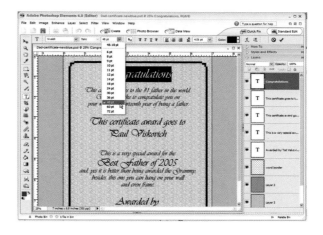

7. Now make sure you save your work. Choose File > Save. In the Save dialog box, give the file a name. I called my file parchment-background-blue.

From the Format pull-down menu, choose JPEG so you can insert this file into a Word document. In the JPEG Options dialog box that opens, set the Quality to Maximum and leave the other settings unchanged. Then click Save.

8. Now, still in the same file, choose File > Save As and call this file dad-certificate or some other name that will distinguish it from your background. (This makes it possible to reuse the background later for another project.) You can save the file in any format you prefer, such as JPEG, but TIFF is a good choice for printing.

Select the Text tool from the Toolbox and enter the text for your certificate, using the formatting tools in the Option bar at the top of the screen to specify the font, size, and color.

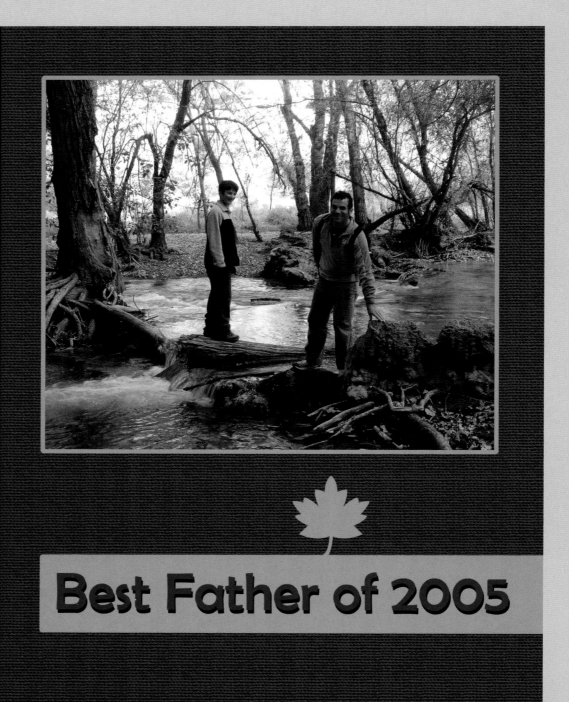

Best Father of 2005

YOU *CAN* JUDGE THIS BOOK BY ITS COVER
Featuring one big picture in this design creates a clean, dramatic cover.
(Design by Davi Cheng; photo by Adriana Kezar.)

 YOU make it

Father's Day Brag Book

Brag books, if you're not familiar with them, are scrapbooks that are usually rather small so they can be carried around easily and used for "bragging" about the photos that appear in their pages.

You can create a brag book of any size, but I've designed this one to fit on a legal-size sheet of paper (8½ by 14 inches) so that when it's printed and folded or cut in half, each page is nearly square and measures 8½ by 7 inches. If you don't have legal-size paper, you can print each page on a separate letter-size sheet and then cut the pages to fit your book.

At a Glance

Software: Photoshop Elements
Template: You'll find a collection of templates for this brag book at www.digitalfamily.com. Start with brag-book-cover.tif to create the cover. The page called "My Adventures with Dad" was created with the template called adventure-page.tif. (You can also use the template called adventure-page.doc to create the design in Microsoft Word.)
Size: 8½ by 7 inches (two pages fit on one legal-size piece of paper)
Font: Berlin Sans FB
Image Tips: Choose a variety of images that include the child and parent or grandparent. Mix close-ups with pictures taken from a distance to add interest to your pages.

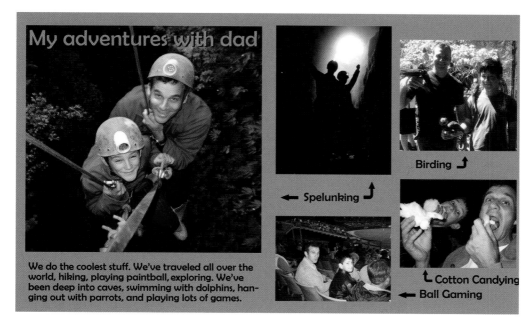

SPELUNKING WITH DAD!
This design features a collection of images with room for captions so you can show off lots of your favorite photos at once.

Create a Cover

This cover template is designed to create a clean design that will work well as a cover for a brag book. Because brag books are relatively small, you're generally better off using just one image on the cover. The textured background helps create the feeling of a book cover and creates a design with a more finished look

1. Download the template called brag-book-cover.tif from DigitalFamily.com. Open Photoshop Elements or another image-editing program that supports layers. Choose File>Open and select the template.

Choose Window>Layers to open the Layers palette. In the example here, you can see that the Layers palette is open, with many layers visible.

Working with Layers

Each layer in an image represents a different part of that image. Notice in the list of layers on the right that the layer for the tan-colored border that will go around your photo is called "Photo Border," and the words are on a separate layer called "Best Father of 2005." Because each element is on a separate layer, you can change them independently.

Layers are useful, for example, when text is on top of a photo and you want to edit it or move it to another place on the photo. Without layers, your typed text would be stuck on the photo, and you couldn't change it again without damaging the photo. With layers, you can select just the text and edit it independent of the photo.

2. To change the text, click on the layer labeled "Best Father of 2005" to select it.

Select the Text tool in the Toolbox, and then click and drag the text you want to change.

3. To add your own image to this design, click to select the Move tool at the top of the Toolbox and then choose File>Open. Select the image you want to add and click the Open button.

Now you need to make sure the image you want to add is the right size to fit in this design. Choose Image>Resize>Image Size to open the Image Size dialog box.

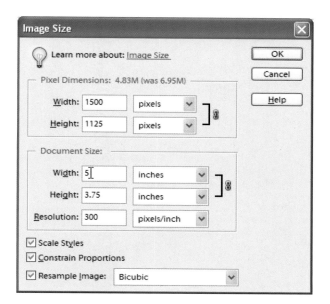

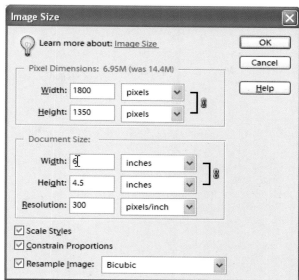

4. First you want to make sure the Resample Image box at the bottom of the dialog box is unchecked (if you see a check mark in it, click to uncheck it). Then set the Resolution to 300 pixels per inch (ppi). The image will change to match the resolution of this template so the image will fit properly after you resize it (next step). This template is set to 300 ppi so it will print a very high quality image. (See Chapter 2 for more on image size and resolution.) Before you change the physical size of the image, make sure the Resample Image box and the Scale Styles and Constrain Proportions boxes are checked.

5. In the Document Size area of the Image Size dialog box, change the width to 6 inches. If the height does not automatically change to 4.5 inches, you may need to crop the image to make it fit properly.

Tip
If the image doesn't fit exactly the way you want, you can click and drag on its bottom right corner to resize it.

6. With the image resized, copy it to the template. To do that, first make sure the Move tool is selected from the toolbar and then choose Select > All.

With the image selected, choose Edit > Copy. Then click your cursor to place it anywhere in the cover template image and choose Edit > Paste.

Click and drag the image to move it into the frame.

When you have your image in place and the text edited the way you want it, save the file. You're now ready to print your design to create the cover for your book.

Create the Interior Pages

Now you'll learn how to create an inside page that features multiple images for your Father's Day brag book. This page is designed to be cut or folded in half.

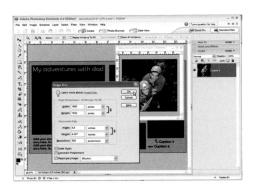

1. Download the template called adventure-page.tif from the Reader's Corner at www.digitalfamily.com. Open Photoshop Elements or another image-editing program that supports layers and choose File>Open to open the template. Choose Window>Layers to open the Layers palette.

2. To add your own image to this design, make sure the Move tool is selected from the Toolbox and then choose File>Open. Select the image you want to add and click the Open button.

Now make sure the image you want to add is the right size. Choose Image>Resize>Image Size to open the Image Size dialog box.

Make sure the Resample Image box at the bottom of the dialog box is unchecked. Set the resolution to 300 ppi.

Make sure the Resample Image box, the Scale Styles box, and the Constrain Proportions box are checked and change the width to 6.5 inches for the large image on this page or 3.25 for the smaller images. (You can use slightly different image sizes, but you may have to adjust the captions and other elements to make it all fit together.)

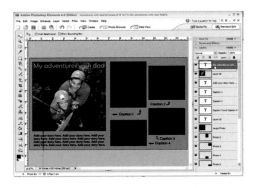

3. With the image resized, choose Select>All and then choose Edit>Copy.

Click your cursor to place the image anywhere in the template and choose Edit>Paste. When the new image appears in the template, click and drag it into place.

Notice in the previous screen that the words "My adventures with dad" disappeared when I moved this image into place. That's because the new layer was inserted on top of the layer that had the text. You can change the order of layers by clicking and dragging the layer in the Layers palette.

To place the words on top of the image, I clicked on the layer labeled "My adventures with dad" and dragged it up above the layer that represents the image I just inserted.

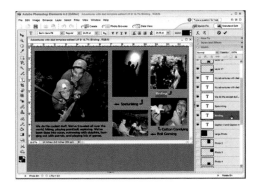

4. Repeat steps 2 and 3 to add all of your images.

To change the text, click on any of the layers that represent the captions. Select the Text tool in the Toolbox and then click and drag to select the text you want to change.

When your images and captions are all in place, save the file. The page is ready to be printed for your book.

Father's Day Card

One of the advantages of working with digital images is that you don't have to pay a photo-processing service to make multiple copies of the same image; you can copy a picture as many times as you like for free in a program such as Photoshop Elements. When you capture a great photo, such as this barrel full of girls, don't be afraid to make the most of it.

To create this design, I first cropped the photo into a circle. Then I duplicated it and rotated the small images around a bigger picture. The following Photoshop tips will help you create similar effects in your digital designs.

At a Glance

Software: Photoshop Elements
Size: 12 x 12 inches
Font: VAGRounded
Image Tips: As you are considering photos for this design, look for elements that suggest a shape or action.

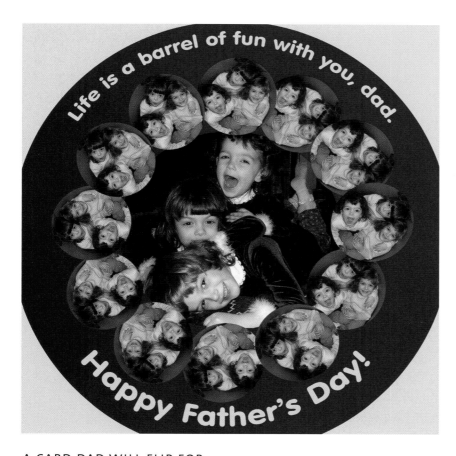

A CARD DAD WILL FLIP FOR
Roll me over, and over, and over. (Photos by Stephen Perrotta.)

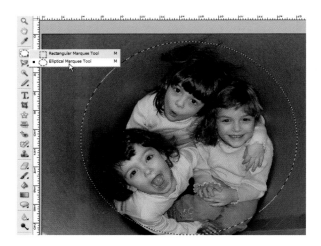

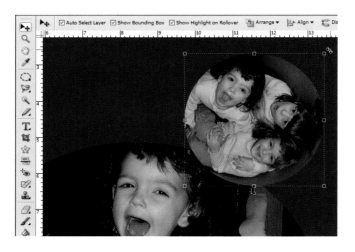

1. Open the photograph you want to work with in Photoshop Elements. Select the Elliptical Marquee tool from the toolbar. (Note: It shares the same icon space with the Rectangular Marquee tool. Just right-click on the small arrow at the bottom right of the icon to select the tool you want to use.)

With the Elliptical Marquee tool selected, click and drag over the image.

Tip:

To create a perfect circle, hold down the Shift key as you click and drag. To adjust the positioning of the circle, use the arrow keys on your keyboard. To start over, click anywhere on the image to cancel the Marquee and then click and drag again.

2. Once you have marked the circle where you want to crop the image, select the Move tool in the Toolbox. Choose Edit>Copy.

Choose File>New to create a new document. Specify the size and resolution. For this project, I created a file that was 12 by 12 inches and 300 ppi for high-resolution printing.

Choose Edit>Paste and click in the middle of the image and drag to position it. Then click just beyond a corner. When you see the curved double arrow shown in this figure, rotate the image.

In this example, I started with a blank file with a blue background and I copied in the image that is in the center by using the Elliptical Marquee tool to copy a round circle from the image and then pasted it into this new design.

3. To create more copies of the image, first open the Layers palette by choosing Window>Layers.

Select the layer that corresponds to the image and then right-click over that layer and choose Duplicate Layer to make a copy. Right-click and duplicate again to make another copy, repeating until you have as many copies as you want.

4. The duplicate layers will be stacked on top of each other and won't be visible in the design area until you click and drag (with the Move tool selected).

Continue to click and drag to position the duplicate copies where you want them.

5. Select the Type tool and type the text you want in the image. Use the formatting options in the Options bar at the top of the work area to specify font, size, and other options.

Use the Create Warped Text tool in the Options bar to bend the text. In the Warp Text dialog box, you can move the Bend slider, as well as the Horizontal and Vertical distortion sliders, to adjust the arc. Move the Horizontal Distortion slider to the far left to reverse the arc of the text as shown in this figure.

Cherish All Your Summer Memories

The projects in this chapter are designed to help you celebrate the joy of the Fourth of July, Father's Day, and all the beautiful summer moments you share with your friends and family. Holidays shouldn't be the only occasions you commemorate with a digital memory project or the only time you send a card. Summer is a great time to start special projects with the kids, share stories with grandparents, and create brag books and scrapbook designs for any occasion.

FOR ANY SUMMER OCCASION

When you just want to remember a beautiful summer day you spent with a friend, download this card template called friends.tif from DigitalFamily.com and use it with the photo featured here or customize it with one of your own. (Design by Jaime Luis Hernandez.)

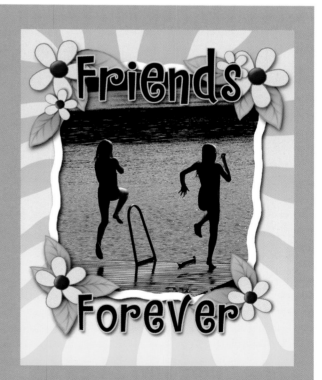

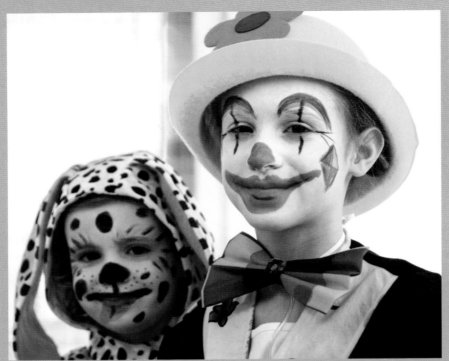

Happy Thanksgiving

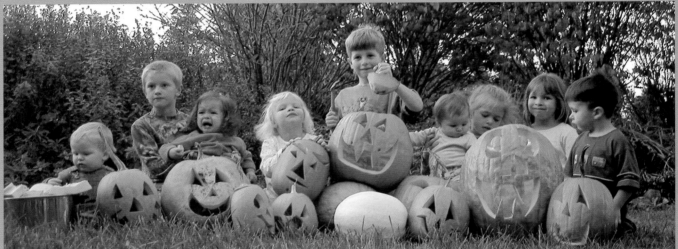

שנה טובה
Happy Rosh Hashanah

5

Fall Holidays:
Tricks & Treats for Everyone

From colorful leaves and fabulous costumes to well-decorated tables and times of deep reflection, fall brings a cornucopia of ways to celebrate the harvest and the changing of seasons. In this chapter, we'll get into more advanced techniques with Photoshop Elements and explore a few more tips for working with programs such as Scrapbook Factory Deluxe. You'll find projects and techniques to help you:

- **Honor Grandma and Grandpa with thoughtful cards and gifts**

- **Dress up your Halloween designs**

- **Cheer your favorite cooks with Thanksgiving scrapbook pages**

- **Commemorate Rosh Hashanah with beautiful cards**

Whether you want to create greeting cards, scrapbook pages, or anything else you can imagine, the advanced techniques in this chapter will help you create designs like a pro.

Capturing Fall Colors

Fall brings great photo opportunities, as well as reasons to celebrate with family and friends. Halloween is one of the most colorful holidays and you won't want to miss taking photos of your favorite ghosts and goblins in their costumes. Pumpkin carving and all the goo and mess that goes with it also make for a great chance to get candid photos. Here are a few suggestions to keep your pictures fun and lively throughout the fall.

BEFORE AND AFTER PUMPKINS
Here's a great idea for pumpkin-carving season, especially when you get a whole group of kids together like this.
(Photos by Stephanie Kjos-Warner.)

LEAVES PAST YOUR KNEES
A pile of leaves creates a fun place to play (and take a great photo). And you don't even need a very big pile to bury a little one like this up to the chin. (Photo by Stephen Perrotta.)

PAINTED FACES
Make sure to snap those Halloween photos as soon as they get their costumes on and makeup in place (and before they smear chocolate all over everything).

Share Your Love with Grandma and Grandpa

National Grandparents Day is a relatively new holiday in the United States. Marian McQuade of Fayette County, West Virginia, created the holiday with the goal of inspiring families to remember lonely grandparents in nursing homes and to honor their heritage. In 1978, President Jimmy Carter made National Grandparents Day official and proclaimed that it should be celebrated every year on the first Sunday after Labor Day. Get the little ones involved and you're sure to delight Grandma and Grandpa with these greeting card designs and customized photo gifts.

THE PERFECT PACKAGE

You can create a card and envelope at the same time when you choose from the Craft Card collections in the Card section of Scrapbook Factory Deluxe. Follow the instructions with the template to fold and glue the flaps in place.

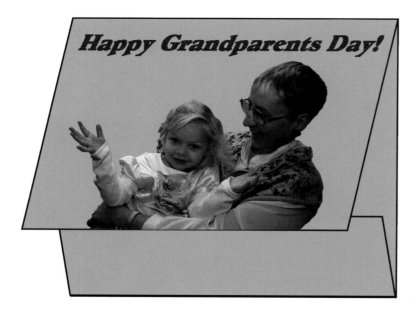

NO ENVELOPE NEEDED

This trifold design is easy to create in a program such as Photoshop Elements or even Microsoft Word, and you don't even need an envelope. The trick is to put the text and images toward the bottom of the page so you can fold it to create the back and bottom. Write a message inside or have your child draw a picture to illustrate it.

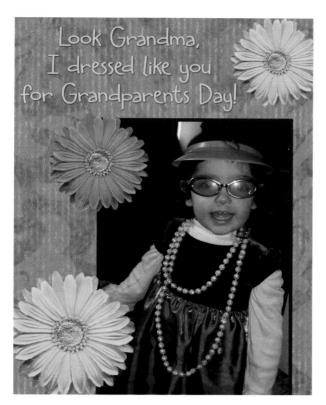

Look Grandma,
I dressed like you
for Grandparents Day!

JUST LIKE GRANDMA

Gina Perrotta's grandmother was quite amused to see this photo of her granddaughter playing dress-up in "grandma clothes." The three-dimensional flower icons add texture, and the drop shadow on the text helps keep the print readable against the blue background. (Photo by Stephen Perrotta.)

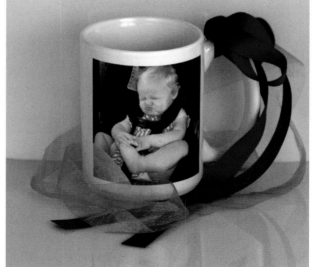

PUT A LITTLE LOVE IN THEIR CUP

A personalized coffee mug like this one reminds grand-parents how much you love them every time they reach for their favorite hot drink. You can order coffee cups and similar items at KodakGallery.com, PhotoWorks.com, PersonalCreations.com, and many other sites.

PLAY WITH ME

Order a deck of playing cards with your children's photo and you'll give their grandparents something special to show off at the next card game—and you might even bring them a little luck. Services that offer personalized playing cards include Shutterfly.com, KodakGallery.com, PersonalCreations.com, and TheHouseofCards.com.

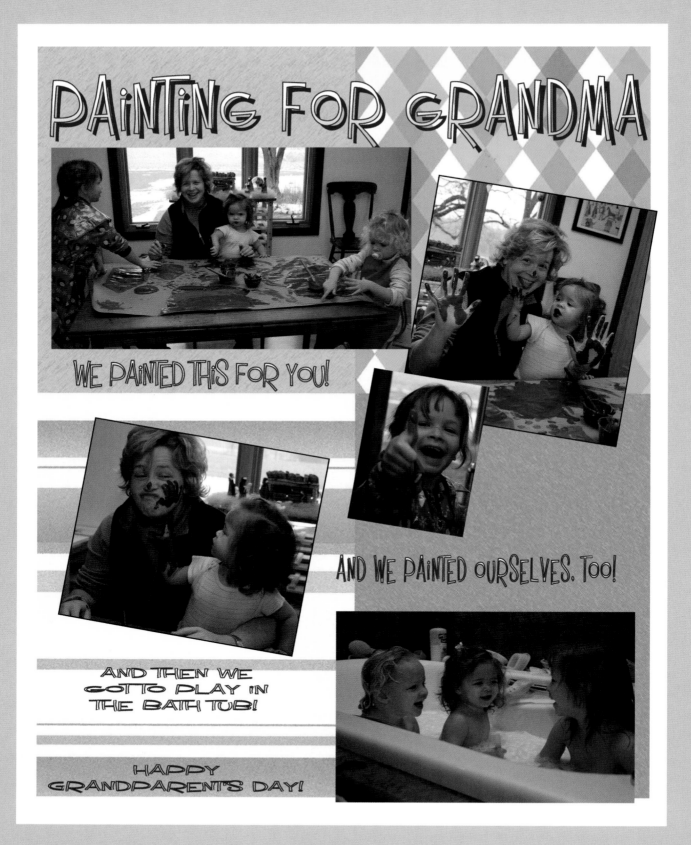

PAINTING FOR GRANDMA

WE PAINTED THIS FOR YOU!

AND WE PAINTED OURSELVES, TOO!

AND THEN WE GOT TO PLAY IN THE BATH TUB!

HAPPY GRANDPARENT'S DAY!

PUT YOUR LITTLE ARTISTS TO WORK
I think I had more fun photographing my nieces as they painted these pictures than they had with the finger paints (and the soap bubbles).

Grandparents Day Scrapbook Page

Involve the kids in your Grandparents Day creations and you're sure to come up with designs their grandparents will love. In this design, the original project of creating a painting for Grandma led to a fun-filled day and a collection of photos that turned into an even better gift.

For this design, I used a template from Scrapbook Factory Deluxe and edited it to create this unique layout. After choosing any template, you can add or remove photos, change the font size and style, and so much more.

At a Glance

Software: Scrapbook Factory Deluxe
Template: Block Designs from the Everyday collection in the Arts and Entertainment category
Size: Fits on a letter-size page (8½ by 11 inches).
Font: Mister Sirloin Rare (Note: There are thousands of fonts in the world, and some of them have really odd names.)
Image Tips: A collection of images like these that capture a series of events can help you tell a story in your scrapbook pages.

1. Launch Scrapbook Factory Deluxe and select Scrapbook to reveal the Choose a Project page, which features easy access to all of the templates and design elements for creating scrapbook pages.

Choose Scrapbooks and then select a scrapbook design from the many options featured in the program. In this example, I chose the design with the words Clownin' Around from Block Designs in the Arts & Entertainment category.

2. When you choose a design, the selected template opens in the Customize Project window, where you can change the text on the page, but on this screen you can only change the text that is already in the template. In the next step you'll get to add more text and images. I changed the text at the top of this page design to say, "Painting for Grandma."

When you finish changing the text, choose Finish and the page will be automatically generated and ready for you to make more changes.

Tip

If you already have a page design open and you want to create a new design, you may be surprised that there is no Close option in the Edit menu. However, if you choose Edit>Save and then Edit>New, the program will automatically close your open design—just make sure you save the page you're working on before you create a new one. See "So Many Options for Saving Your Designs" on page 75 for all the ways you can save your page designs.

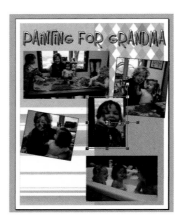

3. To add an image to the page, choose Insert>Graphic>From File. Find the picture you want to use on your hard drive and then click to select the image you want. Then click OK.

To replace an image in a design, just double-click on any existing image or any of the boxes that say "Double-Click to Replace."

4. Once you have added your image to the page, you can click on any corner and drag to resize it. To move an image, click in the center of the image and drag it anywhere on the page.

To add more photos to a design, as I have in this example, choose Insert>Graphic>From File.

5. To add more text, choose Insert>Text and then place your cursor on the page where you want to add words and start typing. To change the font or formatting of the text, double-click on it to open the Edit Text window.

6. When you have finished, choose one of the many save options under File. For example, Export As Image enables you to save your design as a JPEG or TIFF file that you can then open in a program such as Photoshop Elements and make further changes.

If you grew up in the United States, you probably have had firsthand experience with Halloween, a holiday that is celebrated on October 31. In most families, children celebrate by wearing costumes and going door-to-door saying "Trick or treat" and collecting candy or toys.

Even trick-or-treaters may not realize that this fall celebration probably dates back an ancient Celtic festival of the dead. Many historians believe Pope Boniface IV designated November 1 All Saints Day in the seventh century in an attempt to replace the Celtic tradition with a church-sanctioned celebration called All-hallows or All-hallowmas (from the Middle English *Alholowmesse,* meaning "All Saints Day"). The name "Halloween" was originally called "All-hallow-even," as it takes place the evening before All Saints Day.

Here are a couple of design ideas you can use to create a brag book or greeting card with your Halloween photos. From pumpkin carving to dressing up in costumes and all the spooky moments in between, there are so many great ways to have fun on Halloween.

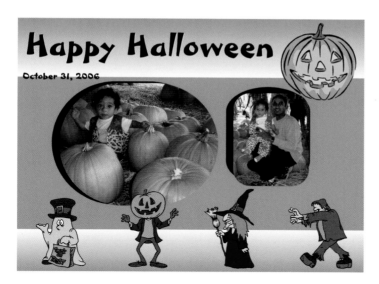

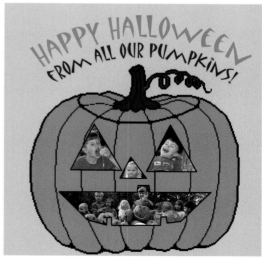

BRING ON THE GHOULS AND GOBLINS
Add color and fun to your scrapbook pages with clip-art elements like the witch and other characters in this design. This template, called pumpkin.tif, is available at DigitalFamily.com. (Photos by Sam Prasad.)

PUT 'EM IN A PUMPKIN SHELL
Create your own jack-o'-lantern and let your favorite carvers peek out from the eyes, nose, and mouth. This design was created from a template in the Halloween collection of Scrapbook Factory Deluxe. (Photos by Stephanie Kjos-Warner.)

Halloween Scrapbook Page

Halloween scrapbook pages are some of my favorites because you have the advantage of great photos of costumes and carving pumpkins. It's hard to go wrong when you start with such captivating images, but you can make them even more interesting. Cute little cartoon bubbles are a fun way to add text to your designs, and Photoshop Elements makes them easy to create with the Shape tool.

At a Glance

Software: Photoshop Elements
Template: The background in this design came from the Digital Scrapbook Memories Seasons and Holidays CD.
Size: 10 by 6 inches
Image Tips: The boys' costumes stand out even better against the background because they have been closely cropped.

WHAT DID YOU SAY?

These boys in costume look like comic book characters, so adding the cartoon bubble to this design was an easy choice. (Photo by Barbara Driscoll.)

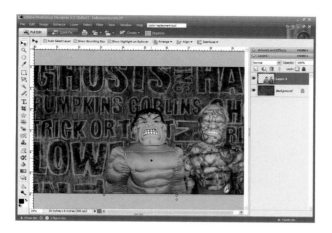

1. Open a predesigned background paper from the Digital Scrapbook Memories Seasons and Holidays CD or create your own background design in Photoshop Elements (you'll find instructions for creating backgrounds in the Father's Day award project on page 107).

Crop the image you'd like to use (see "Crop Out the Background with Magic Extractor" on page 52 for instructions on cropping) and then select File > Copy and File > Paste to copy and paste it onto the background.

2. Select the Background color well at the bottom of the Toolbox and select a color from the Color Picker to use as the background for your text bubble. In this example, I'm using black.

Create a new blank image (File > New) with the Background color selected. Don't worry too much about the size, but make it bigger than you think you'll need it to be. You want to have plenty of room to work with when you put it in your image.

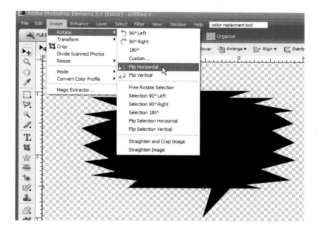

3. Select the Shape tool from the Toolbox. In the Shape tool Options bar at the top of the window, select the cartoon bubble shape you want for your design.

4. With the desired shape selected, click and drag over the image to create the shape. Select the Move tool and then choose Cut Shape from the dialog box that appears when you click on the Move tool.

If you want the tail of the cartoon bubble to be on the left instead of the right side, choose Image > Rotate > Flip Horizontal.

Tip
You can also move the tail to the other side of the cartoon bubble. Use the Rectangular Marquee tool to select just the tail, choose Edit > Cut and then Edit > Paste, and then click and drag on the tail to move it to your desired location. If you do this, you'll need to flatten the layers in the image before you can select them all. To do that, choose Layer > Flatten Image.

5. Choose Select > All to select the shape and then choose Edit > Copy. (Note: If you moved the tail by using cut and paste, you'll need to choose Edit > Copy Merged.)

6. Switch back to the image with your photo and background by clicking on the image in the Photo bin at the bottom of the screen or by selecting the file name from the bottom of the Window menu.

Choose Edit > Paste to insert the cartoon bubble. Click in the center of the bubble and drag to move it, or click and drag on any corner to resize the bubble.

After you get the bubble the size and in the location you want, double-click on it to save the settings.

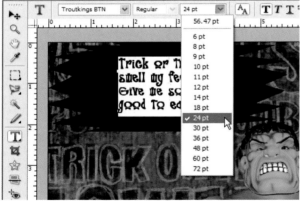

7. To add text to the bubble, make sure the layer that contains the bubble is selected in the Layers palette on the right side of the work area.

Select the Text tool and use the Text Options bar at the top of the screen to specify font, size, and other settings.

Click to insert your cursor into the cartoon bubble and then type.

Tip

If you want to change the type settings after adding your text, click and drag to highlight the text and then make any desired changes using the Options bar at the top of the screen.

Tip

You can also create shapes, such as bubbles, by using the Custom Shape tool, which you'll under the Shape tool. As with the Cookie Cutter tool, you can select from a variety of shapes. What's different about this tool is that instead of using it to cut a shape as you do with the Cookie Cutter tool, you can simply click and drag to draw any shape on an image.

Although harvest festivals are celebrated at different times around the globe, the Thanksgiving holiday in the United States is celebrated on the fourth Thursday of every November. The savory turkey meal shared by families throughout the United States was inspired by a feast held in 1621 by the Pilgrims and the Wampanoag to celebrate the harvest.

Send a Happy Turkey Day Card

Happy Thanksgiving cards are becoming increasingly popular, especially for those who want to avoid the challenges of sending the right greeting card to everyone when there are so many different holidays in December. Get an early start on the holidays and keep things simple by sending one well-designed Thanksgiving card to everyone. While you're at it, design a digital card and you'll save on postage, too.

Although I prefer to make my own greeting cards and send them via e-mail or post them to a website myself, greeting card sites make it easy to select a card (much like you'd buy one in a store) and send it to someone over the Internet. One of my favorite greeting card sites is JacquieLawson.com, which features beautifully designed cards that dance, sing, and delight her visitors. Her designs are created in Flash, an animation program ideally designed for the Internet, and you do have to pay a small fee to send them. If you want to send free greeting cards online, consider Hallmark.com or BlueMountain.com.

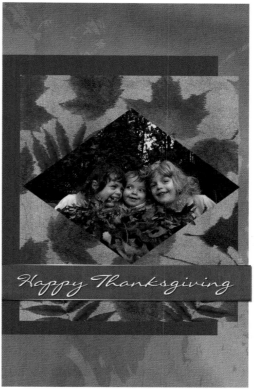

THREE ADORABLE REASONS TO GIVE THANKS
Scrapbook Factory Deluxe features a variety of greeting card designs as well as digital scrapbook templates. And like all the templates that come with scrapbooking programs, you can alter the designs to make them your own. I created this one by using one of the background images included in the program and inserting my own photo and text. (Photo by Stephen Perrotta.)

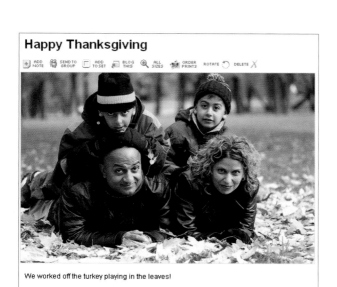

We worked off the turkey playing in the leaves!

TAKE IT ONLINE
Simplify your holiday deliveries by creating an online card at one of the many Internet photo sites. As an added bonus, your friends and family can order their own prints if they want a copy to frame or put on the refrigerator.

As you take photos on Thanksgiving Day, make sure to capture all of the cooks and carvers in action and you'll have the ingredients you need for a delicious scrapbook or cookbook design. This page was created with Scrapbook Factory Deluxe. Here are a few more tips for working with this best-selling scrapbook program.

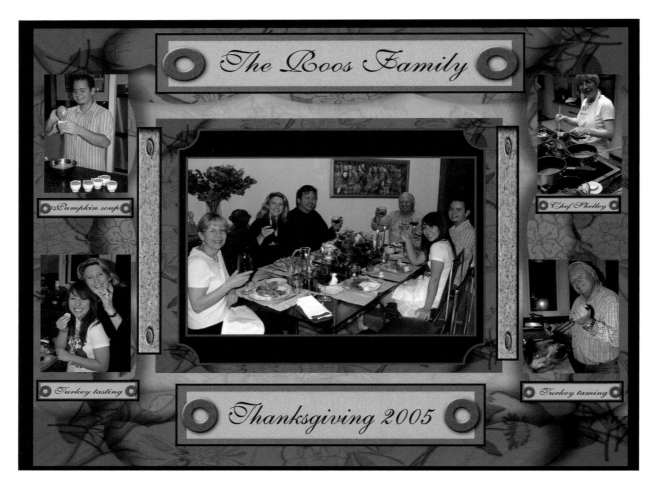

CHEERS TO THE COOKS
Combine photos of your favorite cooks in one beautiful scrapbook page and you'll have a design that's almost good enough to eat.

ADD AND EDIT PHOTOS

Although this design is based on a template included in Scrapbook Factory Deluxe, I altered it considerably to create this design. To do the same, just select any template from the thousands included in the program and add more images by choosing Insert > Graphic > From File.

To alter the shape and size of the images, click and drag on the corner of the image, or double-click to open the image in the built-in image editor and make changes there.

EMBELLISH YOUR DESIGNS

You can add or change the graphic elements in any template to make it your own. Before you even start creating designs, take a few minutes to scroll through some of the thousands of images included in this program so you have an idea of your many options.

WRITE IT IN BIG LETTERS

You can change the size of the text in your designs by clicking and dragging on any corner of a text box, or you can double-click on the text to open the text editor and specify the font size.

Reflecting on Rosh Hashanah

Although Rosh Hashanah is commonly considered the Jewish New Year, there is little similarity between this holy day and the tradition of wild parties and champagne toasts as the clock strikes midnight on January 1. Rosh Hashanah falls on the first and second days of Tishri (or Tishrei), the first month of the civil year and the seventh month of the Jewish year. The date changes from year to year on the Gregorian calendar.

Rosh Hashanah and Yom Kippur are considered the most important of Jewish holidays. The Jewish High Holy Days are observed during the ten-day period between Rosh Hashanah and Yom Kippur. Rosh Hashanah is celebrated with family gatherings and special meals. Yom Kippur, also called the Day of Atonement, is the most solemn day of the Jewish year and is traditionally a time for fasting, reflection, and prayers.

Adding Tradition to Your Designs

The shofar is a ram's horn that can be blown like a trumpet. Hearing the sound of a shofar in a synagogue is an important part of this holiday. Traditionally, 100 distinct notes are sounded each day of Rosh Hashanah as a call to repentance.

Traditional symbols and instruments, such as the shofar, make ideal elements for greeting card designs like the one featured here.

Among the many delicious foods savored on this holiday, you'll almost always find apples dipped in honey, a symbol of the wish for a sweet new year. If you're looking for another image for your Rosh Hashanah cards or scrapbook pages, consider staging a still-life scene like the candles, apples, and honey in the card design on the next page.

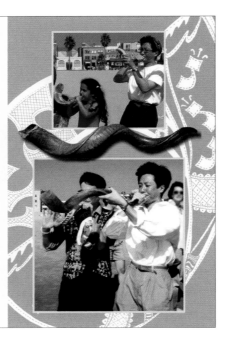

שנה טובה

Happy Rosh Hashanah

SOUND THE SHOFAR

The shofar design on the left side of this card is an original creation that was made many years ago as a gift for my grandparents. You'll find it included in this card template (called shofar.tif) at www.digital family.com. Just add your own photos and this card is easy to personalize. (Design by Davi Cheng.)

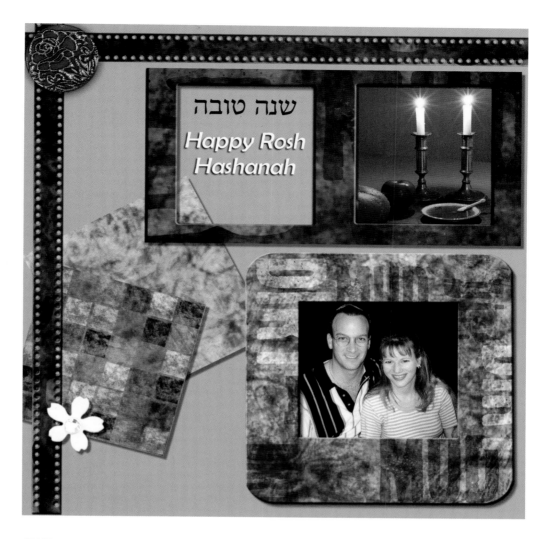

SWEET TIDINGS FOR THE NEW YEAR

The gold colors and textures of the papers and frames in this design create a beautiful, elegant feeling. This card is another example of how you can mix and match the many elements in a digital scrapbooking program to create your own unique designs.

Remember Your Family's History Every Day

In the midst of busy special occasions, it's easy to forget where we are in history—what our place is among the generations that came before us and the ones that will remain after.

As you work on the many designs in this book, take time to imagine how your family has celebrated special occasions in the past and how your traditions may evolve in the future. Often the most thoughtful gifts, stories, and designs are born out of a greater appreciation of the love that endures among family and friends for generations.

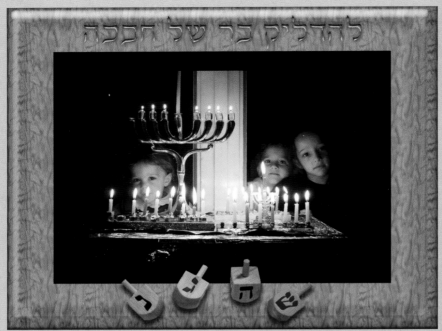

להדליק נר של חנכה

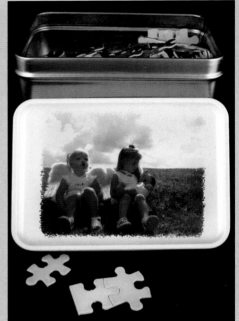

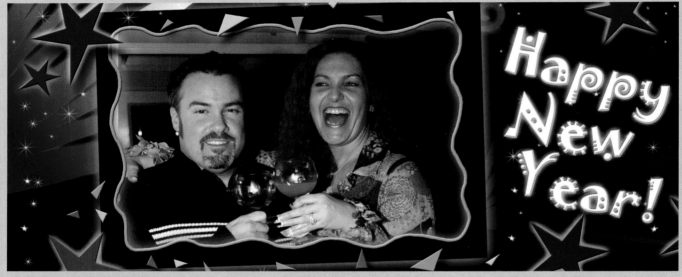

Happy New Year!

恭喜發財

Happy New Year
2006 Year of the Dog

People who are born in
1922, 1934, 1946, 1958,
1970, 1982, 1994, & 2006
This is your Year!

6

Winter Holidays:
Celebrate the Gifts, Treasure the Moments

Winter is a time of celebration for so many cultures around the world, and in this chapter I've included designs that represent some of the many holidays that take place this time of year. Cherish cozy winter days and preserve your family memories with custom greeting cards, digital scrapbook designs, and personalized gifts that will make all your loved ones feel special. No matter which holidays you celebrate, in this chapter you'll learn how to:

- **Take better holiday photos**

- **Design meaningful Hanukkah cards**

- **Make cards and gifts for everyone on your Christmas list**

- **Ring in the New Year from the East to the West with designs for festive cards**

Remember, you can customize and mix and match the designs and projects you find in this chapter and throughout the book. The projects featured here for Christmas, Hanukkah, and other holidays are designed to inspire and teach you the skills you need to create memory projects to fit any holiday.

Capturing the Best Winter Photographs

Every season brings its special challenges for photographers, but winter is one of the hardest—especially if you live in a part of the world that gets snow. The reflective nature of snow and ice can lead to harsh shadows and overexposed whites that lack detail. Even indoor photography can be more challenging because fewer daylight hours and less natural light mean you need to use a flash more often. Here are a few tips to help you balance the light and capture special moments on the shortest days of the year.

If It's Bright, Add Light

This is an old saying among photographers, and, although it may not be intuitive, you'll remember it easily once you learn the trick. From sunny, sandy beaches to bright snow-covered hillsides, the same rule applies: The best way to balance having more light than you can use is to add more light. The experts call it "fill flash." The idea is to use a flash to brighten the dark shadows created by the extreme light on a bright sunny day, which can be even harsher when the light is also reflected off snow.

STAND OUT FROM THE BRIGHT SNOW
If I hadn't used flash in this photo, you'd see dark shadows on everyone's faces caused by the light from overhead, the snow would be even brighter in contrast, and the sky would have less detail.

Focus on the Details

Christmas is a busy time for many families, and the chaos of having guests, buying presents, trimming the tree, and cooking a holiday feast can be overwhelming. At this time of year more than any other, one of the best strategies for capturing great family photos is to focus on the details, not just the big family photo. Here are a couple of ideas to inspire you to take a closer look at your subjects—from head to tail.

TREE TRIMMING
Don't just photograph the entire tree with the whole family or even one child standing in front of it; instead focus in on a specific moment to create a dramatic image.

Wait for the Golden Hour

Early morning and late afternoon are considered golden hours by photographers because the soft light the sun casts when it is low in the sky is more flattering than the harsh light of the overhead sun. In the winter more than at any other time of year, taking pictures during these golden hours can help balance the extreme light, bring out the most beautiful skin tones in your subjects, and help to capture the texture and beauty of snow.

BOTTOMS OP
We all want to see a baby's smiling face, but sometimes a glimpse of the other end can be even more entertaining. (Photo by Anissa Thompson.)

UP CLOSE AND PERSONAL
The soft light of the late afternoon is flattering, even up close.

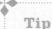

Tip
Look for long shadows to give you a clue that the light is perfect for snapping pictures.

Hanukkah: The Festival of Lights

The Jewish holiday of Hanukkah, also known as the Festival of Lights, commemorates the victory of the Jews over the Hellenistic Syrians in the year 165 B.C.E. and the miracle of the menorah that burned for eight days with only enough oil for one day.

The menorah is an important symbol of the Hanukkah celebration. Easily recognized by its shape, the menorah is a candleholder that supports eight candles plus a *shammash,* or servant candle. Part of the tradition of Hanukkah involves lighting one candle of the menorah every night for eight nights. After the candles are lighted, it is common to share gifts and for children to play the dreidel game.

If you're not sure how to spell Hanukkah, you're not alone. Chanukah, Chanukkah, and Hanukah are all accepted spellings for this holiday.

How to Play the Dreidel Game

The dreidel game is a delightful part of the Hanukkah tradition. The game is played with pennies, nuts, raisins, or chocolate gelts (coins) as prizes. Each player begins with an equal amount of the chosen prize. At the beginning of a round, each person puts a coin, raisin, or nut into the pot and takes a turn spinning the dreidel, which is a small top decorated with a Hebrew letter on each side. When the dreidel falls, the letter facing up determines the winner. The dreidel has four sides, which have the following values:

- The Hebrew letter *nun* (*nisht* in Yiddish) stands for "nothing," and the player takes nothing.

- The Hebrew letter *gimmel* (*gantz* in Yiddish) stands for "all," and the player takes everything in the pot.

- The Hebrew letter *heh* (*halb* in Yiddish) stands for "half," and the player takes half of what is in the pot.

- The Hebrew letter *shin* (*shtel* in Yiddish) stands for "put in," and the player puts one item in the pot.

After a *gimmel* has been spun, each player adds a prize again. When an odd number of prizes are in the pot, the player spinning *heh* takes half plus one. When one player has won everything, the game is over.

It should be noted that the letter *shin* is only on dreidels that are made outside of Israel, because the four letters *nun, gimmel, heh,* and *shin* form an acronym for the Hebrew words *Nes Gadol Haya Sham* ("A great miracle happened there"). If you are in Israel, instead of a *shin,* the dreidel has a side with the letter *pey,* to represent the phrase *Nes Gadol Haya Po* ("A great miracle happened here").

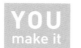

Dreidel Card

This project uses a simple card frame template to which you add your own photo. You can alter the design of this Hanukkah card for other holidays, but it is easily personalized for the Festival of Lights. And if you're a fan of the dreidel game, you may appreciate that all four sides of the traditional dreidel are featured in these images.

At a Glance

Software: Photoshop Elements
Template: Hanukkah1.tif from the DigitalFamily.com website
Size: 9 by 7 inches
Font: Ruth Fancy
Image Tips: This design is made for horizontal images, but by cropping or leaving black space on each side you could use a vertical image.

HAPPY HANUKKAH
The Hebrew words at the top of this card design translate to "Light the Hanukkah candles."
(Design by Davi Cheng; photo by Chayim Alevsky.)

1. First, download the template called Hanukkah1.tif from the Reader's Corner at www.digitalfamily.com.

Launch Photoshop Elements or another image-editing program that supports TIFF images with layers.

2. Select File>Open to open the photo you want to add to feature. Select the image by choosing Select>All. Then choose Edit>Copy to copy the image.

Switch to the template image. In most programs you can switch from one image to another by clicking on either image in the design area or by choosing the name of the file under Window. In Photoshop Elements, you can view all of the open images in the program in the bottom part of the screen and switch from one image to another by clicking on the image you want.

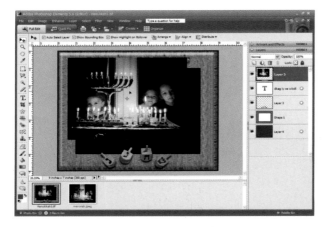

3. Choose Edit>Paste to insert the photo into the same file as the Hanukkah1 template file.

Now for the tricky part: You need to get your photo behind the border that goes around the photo in the template. To do so, you'll need to use the Layers palette. If the Layers palette is not open, choose Window>Layers to open it.

Notice that the frame, the dreidels, and the text are on separate layers in this template (see Chapter 2 for more about layers). The layer that appears at the top of the list in the Layers palette is stacked on top of the others in the image. To position your photo behind the frame, you need to move the layer with your photo until it appears below the dreidels and text but above the background layer and shape.

4. Click to select the layer that represents your photo and, without releasing the mouse, drag until the photo layer is below all of the elements in the Layers palette except the shape and the background layer.

Once you have positioned the photo layer within the frame and behind the dreidels, you can select the image in the design area and drag it until you have it positioned where you want it within the frame.

To resize the photo to better fit the design, click on any of the corners and drag. If you hold down the Shift key as you drag on a corner of the image, you will resize it proportionally and not distort the shape of the image.

Happy Hanukkah Card

This frame template is similar to the one in the previous project, except that it includes space for you to add your own text to the front of the card. As with all of the other templates featured in this book, you can add or remove images, and even change the colors and fonts to make the design uniquely yours.

At a Glance

Software: Photoshop Elements
Template: Hanukkah2.tif from the DigitalFamily.com website
Size: 8½ by 11 inches
Font: Vivaldi
Image Tips: Create a more varied design by using images in different sizes. You could even include three small images across the bottom left instead of one long picture.

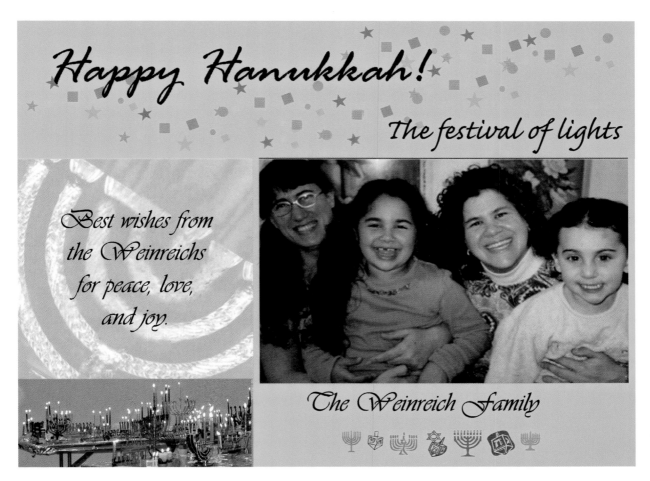

WISHING YOU PEACE, LOVE, AND JOY
In addition to photos of family and friends, you can include images of candles, traditional dishes, and other decorations to personalize this Hanukkah card. (Design by Davi Cheng.)

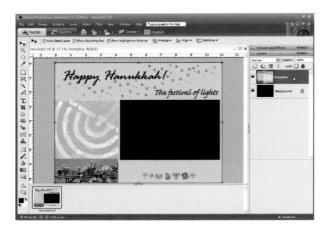

1. Download the Hanukkah2.tif template from the DigitalFamily.com website and open it in Photoshop Elements.

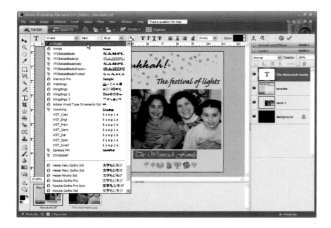

2. Follow the steps from the previous project to insert your photo and position it in the frame area on the right side of this design.

Click to select the template (the rectangle with the letter T) from the Layers palette.

To add text, select the Text tool from the toolbar. (Note: If you didn't select the template in the Layers palette, you won't be able to add text to it.)

Click to place your cursor where you want to add text to the image and type. In this example, I added "The Weinreich Family" just below the image.

To change the font, click and drag to highlight the text and then click the pull-down arrow next to the Font list at the top of the work area and select a font. In this example, I used Vivaldi.

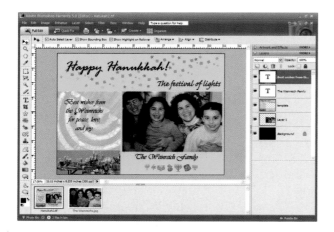

3. You can also add text to the gray-and-white box on the left-hand side of this design. In this example I added "Best wishes from the Weinreichs for peace, love, and joy."

To move the text, select the Move tool from the toolbar and then click and drag to reposition the text.

The Christian holiday of Christmas celebrates the birth of Jesus Christ, whom Christians believe is the son of God. The story of Christmas can be found in the New Testament in the books of St. Matthew and St. Luke, and many of the traditions of the holiday have grown out of those stories.

In the United States and in many other countries, Christmas is the basis for a secular celebration that often features a tree with decorations and the tradition of exchanging gifts. Santa Claus, also known as Saint Nicholas, is a relatively recent addition to the Christmas tradition. Evolved from the Dutch Sint Klaas, the modern Santa is generally depicted as a jolly man with a white beard and a sleigh full of presents pulled by flying reindeer.

Create Your Own Christmas Cards

Celebrate the joy of Christmas with a personalized card that features a photo of your family or your furry friends. When you create your own cards you can include anyone you care about. You'll find several Christmas card templates on the DigitalFamily.com website. Some of these designs are simple frames like the ones featured in the Hanukkah section. Others are designs for the front of a card with an inside you can personalize. You'll also find instructions in this section for creating a card using a template included in Photoshop Elements.

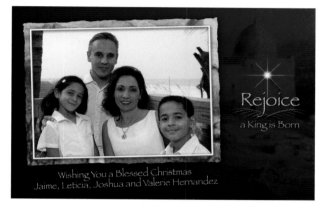

Wishing You a Blessed Christmas
Jaime, Leticia, Joshua and Valerie Hernandez

REJOICE!
You can use your own photo and text to customize this beautiful card that Jaime Hernandez created for his family. Start by downloading the template named Rejoice.tif from the DigitalFamily.com website.

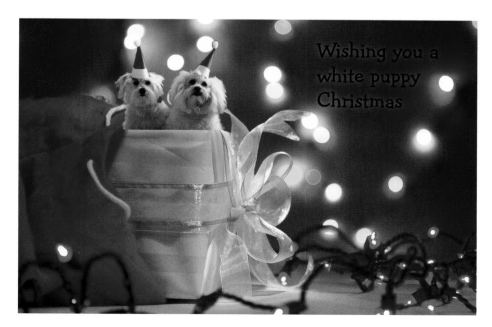

Wishing you a white puppy Christmas

A WHITE PUPPY CHRISTMAS!
Here's a fun idea. Combine a photo, such as this one of a Christmas present, with a cropped image of your loved ones (or furry friends), and then add text over an area of the image to create a personal message. (Puppy photo by Debra Bray.)

THREE LITTLE ANGELS

This template and the other two shown here are each designed to be printed on a standard 8½- by 11-inch sheet of paper and folded in quarters along the dark lines you see dividing this design. The only trick is that the front of the card has to be upside down on the template for it to line up properly after it's printed and folded. (Design by Adriana Romero; photo by Stephen Perrotta.)

We three queens wish you and yours a very Merry Christmas!

ALL I WANT FOR CHRISMAS

Position your photo at the top of the page inside the card to create more room for your message. (Design by Adriana Romero; photo by Anissa Thompson.)

May you find many presents under your tree on Christmas morning.

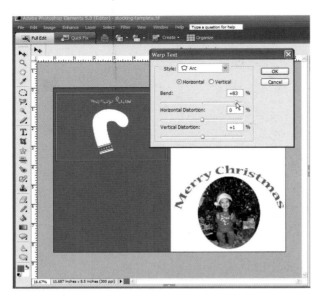

UNDER THE TREE WITH ME

You can play with text in Photoshop Elements to create words around a curve, an arch, and many other shapes. (Design by Adriana Romero; photo by Adela Morales.)

Capture Mom's Best Christmas Recipes

Holidays and food seem almost synonymous in most households. If some of your best Christmas memories come from the kitchen, a family cookbook design may be the perfect way to remember your special times together and honor the cooks that make all those tasty treats.

Although many recipe books feature a picture of the cook in the kitchen on the cover, you can use any image in your design or use a combination of smaller images instead of one big one.

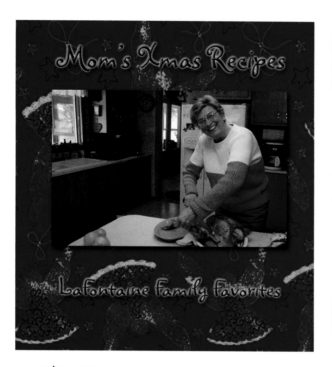

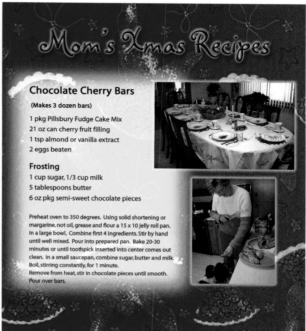

MOM'S BEST

This cookbook design was created to celebrate the best cook in my husband's family: his mother, Gail LaFontaine. To create a festive background, I scanned a piece of Christmas wrapping paper and sized it to fit this 8½- by 11-inch design. Then I altered the color in Photoshop Elements using the Fill option set to Overlay. (See "World's Best Dad Certificate" on page 107 for instructions on changing the color of patterned images.)

THE BEST-FED IN THE HOUSE

Decorate the inside pages of your recipe books with photos that show off the cook's table and maybe even catch her in action with her favorite dinner guests (even the little furry ones).

MAKE IT POP

The Artwork and Effects palette in Photoshop Elements provides many great Layer Effects, such as this embossed text with glowing edges. To use the effects, select an image or text and then click on the icon for the effect you want to apply. Experiment with different filters and effects, and don't be afraid to mix and match them to create your own unique designs. You'll find more detailed instructions for using Layers and Effects in Chapter 2.

After all the fun and presents of the holidays, don't forget to thank your family, friends, and secret Santas for their thoughtfulness, gifts, and visits. The thank-you card templates and instructions featured in this section are designed to make all your loved ones feel very special indeed.

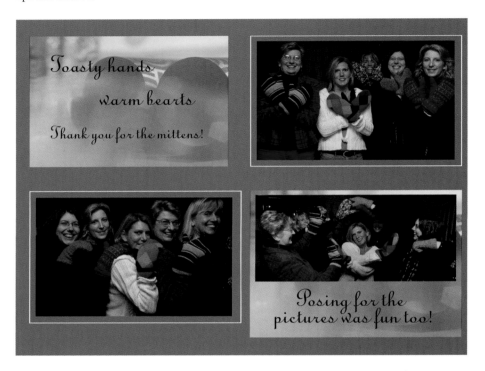

SHOW THEM YOU LOVE YOUR GIFTS

When all of the women in my husband's family received warm, fuzzy mittens one Christmas, it was easy to figure out what to put on the thank-you card. Like the previous thank-you card, this design fills a letter-size page and can easily be folded like a letter and mailed.

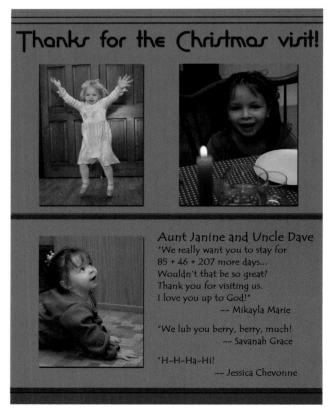

WE LUB YOU!

Use your children's own words to make your thank-you cards and letters more meaningful. This full-page layout fits on a standard 8½- by 11-inch sheet of paper that, folded down the middle the long way, fits inside a standard business envelope, which most office supply stores carry in many colors. (Photos by David La Fontaine.)

Looking for a special Christmas gift for a special person? Give Grandpa a coffee cup featuring his grandchild's photo, give Mom a personalized mouse pad, or surprise the gang with matching T-shirts showing the team photo.

You can personalize almost anything these days—from puzzles to postage stamps—if you know where to order it. Later in this chapter you'll find examples and tips for creating personalized gift items.

PUTTING IT ALL TOGETHER

A gift that features a photo of their grandkids, such as this photo puzzle, is always a hit with grandparents. (See page 156 for instructions on ordering a puzzle like this one.)

Box Your Favorite Photos

People love to show off photos of their children and grandchildren. Here's an easy way to gather your best photos and arrange them in an attractive package anyone can carry around. You can even change the photos, keeping the box always up-to-date with the latest and greatest smiles, dance steps, and other precious moments.

You can use any box for this kind of gift, and you can decorate it with your own illustrations. I found this one at the grocery store. It was originally full of chocolates, but after I finished eating all the candy, I realized it was just the right size for a collection of photos. You may think a box of chocolates is a better gift, but trust me: Most grandparents would prefer a box of photos of their grandchildren.

A BOX OF DELIGHT

What do you do when you have lots of pictures to share and not much time? Wrap up a colorful container, like this candy box, full of printed snapshots.

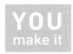

Easy Christmas Card

YOU make it

Photoshop Elements 5 features a Create tool with which it is easy to create greeting cards from a variety of designs. You can choose from many, including ones optimized for online printing services. Note that many other image-editing and layout programs also include card design features like the ones shown in this exercise.

At a Glance

Software: Photoshop Elements
Template: For this card, I chose a holiday-themed template from Photoshop Elements.
Size: Card can be created in 4- by 6-inch or 5- by 7-inch sizes.
Font: Nueva Std
Image Tips: You can alter this design by adding or deleting images and rotating them.

THE PERFECT LITTLE PACKAGE
Photoshop Elements makes it easy to create your own card design, or to use one of the templates that come with the program, like the one used to create this card. (Photos by Brett Phaneuf.)

1. Launch Photoshop Elements and click the small arrow to the right of the Create button at the top of the main work area. From the drop-down list, choose Greeting Card.

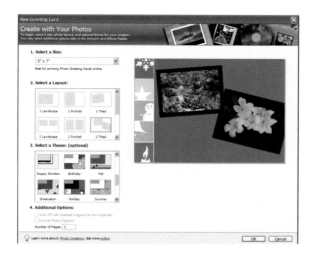

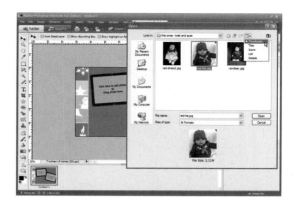

2. In the New Greeting Card dialog box, select a size, layout, and theme.

Mix and match the designs and themes and change the selections until you find the combination you like best. (Don't worry if the photo layout overlaps the card design; you can reposition the placement of the photos after you create the card.)

At the very bottom of the New Greeting Card dialog box, specify the number of pages you want to create. Each page will have exactly the same design. Click the OK button.

3. After the card is generated in the main work area, you can click on any of the image areas and select File > Open to choose a photo from your hard drive.

Select the image you want to add and drag it onto the card.

Tip

Click the small arrow next to the View icon in the top right-hand corner of the Open dialog box to view your images as thumbnails to get a preview of each image the way you see them displayed here.

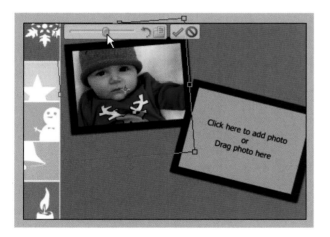

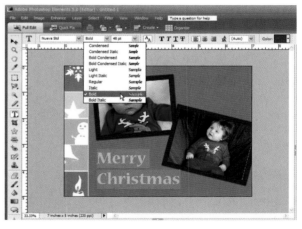

4. You can resize your photos by using the slider at the top of the image, rotate them with the rotate button, or select a different image by clicking on the Get New Image icon.

You can also resize the image by clicking and dragging any of the corners, but be careful not to distort the image. To reposition the image within the frame, click in the middle and drag.

To move the image and frame together, double-click on the image to hide the controls and then click and drag. Double-click on the image again to make the controls visible.

5. To add text, just select the Text tool from the Toolbox, and then click within the image to insert your cursor and type.

Use the text formatting options in the Options bar at the top of the screen to change the font, size, color, and other settings.

Once you've finished adding photos and text, you can save the card design and print it or e-mail it.

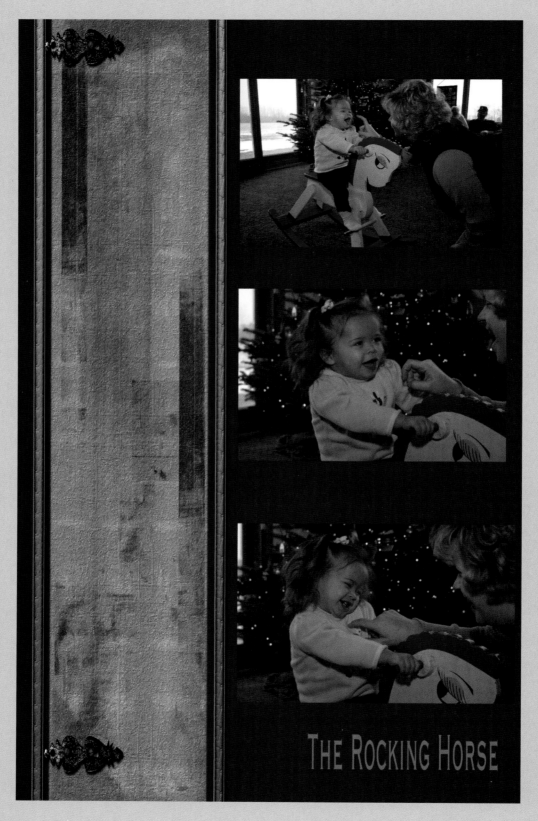

ROCKIN' AROUND WITH YOU

This brag book tells the story of a handmade rocking horse my sister-in-law received from her father one Christmas. Here I created a vertical cover for the brag book, but you can easily alter the template to make the cover horizontal. You can edit templates in Scrapbook Factory Deluxe to create new designs with more photos, more text, and any other changes you can imagine.

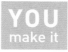 **YOU** make it

Christmas Brag Book

••

Is there a family toy or other treasure that has been passed down through the generations in your family? A Christmas brag book is an ideal way to capture the love and memories of such a special gift, and to share the joy with those who've helped create the tradition. In this project, I used a multipage template from Scrapbook Factory Deluxe to create a series of pages that tells the story of a little rocking horse in pictures and words.

At a Glance

Software: Scrapbook Factory Deluxe
Template: The Old School design, selected from the Albums & Books collection
Size: 8 by 5 inches
Font: Bodini
Image Tips: Use a series of images taken in close succession to help show movement, like the rocking on this horse.

When my oldest daughter turned three, I surprised her with the horse under the Christmas tree. When she and her and younger sisters ride it, their enthusiasm is contagious. The horse is often the center of attention at our house and our youngest can spend hours riding that little rocking horse and giggling.

FLIP THROUGH ALL THE PAGES

Whether you want a brag book with one page or 100, you can create as many as you like from the many templates in scrapbooking programs, and you can even print out extra copies for friends and family. You can also easily switch from vertical to horizontal formats depending on your design.

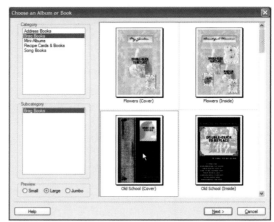

1. Your first step after you start the program is to select the kind of project you want to create from the Choose Project page, which opens automatically. In this case, I've chosen Albums & Books.

2. You'll find many templates in each section of this program. First choose a category from the left. In this example, I chose Brag Books. (Note that some design categories also have multiple subcategories.)

You can scroll through the template designs by using the arrow at the bottom right of the screen. In this example, I chose the Old School design. Once you're made your selection, click Next.

Tip
You can use the radio buttons under Preview in the bottom left-hand corner of the screen to enlarge or reduce the template images as you make your selection.

3. Choose a Fold Type from the drop-down list at the top of the dialog box. This will determine how the pages are folded to turn this design into a book.

Change the text by selecting and typing to replace the words in the left-hand side of the window. You can add as much text as you like, and you can change the font and size after the page is generated. You cannot replace or add images until after you've generated the page.

Click the Finish button to generate the page.

4. Double-click on the image holder and browse to find the photo you want to insert into the design.

To resize the image, click and drag any corner. To reposition the image, click in the middle of the image and drag.

You can also change the size and positioning of any element in the design. For example, you can click to select the background image, and then click and drag on any corner to change its size.

5. To change the text, double-click on the words to open the Edit Text dialog box.

Click and drag to highlight the text and then specify the font, size, and other settings. Use the tabs at the top of the dialog box to access additional options, such as color.

6. Use the buttons at the bottom of the screen to switch between the cover, the back, and the inside pages. In this image, I've selected the inside page.

You can rearrange the images by clicking and dragging, and you can add or delete images to change the layout. In this example, I've removed some of the image holders by clicking to select them and using the Delete key to remove them. You can also resize, move, and remove other elements, such as icons and corner brackets, by selecting them and then clicking and dragging to resize or reposition, or by pressing the Delete key to remove them.

To add additional images to a design, choose Insert > Graphic > From File and browse to find the image you want to insert.

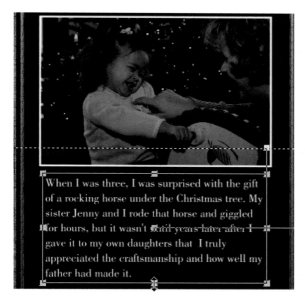

7. You can add as much text as you like, but if it exceeds the boundaries of the preset text box (as it did in this example), you'll need to click and drag to enlarge the box or make the text smaller.

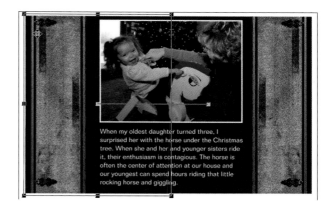

8. To add more pages, save your album and create a new identical album. When you have finished and printed the pages, you can combine them to create a longer book.

Because I didn't want to create another cover, I altered the cover template to look like an inside page. First I deleted the background image that was on the cover, then copied the background images from the inside page and pasted them into place to match the inside page design.

❖

Tip

When you're finished with your design, Scrapbook Factory Deluxe gives you a variety of options for saving or printing your file. See "So Many Options for Saving Your Designs" on page 75 for more details.

Photo Puzzle

One of my family's favorite traditions—after we've opened all the presents on Christmas morning—is to gather around a big table and put puzzles together. It's a great activity for the entire family and lends itself to catching up with conversation as we match each piece to its place in the puzzle. This year I made our family tradition even more personal by ordering a puzzle printed with a photo of my three nieces.

Many websites allow you to make custom puzzles, but one of the most popular is KodakGallery.com. All of the sites that offer custom puzzles work in the same basic manner, so even if you choose a different service, you can expect the process to be similar. Here are some basic instructions for creating a puzzle at KodakGallery.com.

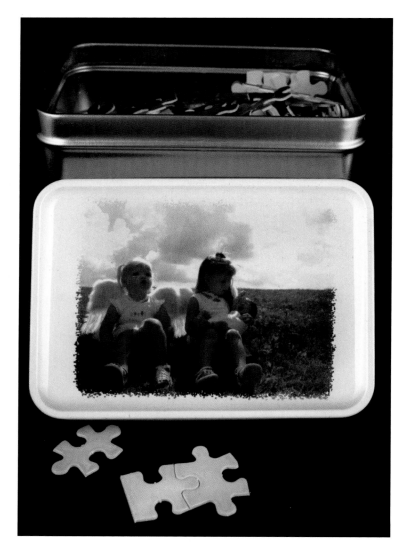

At a Glance

Online Service: Services that offer personalized puzzles include KodakGallery.com, Piczzle.com, MGCPuzzles.com, FindGift.com, JigsawPuzzle.com, PhotoWorks.com, and PersonalCreations.com.

Size: The featured puzzle, created at KodakGallery.com, has 500 pieces and measures 10 by 14 inches when completed.

Image Tips: You can turn nearly any photo into a puzzle. If you want to make the puzzle more challenging, choose an image, such as the one featured in this example, that has lots of sky or other solid colors.

PHOTO PUZZLES ARE GREAT FAMILY FUN

I created this puzzle of my nieces by uploading a photo over the Internet. The final package was sent in its own tin with the photo on the cover, making it easy to wrap and give as a gift. (Photo by Stephanie Kjos-Warner.)

1. Connect to the Internet and go to www.kodak gallery.com. Click on the Shop tab and choose Specialty and Games from the pull-down menu.

2. Click on the link under Puzzles to get started.

3. If you haven't already created an account with KodakGallery.com, you'll have to do so before you can create a puzzle or other gift item. Just fill out their simple registration form and continue through the puzzle-making process.

Click the Browse button to choose an image to upload. Once you've uploaded photos for your project, most sites (including KodakGallery.com) will keep them for you to use in any project you create with them in the future.

4. If you change your mind after you've uploaded your photo, you can switch the photo with another image by uploading another photo or choosing one you've already uploaded.

Once you've selected the photo you want, choose Add to Cart and complete the ordering information with your payment method, shipping address, and so on.

Personalized Christmas Ornaments

If you want to create customized Christmas tree ornaments, you'll find plenty of options to choose from. Many craft stores sell kits that work like small picture frames—you just open the ornament, insert your photo, close it back up, and hang it on the tree. You can also create ornaments with images printed directly on a ceramic surface. That's how I created the ornament shown here.

At a Glance

Online Service: There are many websites and stores that offer customized ornaments, including KodakGallery.com, PhotoWorks.com, PersonalCreations.com, and PersonalizationMall.com.

Size: Ornaments are usually small and flat. The one shown here is about 2½ inches wide at the longest points.

Image Tips: Because ornaments are small and will usually be viewed from a distance, you should use a close-up photo of a face or other scene that can be easily recognized when you stand back from the tree.

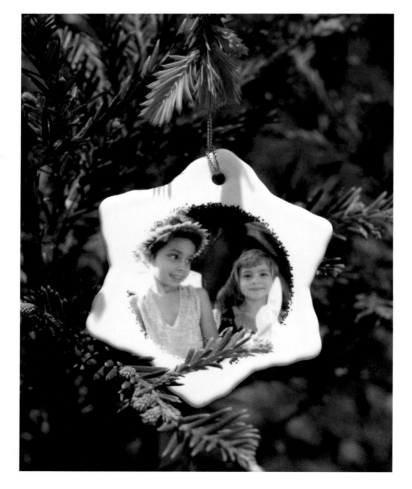

DECK THE TREE WITH ME!
Delight your children with Christmas tree ornaments that showcase their photos.

1. Connect to the Internet and enter the address of a site that offers customized ornaments. In this example, I'm using PersonalizationMall.com.

From the home page of the site, choose Christmas from the pull-down list under Occasions.

On the next screen, choose Personalized Ornaments.

2. Select the ornament design you want from the collection displayed on the ornaments page. I selected the Shining Star Photo Ornament to create the example in this lesson.

Tip

Because PersonalizationMall.com does not provide any cropping or editing tools, make sure you crop your photo in a program such as Photoshop Elements before you upload it to the site.

3. At the bottom of the Shining Star Photo Ornament page, you'll find a simple form you need to fill out to customize your ornament.

Use the Browse button to upload a photo from your computer. If you prefer, select the radio button next to the words "I will mail my photo to you," and you can send a printed photo to the company address. (You'll find their address at the bottom of their contacts page.)

Once you've selected the photo you want, choose Add to Shopping Cart and complete the ordering information with your payment method, shipping address, and so on.

Don't Forget the Card

The gifts in this section are great fun, but they'll have even more meaning when they're accompanied by a personal greeting card. Although you can have these gifts sent directly to your friends and family when you order them online, I prefer to have them sent to me first so I can make sure they came out the way I intended and package them with personalized cards and messages before I deliver them. Once you've found the perfect photo for your T-shirt, mouse pad, puzzle, or other gift, you can complete the package by putting the same photo on the greeting card you send along with your gift. For even more dramatic impact, order your own customized postage stamps (see "Personal Postage Stamps" on page 12).

Celebrate the New Year

January 1 marks the beginning of a new year in much of the world and is a great reason to stay up late to celebrate at the stroke of midnight. If you haven't sent out cards for any other holiday this winter, consider sending a New Year's card like the ones featured in this section, or mix and match the designs in this book to create your own special New Year's message.

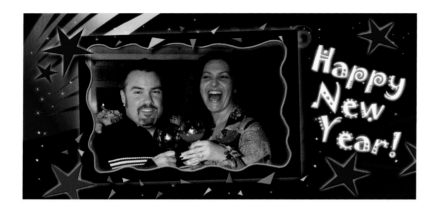

CHEERS!

Shout a cheer and insert your own photo into this festive design. You'll find this template (called NewYear.tif) at DigitalFamily.com. Follow the instructions for the Hanukkah card on page 141 to insert your own image into this template frame. (Design by Jaime Luis Hernandez.)

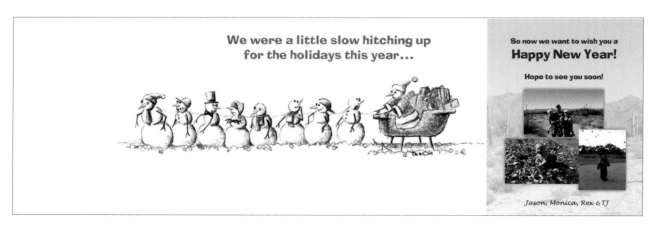

HITCH US UP!

This design features an accordion fold that allows the card to open up to a long, horizontal format. On the front, one little snowman peeks out from the snowy white background, while inside there's room for all his friends, including any photo you want to add. You'll find a template for this card (called Hitch.tif) at DigitalFamily.com. (Design by Tom McCain.)

On January 6, most Latin American countries celebrate *Día de los Reyes*, or Three Kings Day (also known as Epiphany), the day when the three wise men followed the star to Bethlehem, bringing gifts of gold, frankincense, and myrrh to the baby Jesus.

Also known as Three Wise Men Day, this celebration's traditions vary among countries. In some places, children receive gifts from the wise men, or kings, on January 6 instead of Christmas day. In other places, people exchange most of their presents at Christmas but leave a smaller gift, perhaps some candy, for children on the morning of the sixth.

Traditionally, children leave their shoes beside their beds on the night before Three Kings Day and awake to find that the kings have left a little present in their shoes. Some children also leave water and food for the kings and their camels.

Mom, the three kings sure knew how to choose the good kids, cause you are the best mom in the world.

FELIZ DÍA DE REYES

THE CAMELS WERE HERE!

My friend Adriana Romero shared this sweet story and photo: " When my mom was a little girl, her grandfather Ovidio left a beautiful doll for her, one that she had been dreaming of and didn't get for Christmas. But her biggest surprise was on the front porch, where she found sand with footsteps the camels had left when the kings came to visit!" Many years later, Adriana surprised her mother again by creating this very personal card and sending it to her on January 6.

Three Kings Day Card

This card, designed to celebrate Three Kings Day, can be used with the three smiley faces, shown in the first card design, or you can customize the card by adding your own pictures in place of the faces under the crowns. The Spanish text under the crowns translates to "May all children feel like kings today," and the greeting at the bottom of the card translates to "Happy Three Kings Day."

At a Glance

Software: Photoshop Elements or another image-editing program that supports layers
Template: three-kings.tif template from DigitalFamily.com
Size: 8 by 5 inches
Font: Liorah
Image Tips: It's best to use photos of children's faces that can be cropped into circular shapes.

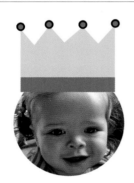
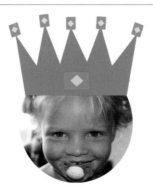
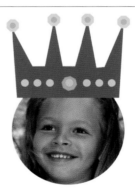

Que todos los niños
se sientan como reyes hoy...

Feliz Día de los Reyes Magos

KINGS FOR A DAY
Make your children feel like royalty by adding their photos to this design and fitting the crowns over each of their heads. (Design by Adriana Romero.)

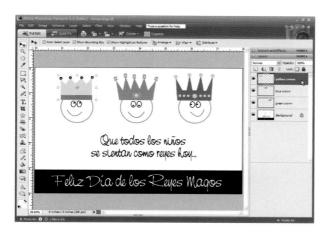

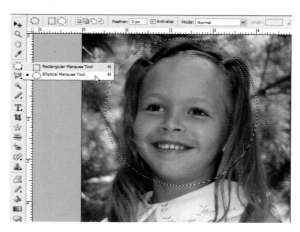

1. Download the template three-kings.tif from DigitalFamily.com and launch Photoshop Elements to open the template.

2. Open the three images you want to use for the faces. Click to select the Elliptical Marquee tool from the toolbar. If the Elliptical Marquee tool is not visible, right-click on the Rectangular Marquee tool and select the Elliptical Marquee tool. Click and drag over the image to create a circle around the face. Choose Edit>Copy to copy the selected area.

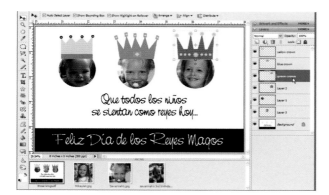

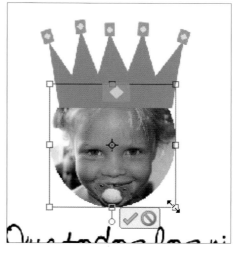

3. Switch back to the template image and choose Edit>Paste to insert the photo. Repeat this step two more times to add photos under each crown.

If the Layers palette on the right side of the screen is not open, choose Window>Layers to open it. Click and drag to reposition the layers that represent the photos under the layers that represent the crowns.

4. To resize a photo, click on it and drag any corner. To move a photo, click on the center of it and drag.

A Different Card for Every Chinese New Year

Chinese New Year doesn't fall on January 1, and it's not even celebrated on the same day every year. Chinese New Year begins with the first new moon of the new year and ends on the full moon fifteen days later, when the Lantern Festival is celebrated with lanterns and a parade.

The Chinese calendar is centuries old, far older than the Gregorian solar calendar most commonly used today. A month in the Chinese is based on the lunar cycle, which lasts about 29½ days. To catch up with the solar calendar, the Chinese calendar adds an extra month every several years (much like the extra day added on leap year in the Gregorian calendar). For this reason, Chinese New Year falls on a different date each year on the solar calendar. As part of this ancient tradition, the images of animals are used to represent different years.

WHEN IS CHINESE NEW YEAR?

You can learn more about Chinese New Year, the lunar calendar, and the history of the holiday at www.chinapage.com/newyear.html.

恭喜發財

Happy New Year
2006 Year of the Dog

People who are born in
1922, 1934, 1946, 1958,
1970, 1982, 1994, & 2006
This is your Year!

恭喜發財

新年快樂

Happy New Year
2007 Year of the Pig

People who are born in
1923, 1935, 1947, 1959,
1971, 1983, 1995, & 2007
This is your Year!

恭喜發財

新年快樂

Happy New Year
2008 Year of the Rat

People who are born in
1924, 1936, 1948, 1960,
1972, 1984, 1996, & 2008
This is your Year!

Create Your Own Holiday Traditions

As you plan the best ways to celebrate the holidays in your own home, consider drawing on the many traditions featured in this chapter. Whether you celebrate Christmas, Hanukkah, Kwanza, or some other holiday, your children may also enjoy feeling like kings for a day on Three Kings Day or exploring the many animals that represent Chinese New Year. The experience may even help them learn more about the world and the many ways people celebrate the seasons.

Expand your holidays and your horizons by creating a variety of designs and use the templates and instructions in this book to make greeting cards and gifts for all your friends. Peace, love, and joy to all and may all your dreams come true.

A DESIGN FOR EVERY YEAR
These card frame templates are designed with the animals that represent each year according to Chinese tradition. (Designs by Davi Cheng.)

Grandma's graduation

I'm so proud of grandma. She looks almost as good as I do in a cap and gown!

EXTRACURRICULAR

Come play princess at my Birthday Party!

Happy Birthday

EA

LAST YEAR'S BIRTHDAY WAS SO MUCH FUN WE'RE HAVING ANOTHER PARTY THIS YEAR!

YOU'RE INVITED
DECEMBER 13

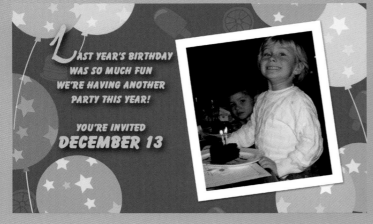

We went to Niagara Falls

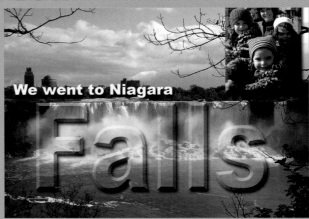

7

Measuring Milestones:

From Birthdays to Graduations & Beyond

Families gather for so many wonderful special occasions that I had to include a chapter for all the events that happen throughout the year. From family reunions to anniversaries, from quinceañeras to Bar or Bat Mitzvahs, we have many reasons to celebrate as families. This chapter showcases many more ways you can use digital designs to enrich your family gatherings and preserve memories. In this chapter you'll learn to:

● **Create beautiful personal invitations**

● **Inform everyone about a special event with a website or blog**

● **Design congratulatory cards for any occasion**

● **Show off your vacation photos with a digital slideshow**

Alter these designs to create invitations for any special event, online photo galleries to showcase pictures throughout the year, and thank-you cards for all your loved ones.

Special Occasion Photo Tips

Starting with great pictures for your digital designs is like having the freshest ingredients for a recipe. If you want your projects to be successful, make sure your photos of those memorable moments are strong. Here are a few photo tips you can use throughout the year, no matter what the occasion.

Make a Silly Face

Sometimes the subject of a photo gets tired of smiling. If you've ever been the center of attention at a wedding, graduation, or other event, you'll understand. Once in a while, instead of asking your subjects to say "cheese," get them to make a silly face. Use this photo tip to get fun pictures, but it will also help your subjects relax so that when you're ready to take a more formal photo, they are refreshed enough to give you natural and beautiful smiles.

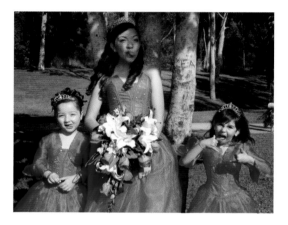 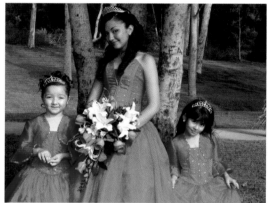

FUNNY FACE
A photo session at a quinceañera left these three young ladies tired of smiling but eager to be playful when I suggested they make a silly face instead.

Ask Everyone to Take Pictures—and Share Them!

Invite everyone who is coming to your event to bring a camera and take pictures. Often the best candid shots are taken by a guest rather than a professional photographer. To collect everyone's photos at the end of the event, create an online photo album at a site such as Shutterfly.com or Flickr.com and then invite all your photographers to upload their images to the same site so everyone can share them and even order prints.

LET ME TAKE A PICTURE
The young woman in this picture was able to get pictures of her friends' antics that the professionals on the scene might never have been able to capture. And while she wasn't looking, I was able to capture this photo of her.

Take Better Cell Phone Pictures

These days it seems like nearly everyone has a cell phone capable of taking pictures, and sometimes the only camera you have at an event is the one that came with your phone.

Unfortunately, the low resolution of these tiny cameras makes it even harder to get a good photo. To keep cameras in cell phones small, the quality of the images has to be dramatically reduced. You'll never be able to create a big poster-size image from your cell phone photos, but they are handy when you want to capture a moment, and you can get the most from your cell phone images if you keep these tips in mind:

- Hold the phone steady. The slightest movement can lead to lens blur on these tiny devices.

- Lighten up. Cell phone cameras need lots of light, so photos taken on a sunny day outside will always look better than pictures taken inside a dark club.

- Get in close. Cell phones are not very good at capturing landscapes, but they can do a fine job when focused on a child's smile.

- Don't get *too* close. Cell phone cameras tend to have wide-angle lenses that can distort a subject when it's too close. This distortion can lead to funny effects, or strange and embarrassing ones. In general, shoot from just above your subject's face to put emphasis on the eyes instead of the nose. Experiment with different angles to create the most flattering pictures.

- Take a self-portrait. Hold your camera at arm's length to take your own photo. If you adjust the camera so your face is to the side of the picture, you'll even have room for a friend or to include enough background to show where you are.

GOTCHA!
While the professional photographer was busy, these young men were having fun taking photos with their cell phones.

Some of the best digital designs I've seen center around a series of images, such as these shots of a little boy blowing a bubble. If you photograph the same action a few times, you have a better chance of getting a good sequence. Then, select the best images from each effort and arrange them for use in your final design. A series of photos such as these is ideal for scrapbook pages, brag books, and even flip books. The pictures shown here were taken in a studio, but you can use the same idea at any special event.

BIGGER . . . BIGGER . . . BIGGER . . . POP!

Joey Gizowskia was happy to keep blowing bubbles while the photographer Mary Bortemas captured these images in her Michigan studio.

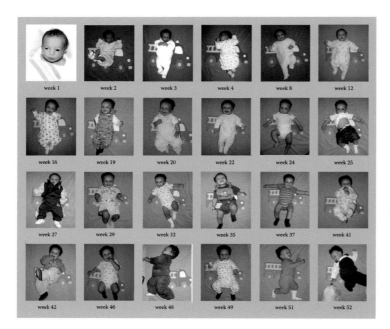

THE MANY DAYS OF TREY

Here's another take on a series of photos. Anissa Thompson photographed her son Trey on the same colorful blanket every week during the first year of his life, then she combined the photos that show the most change in a colorful design. You can include a design like this with a birthday invitation to celebrate how much your baby has grown already! Some of your friends and family may even want to frame it!

Create the Perfect Party Invitation

No matter what the special occasion, your invitations set the tone for your party or event. The perfect invitation makes your guests feel welcome even before they arrive. Whether you want to create one you'll send by e-mail or one you will print and mail or hand deliver, there are many ways to make your cards stand out.

Don't get so carried away with the designs that you forget the most important elements, such as the correct location and time. It may seem obvious, but you'd be amazed at how many people have to reprint their invitations because of mistakes or information that is left out.

My best advice is to proofread your invitations several times, especially if you're printing hundreds of copies. And don't trust yourself to check them over. Get as many people as possible to read the entire invitation before you print them out or send them, especially if they are in more than one language.

Here's a checklist of information your invitation should include:

- A description of the event

- The name of the person being honored (graduate, anniversary couple, Bar Mitzvah, and so on)

- The name of the host(s)

- The date of the event

- The time of the event

- The location of the event

- Directions to the event

- Gift registry information (if desired)

- It's also nice to include a personal message, and, thanks to the wonders of digital editing, you can add photos to make your invitation even more special.

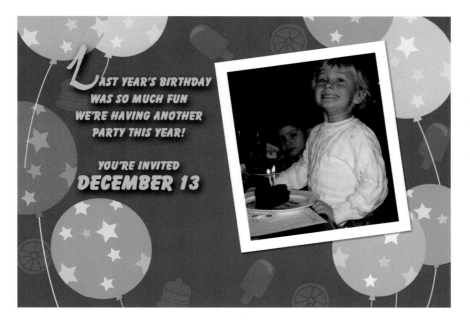

HAPPY BIRTHDAY TO ME!
Create your own fun message for the front of your invitation and keep the basic design simple. That way you'll have room to play with the design. You can include the time, place, and other details on the back or inside of the invitation. (Photo by Barbara Driscoll.)

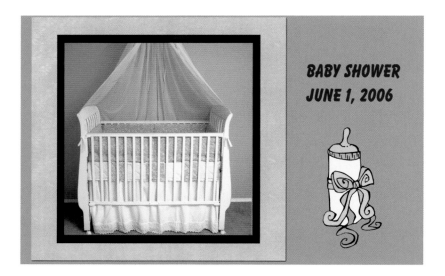

FRAME YOUR PHOTOS

Using two frames around this picture of a crib helps make it the focus of attention on this baby announcement.

DOUBLE THE FUN

You can combine more than one pre-designed frame in a program such as Scrapbook Factory Deluxe to make your photos stand out—even in the most colorful designs.

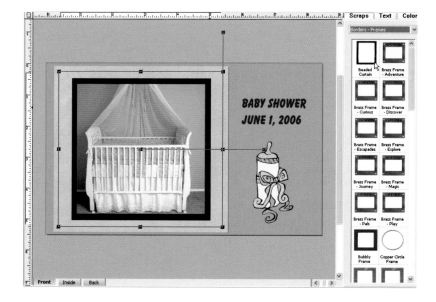

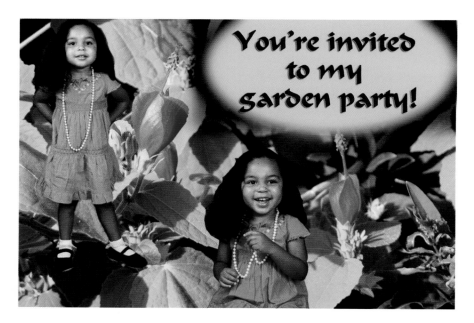

GET CREATIVE WITH YOUR INVITATIONS

Create the illusion that your child can walk on water, ride a wave, or sit on the leaf of a flower and you're sure to get everyone's attention. This whimsical garden party invitation was created by combining a photo from the garden with these carefully cropped school pictures of Evan Burrell. (See Chapter 2 for instructions on cropping photos with Magic Extractor.)

The projects in this section are designed to commemorate traditional rites of passage—from christenings to Bar Mitzvahs to quinceañeras—celebrated in many cultures and religions. As with the other projects in this book, you can adapt them to use for any holiday or special event. For example, the quinceañera design created at Scrapblog.com could be altered to feature photos from a christening, a wedding, or Bat Mitzvah.

Share Bar and Bat Mitzvahs over the Web

When most Jewish boys turn thirteen, they reach the age of maturity and become Bar Mitzvah (Hebrew for "one to whom the commandments apply"). They usually celebrate their Bar Mitzvah with a religious ceremony and a party. Jewish girls become Bat Mitzvah when they turn twelve, although most wait to celebrate this rite of passage until their thirteenth birthday like their male counterparts.

Traditional printed invitations for Bar and Bat Mitzvahs can be elaborate and carefully designed, but the latest trend in gathering family and friends for this special occasion is to create a website, complete with maps, photos, and a form where guests can RSVP online.

When you create a Bar or Bat Mitzvah site through a service like MyEvent.com, you simply choose a template for your design and then fill in a series of forms to automatically create Web pages with all your information. All you need is a browser and a connection to the Internet, and you can create different pages for each event and add stories, quizzes, and even audio and video.

WHO'S THE BAR MITZVAH?
For Jared's Bar Mitzvah, his family created a site at MyEvent.com with photos, a brief story about him, and all the details about the event.

MAKE IT EASY TO RSVP

When you include a registration form on your Bat or Bar Mitzvah site, your friends and family can RSVP online, and you can easily keep track of all of your guests.

HOW WELL DO YOU KNOW THE BAT MITZVAH?

Make your site more entertaining by adding a quiz with questions about your friends, favorite foods, and other fun facts.

Commemorate a Christening

Among Christians, a baby's baptism—often called a christening—is a special time to gather family, friends, and godparents (a role traditionally assigned to close friends or family of the child's parents). The majority of Christians—including Catholics, Anglicans, Lutherans, Presbyterians, and Methodists—practice infant baptism.

Christenings are usually held in a church, with the baby dressed in a long white gown symbolizing purity. The ceremonies are often brief and followed by a private party or family meal.

Dress the Part for a Quinceañera

Celebrated throughout the Spanish-speaking world, a *quinceañera,* also called Quince Años (meaning fifteen years), marks a young woman's coming of age on her fifteenth birthday.

Celebrations vary by country, and many girls wait until their sixteenth birthday to hold the gala event, much like the "sweet sixteen" parties better known in the English-speaking world.

In a traditional Roman Catholic quinceañera, the day begins with a mass and the quinceañera herself wears a formal dress (usually white to symbolize innocence). Much like a wedding party, a number of maids of honor and other attendants often accompany the quinceañera. The mass is almost always followed by a party that includes lots of eating, dancing, and opportunities to take photos of the well-dressed guests. As with many celebrations, formal gowns and tuxedos are the traditional garb at a quinceañera.

Create Thank-You Cards for Any Occasion

After a christening, quinceañera, Bar or Bat Mitzvah, or any other special occasion, loved ones who attended will appreciate receiving a thank-you card. Creating your own thank-you cards is a great way to share photos from the event with family and friends.

Using a photo-editing program such as Photoshop Elements, you can easily combine pictures and words to create a truly personal and memorable thank-you card that is sure to be treasured for years to come.

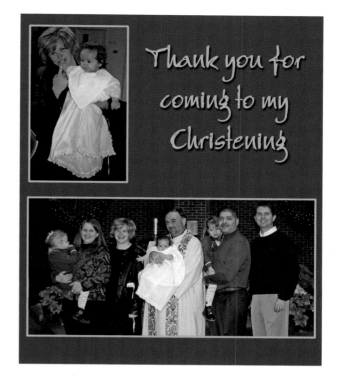

GOD BLESS JESSICA
Combine your best photos to create a thank-you card your friends and family will cherish, like this one in which baby Jessie is wearing a christening gown made by her Grandmother Helen.

CREATE A FRAME FOR YOUR PHOTOS
Add color and definition to your designs you've created in Photoshop or another image-editing program by framing your photos and other graphics with a colorful border. Select the image and then choose Edit>Stroke, then specify the color, and other options in the Stroke dialog box.

Online Scrapbook

Share your special moments with friends and family around the world by creating a blog (short for Web log), or online journal, with an online service such as Scrapblog.com. Blogs make it easy to share text and photos without having to learn Web design or buy special software. Scrapblog.com features templates, graphics, and editing tools so you can easily upload your photos, create a digital scrapbook, and then share it with anyone connected to the Internet. The published site can be public or private and includes interactive features such as you find in most blogs, or online journals, so your friends and family can add comments and notes.

At a Glance

Online Service: Scrapblog.com
Font: Times New Roman
Image Tips: Using a combination of close-up images and images that feature a larger group works well in this type of scrapbook layout.

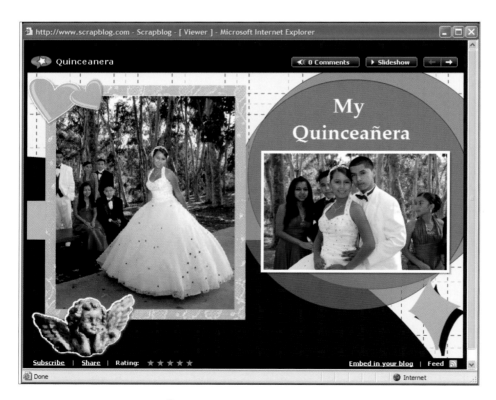

MY VIRTUAL QUINCEAÑERA
Upload your photos and add graphics to easily create an interactive Web page for any special occasion at Scrapblog.com.

1. Like most online design services, the first thing you have to do at Scrapblog.com is fill out a registration form. You can create as many Scrapblogs as you like and name them to keep them organized.

2. Choose from a variety of themes and then alter the text, images, colors, and other elements with the online editing tools. For this design, I chose the Wedding template and then changed the text and other details to work for a quinceañera.

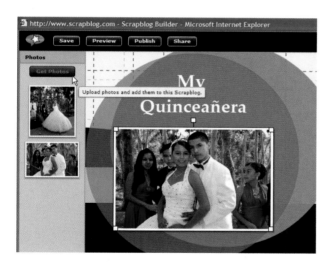

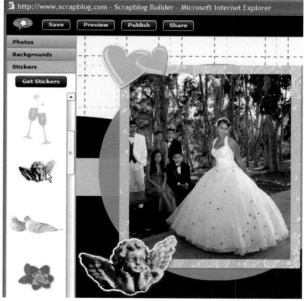

3. Select Get Photos to upload your photos to the site. Once your photos are selected, you can just drag and drop them into the design.

4. You can also add predesigned graphics to your pages, change the size and location of graphics, and move them around to create your own designs.

Tip
You'll find basic editing tools for cropping and resizing images on Scrapblog.com, but if you want to make significant changes to a photo, you'll have more options in a program such as Photoshop Elements.

Graduation Celebrations for All Ages

Every graduation deserves some recognition, whether the graduate is finishing kindergarten or polishing off a second Ph.D. Old or young, we all look kind of silly in a cap and gown, at least until we throw the cap in the air. These days it's hard to get to every family gathering, but we can all share the experience, thanks to the World Wide Web, by creating a website or a blog.

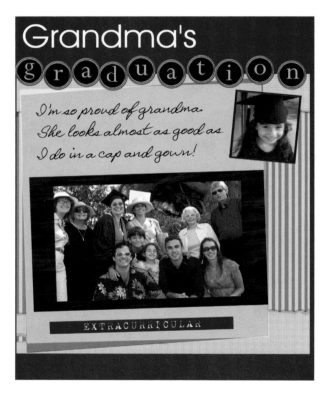

CONGRATULATIONS, GRANDMA!

Gather the best images from any graduation ceremony and mix them with provocative quotes to create a design that will keep your graduate smiling. Susannah Whitmore enjoyed having three generations at her graduation, even though her granddaughter stole the show once in a while. This design was created by altering the Choir Solo template in the Education and School category in Scrapbook Factory Deluxe.

GRADUATION DAY

This graduation page for Trey Thompson was created by his mom for all the friends and family who couldn't be with Trey on his special day. Many families are creating blogs where they can share photos and stories like these. You'll find a free, easy-to-use blog service at Blogger.com. (Design and photo by Anissa Thompson.)

In the past, travelers spun fantastic tales of their journeys, using oil paintings or prints made from woodcuts to give their audiences a visual token of their adventures in distant lands. Your family trip may not seem as eventful as these great epics, but you do have one huge advantage over those old-time travelers: You can tell your tales with modern technology, beaming pictures and slideshows over the Web, and creating printed scrapbook pages and cards using cool digital effects that are sure to delight your friends and family.

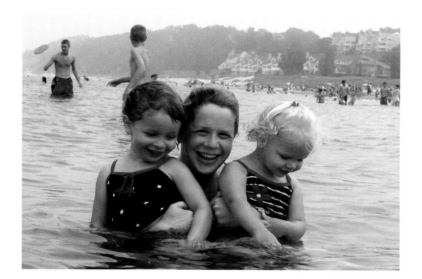

OUR TRIP TO THE BEACH

Family vacations provide lots of opportunities to take great photos. Keep your camera handy for the candid shots, like this little girl burying her sister in the sand, as well as the more posed photos like this mother with her two daughters in the water. (Photos by Kevin and Stephanie Warner.)

Tip

Keep your camera in a big ziplock bag when you're not using it to help minimize the chance of damaging it with sand or water.

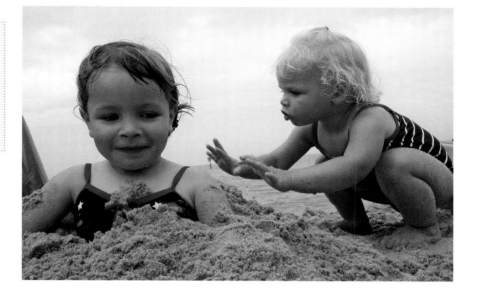

 YOU make it

Vacation Photomontage

When the Perrottas went to Niagara Falls, they came back with great memories, and lots of great photos. By creating a photomontage in Photoshop Elements they were able to tell the story of their trip in one eye-catching page. Adding a drop shadow, as on the words "We went to Niagara," is an easy way to make text stand out against a background. The treatment of the word "Falls" is a little trickier and tends to work better against landscapes than on faces.

At a Glance

Software: Photoshop Elements
Size: 7 by 5 inches
Font: For best results, use a bold, thick font sized to fill as much of the image as possible. Here I used Arial Black.
Image Tips: Photo-filled text, like the word "Falls" shown here, works best with images that don't have too many details.

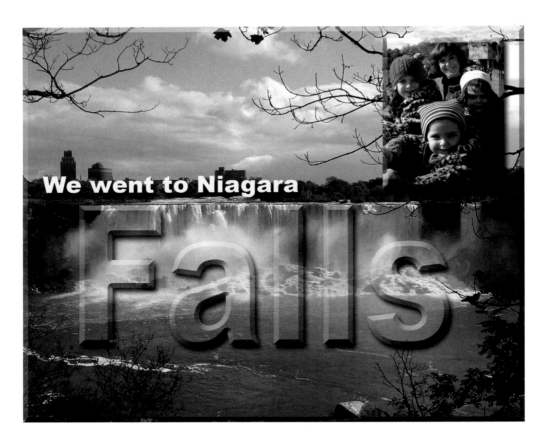

FUN WITH PHOTOS AND TEXT
The drop shadows on the text and small photo and the bevel effect on both photos make this scrapbook page look even more dramatic. (Photos by Stephen Perrotta.)

Add Drop Shadows and Bevels

You can use layer styles in combination and apply multiple effects to the same element. In this example, I added both a drop shadow and a bevel to the text and the image. You'll find these options in the Artwork and Effects palette. To find the styles I used here, choose Layer Styles category and then choose Bevels subcategory. Double-click on any icon to apply the style. To add the drop shadow, which makes the text stand out better against the background, choose the Drop Shadows subcategory of the Layer Styles category and double-click on any drop shadow icon.

1. Choose File > Open to open an image in Photoshop Elements. To add text, select the Text tool, and then click anywhere on the image and type. To modify the text, click and drag to select it and then choose the color, font, and so on from the Options bar at the top of the work area. Select the Move tool at the top of the Toolbox, and then click and drag to move the text. Click and drag on any corner to resize the text.

2. To add a drop shadow to the text, you'll need the Artwork and Effects palette. If it's not already open, choose Window > Artwork and Effects and then click on the small arrow at the top left of the palette to open it.

 Click on the Apply Effects icon (the one in the middle of the row of five icons at the top of the palette), then select the Layer Styles category and then the Drop Shadows subcategory, to display the Drop Shadow icons.

 Make sure the layer with your text is selected (the blue shading in this example shows which layer is selected). Then double-click on the icon representing the kind of drop shadow you want. In this design, I used the Low drop shadow to add the small line of black behind my white text to make it stand out against the photo.

❖

Tip

You'll find many options in the Artwork and Effects palette if you click on the arrows next to the Category and Subcategory fields just under the Special Effects heading. I encourage you to experiment with the many special effects, some of which are covered later in this project.

3. Open another photo. Choose Select > All and then Edit>Copy, return to the original photo, and choose Edit>Paste to add the photo to the main image.

Once the image is added, you can click and drag on any corner to resize it. You can also click and drag in the middle of the image to move it.

To add a drop shadow to an image that is pasted over another image like this, make sure the layer with the top image is selected, and then double-click on the icon representing the kind of drop shadow you want in the Artwork and Effects palette.

To add a beveled edge to an image, choose the Bevels subcategory, make sure the image is selected, and double-click any of the bevel icons.

How Come the Tool Won't Do What I Want?

If you're ever resizing or moving a text layer or an image layer and you find you can't do something else the way you'd expect, go back to the layer you just adjusted and double-click on it in the main work area. Any time you make adjustments to a layer, you need to apply those adjustments before you can perform most other actions, and the easiest way to apply them is to simply double-click on the layer. Don't worry, you can choose Edit>Undo to remove the change if you need to (but Undo and many other features won't work until you have applied the change).

Create Advanced Text Effects

By combining the power of layers with the ability to select text or any part of a photo, you can create advanced effects like this photo-fill text design by using the special effects options in the Artwork and Effects palette. Here are step-by-step instructions to walk you through. Follow them carefully: This trick is a little complicated.

Note
To cut out distractions, I actually added this photo-fill text effect before I added the other text and image, but you can add the effect even after you have added other elements to your design.

1. The first trick to this fancy feature is to add text to your image and make it as thick and bold as possible so you have room for the image to shine through the letters.

In this example, I used the font face Arial Black, set it to bold, and made the text very large. You can click and drag on any corner of the text area to resize it. You can even make the letters longer or fatter by clicking and dragging on the right side or the bottom of the text layer.

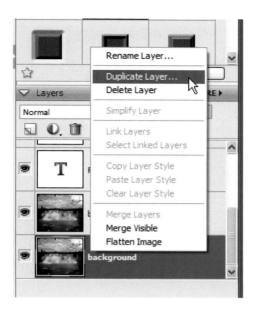

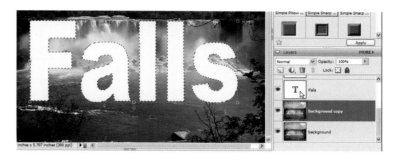

2. Next, you want to make a duplicate copy of the main photo. In this example, it's the background image, but it doesn't matter what it's called; you just need to have two copies, each on its own separate layer.

To duplicate a layer, right-click over the layer you want to copy and choose Duplicate Layer. (On a Mac, you can press Control and click on the image.)

3. Next you want to select the text, but not by clicking and dragging the way you usually select text. Instead, hold down the Control key and click on the Text icon in the Layers palette. (If you're using a Mac, you'll want to hold down the Command key and click.) You'll know you've got it right when you see the text outlined with a dashed line as you see in this example.

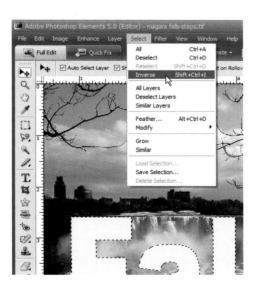

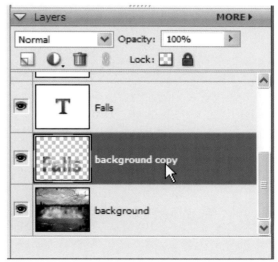

4. Here's another tricky step. What you want to do is select everything in the image that is around the text so you can delete it and leave only the part of the image that is behind the text. Here's how: With the text selected, choose Select>Inverse from the menu. This automatically reverses the area selected.

5. Next, you need to make sure you have selected the layer that holds the duplicate of your background, or main, image so when you delete everything but the text, you delete it from that duplicate copy of the image, not the main image. Select the layer that says "background copy." Then simply press the Delete key to cut the text out of the picture.

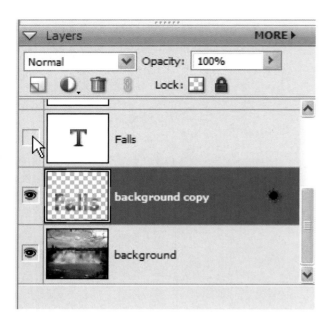

6. Now I don't need that white text anymore, and I have two options for getting rid of it. I can click and drag the layer over to the small trash icon in the Layers palette to throw it away, or I can click on the icon of the eye that is on the layer to turn it off.

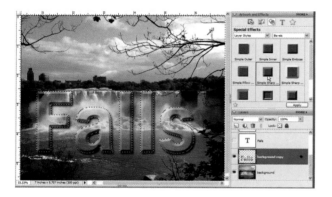

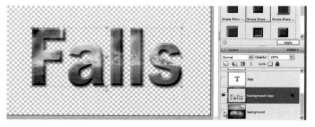

7. To create the drop shadow and bevel effect shown, first click to select the layer that has the text cut out of the image.

Use the Artwork and Effects palette to add a drop shadow and bevels to the word "Falls" as you did earlier for the rest of the text and the small image.

8. Here's a bonus step: If you want to create this text effect and use only the text without the main image, just turn off the background image to isolate the text. To use the text in another image, make sure the layer with the text is selected, choose Select > All and then Edit > Copy, and you can paste the photo-filled text into any other image or design.

Don't Get Discouraged

If you've reached the end of this project and still feel confused, you're not alone. The techniques in this project use some of the most advanced features in Photoshop Elements, and you may have to try these steps a couple of times before you get the hang of it. Don't worry if you're not quite there. Learning to use a design program requires trial and error. If you're still not getting this lesson, go back and try the steps again and look carefully at the dialog boxes and images to make sure everything on your screen matches.

 # Digital Slideshow

Everyone is familiar with the vacation slideshow, but thanks to technology, you can take your slideshow into the twenty-first century. You can easily upload digital images to any number of online photo sites for free to create a Web-based slideshow. If you prefer to share your photos in person, the following steps show you how to use Photoshop Elements to create a slideshow that plays on your computer.

At a Glance

Software: Photoshop Elements
Image Tips: Since the image fills the entire computer screen, any type of photo will do. However, make sure you limit it to your best photos so your audience won't get bored.

SKIPPIN' ALONG WITH MY SIS

When you create a slideshow, you can specify the order of the photos and even add music or a recorded narrative to help tell the story while the show plays. (Photo by Stephanie Kjos-Warner.)

1. Open Photoshop Elements and click on the Organize button at the top of the work area.

Choose File>Catalog and then click on the New button to create a new catalog where you will store only the images you want in your slideshow.

Choose File>Get Photos>From Files and Folders and then select the images on your hard drive that you want to use in your slideshow. You can select an entire folder or select individual files from within a folder. Then click the Get Photos button.

Choose Only the Best Photos

If you've graduated to a digital camera, you should have lots of pictures to choose from for your slideshow. But there's a flip side to the ease of taking digital pictures: The more photos you take, the more you need to exercise restraint in selecting only your best images to share. By including only the winners, you save your friends and family the tedium of viewing every snapshot from your vacation, and you make yourself look like a better photographer at the same time.

First sort through all the pictures from your family vacation or other special event and consider what was most important and what photos you can cut. Just because you took pictures of everyone in front of the Empire State Building doesn't mean you have to include all of them.

One of your most important decisions in creating a slideshow is deciding which photo to show first. Resist the urge to show your images in chronological order; instead, start with one of your best photos or a funny picture to set the mood.

2. Choose File>Create>Slide Show. Or you can click on the Create button at the top middle of the work area and choose Slide Show from the drop-down list as shown in this example.

3. In the Slide Show Preferences dialog box, you can specify a variety of settings, including these cryptically labeled features:

Static Duration: The number of seconds each image should appear on the screen.
Transition: A long list of choices to create a dissolve, swipe, or other transitional effect. In this example, I selected Slide Left, which means each image will slide to the left as a new image appears.
Transition Duration: The number of seconds the transition should take to completely replace the image.

Click on the Background Color color well to change the color that will appear behind any images that don't fill the screen.

Make any other desired selections. And remember, if you don't like the results, you can go back and start over. Then click OK.

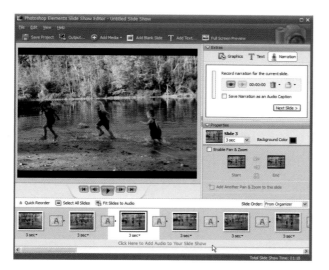

Tip

If you click to put a check in the check box next to Enable Pan and Zoom, the program will automatically zoom in and move around each image as it progresses through the slide show—a cool trick for creating the illusion of motion.

4. In the Slide Show Editor dialog box, you can specify a variety of settings and even add narration and a soundtrack. To take advantage of sound-recording features, you'll need some kind of microphone. (You can purchase headsets with microphones to use with a computer at most office supply stores.)

To add a soundtrack, you'll need to have the sound files you want to use on your hard drive. You can use sound files in any of these formats: MP3, WAV, Windows Media Audio, and AC3.

You can change the order in which the slides appear by clicking and dragging them in the photo bin at the bottom of the dialog box.

5. When you're ready, click on the Output button at the top of the screen and choose from the options available for saving or sending your slideshow. When you had made your selection, click OK.

To play your slideshow, just double-click on the new file on your hard drive, CD, or other memory device. The slideshow will begin automatically and you can sit back and watch your slideshow with family and friends.

So Many Options

After you have created your slideshow, you can save it, send it to a friend, or even watch it on your television set.

- Choose Save As a File to save your slideshow as a Windows Media Video file that you can play it back from your computer.

- Choose Burn to Disc to save your slideshow on a CD, DVD, or other disc.

- If you choose E-mail Slide Show, Photoshop Elements automatically saves a copy of your images as a PDF, launches your e-mail program, and attaches the new PDF file to a new e-mail message.

- The Send to TV feature only works if your computer and television are already connected.

Letters & Websites to Share Throughout the Year

Special occasions warrant special treatment, but if you want to keep in touch with family and friends throughout the year, consider creating a family website (or even separate websites for each member of the family, as my friend Manuela Torgler did in the example featured in this section). If you prefer to share your stories through printed pages, creating a family letter is still a fine way to keep in touch through snail mail.

Design a Colorful Family Letter

You don't have to wait until Christmas or New Year's Eve to send a family letter. Use them to keep in touch throughout the year or send them to inform friends and family of any special event, such as a new job, new home, or new baby.

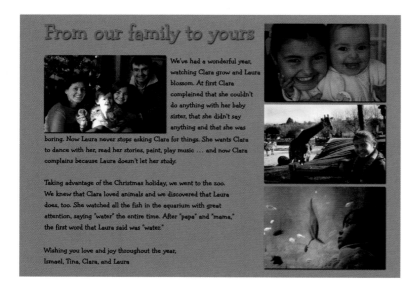

WITH LOVE FROM BARCELONA
My Spanish friends Ismael and Tina were blessed with a second daughter last year and had many fresh stories to share with family and friends. (Photos by Ismael and Tina Nafria.)

Design a Website for Each Member of the Family

Soon after Manuela Torgler launched her own website, she found herself creating a site for each member of her family as well. Then she designed a front page the entire family can share. The simple design of the first page loads quickly and makes it easy to find links to Mom, Dad, and both girls.

This is a custom website design, created with a professional Web design program called Adobe Dreamweaver. If you have graphic design experience like Manuela and want to create custom websites, you're sure to appreciate Dreamweaver, a popular program among professional Web designers. You can also create custom websites by using Microsoft Expression Web, Microsoft FrontPage, or Adobe GoLive.

If you're new to Web design, you may be better off using an online service such as the one at MyEvent.com instead of purchasing expensive software and learning the advanced design skills required for using Web design programs.

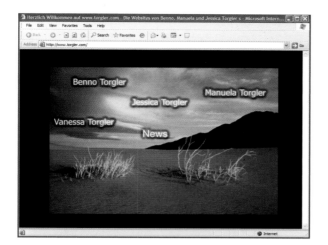

A HOMESTEAD ON THE WORLD WIDE WEB

This single photo creates a clean, eye-catching design. The names are links to each family member's page. (Design by Manuela Torgler.)

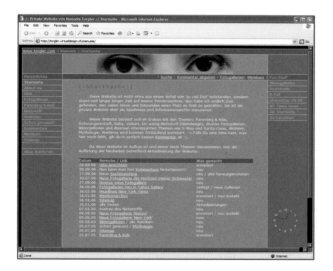

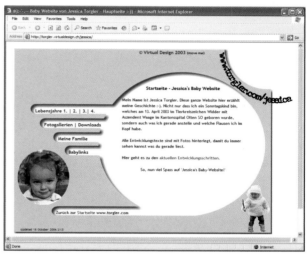

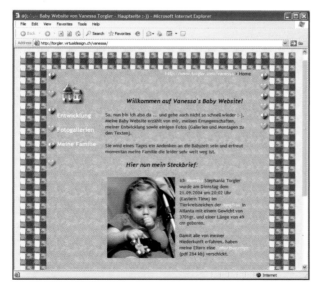

I WANT MY OWN WEBSITE

Even if every member of your family insists on having his or her own Web page, creating one home page that links to all of them is a great way to keep everyone connected. (Design by Manuela Torgler.)

Embellish Your Designs

Just because you create a scrapbook page or card or family letter on your computer doesn't mean you can't add to it after you print it. Give your creations a three-dimensional feeling by pasting on leaves, stickers, ticket stubs, and other mementos.

And don't forget, because you made your design on the computer, you can print as many copies as you want of each design and then customize them for each person you want to give a copy to, adding embellishments chosen specially for that person.

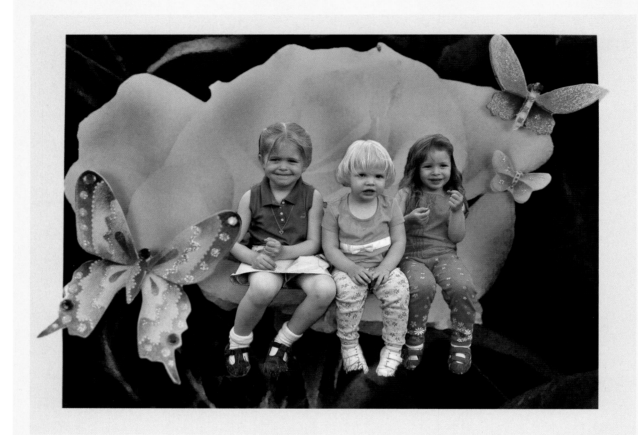

ADD STICKERS AND 3-D ACCENTS
You can find raised stickers like these in most craft stores. Add them to your digital scrapbook pages after you print them to create even more elaborate designs.

About the Author

Janine Warner is the author of more than a dozen books about the Internet and design, including *Creating Family Web Sites for Dummies* and *Dreamweaver for Dummies*. She is also the host of a series of Web design training videos for TotalTraining.com.

Janine was inspired by her own family to create the *Digital Family Album* book series and DigitalFamily.com website, in which she combines her Web design, teaching, and journalism experience to help families create lasting digital memories.

Janine is an award-winning reporter and editor whose articles and columns have appeared in a variety of publications, including the *Miami Herald, Shape* magazine, and the Pulitzer Prize–winning *Point Reyes Light* newspaper. She has also been a regular guest on television and radio programs about the Internet and how families use technology.

Janine has been a part-time faculty member at the University of Southern California Annenberg and the University of Miami. She also served as Director of New Media for the *Miami Herald* and as Director of Latin American Operations for CNET Networks. She lives with her husband in Los Angeles. To learn more, visit her websites at www.jcwarner.com and www.digitalfamily.com.

Contributing Designers

Davi Cheng is a graphic designer who was born in Hong Kong and immigrated to the United States with her family when she was fourteen. In addition to her rich Chinese heritage, Davi has embraced Judaism and is actively involved in the Jewish community, and her artwork reflects the diverse aspects of her life. Davi has created original Jewish art with a Chinese flare—including a Ketubah (Jewish wedding contract) in Chinese, Hebrew, and English. She has worked as a marketing graphic designer for Yahoo Inc., a medical research laboratory, non-profits, and other organizations. Davi lives in Los Angeles with Bracha, her college sweetheart of twenty-eight years. You can view some of her work on her website at www.davidesignstudio.com.

Adriana Romero is a designer who specializes in print, Web, and multimedia design for clients in Latin America and the United States. Her professional experience includes working for a variety of companies, including IBM, El Universal, Aue Design Studio, and Meister Media Worldwide. Adriana has a BA in Mass Communications from Universidad Católica Andrés Bello in Venezuela. She also studied Visual Communications and Design at Cuyahoga College in Ohio. To learn more about Adriana's passion for great design, visit her website at www.disenno.com.

Tom McCain is a cartoon illustrator and Web designer (and Janine's uncle). In his work he focuses on rivers, trails, children, and culture. Along with his wife, Mindy, Tom was a coauthor of *Digital Family Album Basics* and contributed several designs for family projects. He lives in Indianapolis.

Index